MW01485246

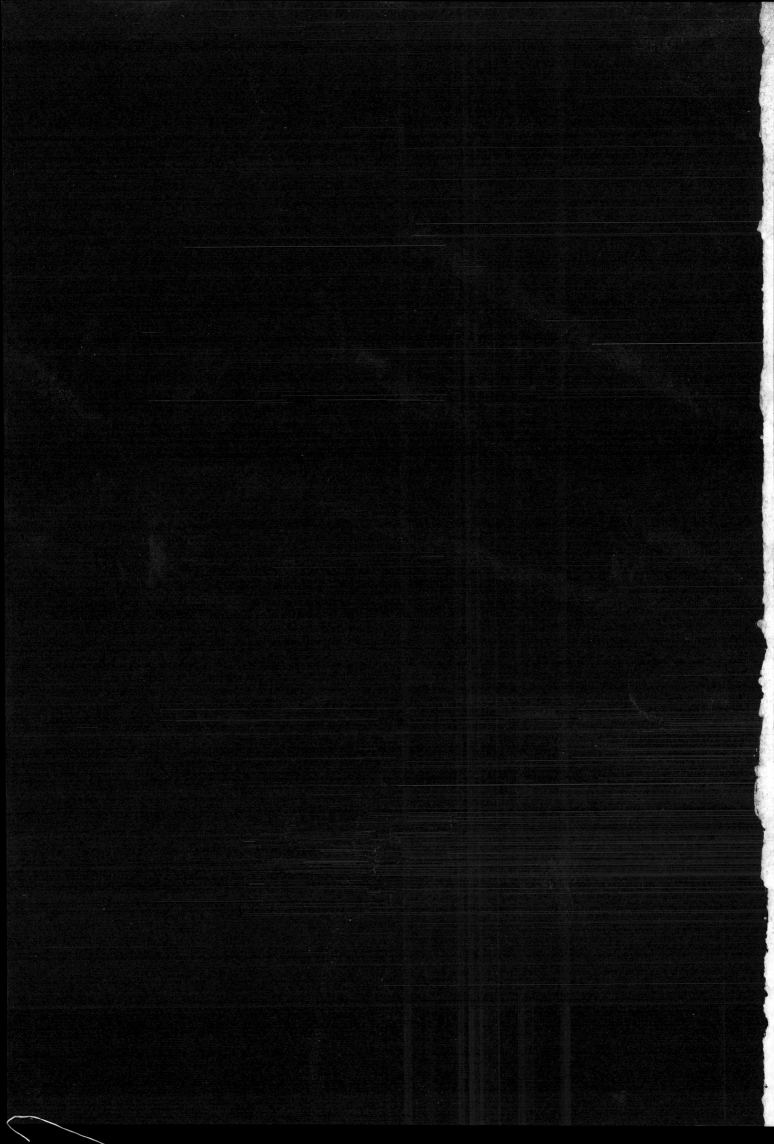

Graphis Inc. is committed to celebrating exceptional work in Design, Advertising, Photography, & Art/Illustration internationally.

Published by **Graphis** | Publisher & Creative Director: **B. Martin Pedersen**

Chief Visionary Officer: **Patti Judd** | Design Director: **Hee Ra Kim** | Designer: **Hie Won Sohn** | Associate Editor: **Colleen Boyd**

Editorial Interns: **Summer Buffin, Isabel Meyers** | Account/Production: **Bianca Barnes**

Graphis New Talent Annual 2021

Published by:
Graphis Inc.
389 5th Ave.
Suite #1105
New York, NY 10016
Phone: 212-532-9387
www.graphis.com
help@graphis.com

Distributed by:
National Book Networks, Inc.
15200 NBN Way,
Blue Ridge Summit, PA 17214
Toll Free (U.S.): 800-462-6420
Toll Free Fax (U.S.): 800-338-4550
Email orders or inquires:
customercare@nbnbooks.com

ISBN 13: 978-1-931241-99-1

This book contains some logos
that were designed by students for
mock clients for the purpose of
completing classroom assignments.
All trademarks and logos depicted
in this book belong solely to the
owners of the trademarks and logos.
By using the trademarks and logos
in these student projects, neither the
schools nor the faculty and students
intend to imply any sponsorship,
affiliation, endorsement, or other
association with the trademark and
logo owners. The student projects
were executed strictly for noncom-
mercial, educational purposes.

Any photography, advertising,
design, and art/illustration work
must be completely original. No
content owned by another copyright
holder can be used or submitted
unless the entrant has been granted
specific usage rights. Graphis is
not liable or responsible for any
copyright infringement on the part
of an entrant, and will not become
involved in copyright disputes
or legal actions.

We extend our heartfelt thanks to
the international contributors
who have made it possible to publish
a wide spectrum of the best work
in Design, Advertising, Photography,
and Art/Illustration.
Anyone is welcome to submit
work at www.graphis.com.

Printed by The Foundry

Contents

Platinum Award-Winning Instructors & Students from 2011:

EFET (Ecole Française d'Enseignement Technique)
Instructor: Yves Michel Chatrain
Student: Michael Mohr

SVA (School of Visual Arts)
Instructors: Frank Anselmo, Carin Goldberg, Robert MacKall,
John Mariucci, and Vinny Tulley
Students: Eun Haee Cho, Hez Kim, Young Wook Kim, Yoon Bin Lee,
and Michael MacKay

In 2011, ten years ago, these Instructors produced timeless work.

INSTRUCTOR VINNY TULLEY

P251: Credit & Commentary **Student:** Michael MacKay | **School:** School of Visual Arts Images 1 of 3

INSTRUCTORS ROBERT MACKALL, JOHN MARIUCCI

P251: Credit & Commentary **Student:** Eun Haee Cho | **School:** School of Visual Arts Images 1 of 2

**Twilight
visions
surrealism**

Ilse bing
André Kertész
Brassaï
Germaaine Krull
Dora Maar
Man Ray
Jacques André Boiffard

january 29, 2010-
may 9, 2010

Media Preview
january 28, 2010
11:30am-1:00pm

Museum Hours
Mon-Fri
10:00am-5:00pm
Tuesday
closed
Sat-Sun
12:00am-5:00pm

1133 Avenue of
the Americas,
New York, NY10036

www.icp.org

P251: Credit & Commentary **Student:** Michael Mohr | **School:** EFET (Ecole Française d'Enseignement Technique)

P251: Credit & Commentary **Student:** Michael Mohr | **School:** EFET (Ecole Française d'Enseignement Technique)

ADVERTISING:

Colin Corcoran | Independent Copywriter | IndependentCopywriter.com

Biography: Since 2006, Colin has been the most consistently awarded and one of the most in-demand freelance CDs/copywriters across the U.S. He has won over 300 accolades, including being the writer with the most work selected in Graphis' 2019 and 2020 Ad Annuals, and published in Communication Arts' 2016 and 2019 Ad Annuals. As a past instructor at Brainco, University of Minnesota, Academy of Art, and current professional mentor, he has helped new talent get their work into The One Show College Competition and CMYK Magazine while also successfully steering students into jobs at top agencies such as Wieden + Kennedy, Droga5, CP+B, Goodby Silverstein, BBDO, and 180LA.

Commentary: Every ad campaign is a formula. The trick is not to make them sound or look like one by just writing and art directing almost exactly the same execution each time. Magazines and newspapers may be dying, but static images will always be here to stay. With ads optimally displayed on backlit HD screens—instead of imperfectly printed on paper—an emphasis on craft is more important now, not less.

Carolyn Hadlock | Executive Creative Director & Principal | Young & Laramore

Biography: Carolyn pushes, prods, and inspires her teams to create their most effective work. Her vision and thoughtful leadership improve every campaign she touches. Her creative direction has delivered results for clients like Brizo, Stanley Steemer, Trane, Hotel Tango Distillery, Goodwill, and even an order of Carmelite nuns. Carolyn is passionate about developing talent and helped found The Creative Leaders Retreat with The One Club in 2014. In 2016, she created the blog Eunoia: Beautiful Thinking when she became the ECD. What started as a personal development project has expanded into a thought leadership platform for the agency.

Commentary: I was pleasantly surprised to see the level of thought and execution from this pool of new talent. They seemed to have transcended the shiny object trap of technology and are well versed in using technology to harness their ideas. Execution was strong and wasn't gratuitous. There's a nice balance of concept and execution happening with this new generation of students who are digital natives. The diversity of geographic entries made for an exciting showcase to judge. Diversity is a key engine of growth and energy for communications so it was good to see multiple countries and schools enter the competition. Design was strong and there was a strong showing of students not being afraid to experiment visually. I could definitely feel the confidence and boldness from this work. That is exciting. Illustration continues to be strong. I can't wait to see what this new group of talent does in the real world with real brands. It will be exciting to watch.

DESIGN:

Peter Bell | Creative Director | Tombras

Biography: Peter Bell is a designer, art director, and creative director who strives to bring strategic and creative ideas to the brands he touches. He's been a brand steward to their target audiences and has helped solve their complex business challenges with disruptive and effective solutions. Over the last twenty-nine years, he's earned both national and international recognition for his work in advertising and design from institutions such as Graphis, Communication Arts, One Show, Print Regional Design, HOW Design International, and even Dirt Rider magazine (for a Product of the Year award). He is now at Tombras as a creative director working on whiskey, golf, and BBQ accounts while contemplating long walks along the beach.

Commentary: I'm grateful to Graphis for allowing me to be a witness to this next great class of talent—their efforts reflected visible signs of greatness to come. The work that rose to the top demanded your attention, your intellect, and your intention. The level of polish and thoughtfulness shown in the work was not lost in my admiration for their dedication to the craft. I look forward to what this generation of thinkers and doers will bring to our collective conscious going forward. A special thank you to the mentors and professors guiding these students—your guidance, collaboration, and commitment is a testament to the level of work entered in the 2021 New Talent Annual.

Carmit Haller | Designer & CEO | Carmit Design Studio

Biography: Carmit Haller is the owner of Carmit Design Studio. For the past twenty years, she's been working as a lead graphic designer in the fields of consumer market, high-tech startups, and luxury real estate. Her passion lies in poster design and typography. Haller addresses cultural, social, and political topics in a strong and thought provoking view. Carmit is the recipient of worldwide prestigious awards from Graphis, Rockport Publishing, and others. She's been a member of AIGA since 2007 and a Mentor since 2020, and currently resides in San Francisco, CA.

Commentary: What a fine collection of talent, excellence, creativity, and out of the box thinking. I was deeply impressed by the video and typography disciplines, which were full of wit and humor. They made me smile in awe.

Boris Ljubicic | Designer & CEO | STUDIO INTERNATIONAL

Biography: Boris Ljubicic is a recognized explorer of visual communications and design. His works cover all design categories: visual identity, typography, billboards, books, TV, and web design. His works are exhibited in half a dozen significant international competitions and regularly appear in international magazines, yearbooks, and specialized publications. As an author originating from a so-called transitional country, he dedicated his efforts to sports, culture, economy, and politics. He achieved excellent results in each of these areas, changing the global standards along the way. In his quest for a Croatian visual identity, he sacrificed his creativity and dedicated himself to a higher goal. His international diversity is not a style or 'handwriting', but a concept aimed to form a public opinion. He won almost all of his contracts through public tenders, but he also has a collection of works that were not published. He's the founder of STUDIO INTERNATIONAL, which is named because Boris considers the visual language and professional standards he regularly applies to be a global activity.

Commentary: The best works are in the category of posters and books. The posters I gave 10 are really remarkable. "THE GODFATHER" for the famous film by Francis Coppola is very eloquent and simple in the synthesis of two elements: Christianity and crime! Great simplicity that sums up the story in only one image. WHO AM I ANYMORE? is just beautiful. At first glance you see a beautiful face, and only then a subtle intervention in black and white photography. The poster captivates with its simple visuals. POUND FOR POUND_BOXING POSTER shows everything with a narrative photo in which the text is included. You have the impression that you are attending the event on your own. VIRUSES is the witty involvement of global leaders in the current Covid 19 pandemic. However, the author clearly has a better and deeper political message, and the Covid 19 motif is only diligently used. A great shallow poster! Books are also good: THE WOMAN DESTROYED impressively evokes the content with a minimal line drawing. HIDE & SEEK explains the topic very well with its cover with closed doors, black and white photos, and conceptual photo details.

Youhei Ogawa | Designer & Art Director | OGAWAYOUHEI DESIGN

Biography: Youhei Ogawa is a Japanese graphic designer and art director. He lived in Kobe until he was eighteen before moving to Osaka and entering university. He started working as a graphic designer directly upon graduating. Youhei has recieved the Best Work award for applied typography from the Japan Typography Association three times, and has also won other design awards over fifty times. His specialities include logotype and symbol mark design, and his main work includes corporate CI and VI, branding, logo designs for small stores and companies, design work for art museums, and performing arts and concert posters.

Commentary: Graphic design is visual communication. In order to convey information visually, you have to stop someone dead in their tracks and get them to turn around. There are two possible things that can do that: something 'beautiful', or something 'interesting'. These two values are shared around the world; they're unwavering reference points in evaluation. The instant I viewed each work I judged whether they were beautiful, interesting, or neither. The New Talent Annual is a competition for those making their way into the world; basically a mass of people with potential. I took this into consideration, and evaluated works highly when I felt that, though slightly lacking in quality, they made up for it with wonderful ideas and a positive attitude in their approach. May light shine on the young talent of the future!

Sasha Vidakovic | Designer & Strategist | SVIDesign
Biography: Sasha Vidakovic, a multidisciplinary designer and strategist, is a creative force behind some of the most iconic luxury brands in fashion, hotels, yachting, design, interiors, fine manufacturing, and retail. His prolific output covers brand identities, packaging design, books, wayfinding systems, knitwear, UI, posters, and more. Sasha's clients include Victoria Beckham, Rosewood, Dorchester Collection, F1 Racing team, Harrods, Coxmoore, Moroso, Azimut yachts, Taschen, Alfa Romeo, Ferragamo, and Zegna. He works closely with business owners and investment groups to maximise the value of both their existing and new projects through brand creation and design. In addition to his professional activities, Sasha has exhibited his work in one man shows, judged design competitions, and won numerous awards. His work is regularly published in design books and magazines worldwide. He also lectures regularly at design schools and colleges in Italy, the USA, and the UK. Sasha is a Fellow of the Royal Society of Arts and ULUPUBIH. He leads a dedicated international team of associates from his design studio SVIDesign in London.
Commentary: It is always so exciting to witness how a new generation of creatives sees the world and where they are going to take it. Some amazing works. Thank you Graphis for providing the stage.

Fred Woodward | Editorial Designer | Fred Woodward Design
Biography: Fred Woodward is an American graphic designer and art director working primarily in magazines and books. He has received lifetime achievement honors from The American Institute of Graphic Arts, The Art Directors Club, The Society of Illustrators, and The Society of Publication Designers. Woodward was GQ's Design Director from 2001-2017, having previously served a similar tenure at Rolling Stone (1987-2001).
Commentary: I saw a strong move toward motion. There was one 'title sequence' in particular that was so full-grown, so completely realized, that the late great Saul Bass must surely be resting peacefully tonight.

PHOTOGRAPHY:
Craig Cutler | Photographer & Director | Craig Cutler Studio
Biography: Craig Cutler's combination of craft and style brings an element of art to his work as a director and photographer. Conceptual thinking lays the foundation for both his print and film approach. Each of his projects, personal or client directed, begins with concepts that take shape initially as sketches and evolve through a series of revisions and additions until a final direction is honed. Craig's work is further differentiated by his focus on lighting. He strips each piece of its setting and uses lighting to evoke the message integral to his concept. A frequent recipient of awards for his advertising campaigns and personal work from Graphis, American Photography, and Communication Arts, Craig blends his three decades of experience with contemporary vision to create timeless art. You can see more of his work at www.craigcutler.com.
Commentary: It is interesting to see what students are doing. I responded more positively to the more simple ideas and compositions. I thought much of it was too heavy handed in digital retouching and effects, but there were a few that stood out, such as the still life with a water glass and fruit behind it. I think all of them should pick up and read a Irving Penn book. His eye for composition and lighting in portraiture and still life is still timeless even today. My advice would be to look at his work and really study his images. The scuff on the paper in his still life, the broken carpet threads on the floor of his portrait, and the sharp shadow that loses all detail are no accidents.

Nicholas Duers | Photographer | Nicholas Duers Photography
Biography: Nicholas Duers is a commercial still life photographer/director in New York City. He has been shooting predominantly in NYC since 2007, servicing agencies, brands, and magazines in the fashion, beauty, entertainment, and luxury goods sectors. He studied fine art photography at the Photographic Center Northwest in Seattle, WA, before further developing his aesthetic at the Rochester Institute of Technology. Today, he operates out of his studio in Midtown Manhattan, and is represented in the US by Farimah Milani. In addition to Graphis, his work has been recognized by Px3 Paris, the Intl'l Photo Awards, Moscow Int'l Foto Awards, Tokyo Int'l Foto Awards, Advertising Photographers of America, Surface Magazine's Avant Guardian, and Photo District News, among others.
Commentary: There are so many photography and design competitions out there, but Graphis has a caliber of work and curation that seems to elude the others. It is truly a pleasure to see the work of emerging talents, especially on this platform. I only wish there was more of it. There are so many up and comers that I see on Instagram and from all around the globe who are producing ad-quality still life work who would be great for a contest like this, and I'm bummed I don't see more of them represented here. I am going to make a more concerted effort to spread the word to the emerging individuals who pass through my studio, and who I connect with on social media, to submit their work to Graphis!

Stan Musilek | Photographer | Musilek Photography
Biography: Stan Musilek was born in Prague (before Prague was cool). His first artistic endeavor was making a dark room in his mother's pantry and relentless photographing the neighbors. He moved to Germany and attended college in Heidelberg, where he studied mathematics until realizing photography was sexier than math. He eventually immigrated to the United States, where he opened his first studio in San Francisco, followed by a second studio in Paris. Since then he's shot lots of stuff and won lots of awards, and he enjoys making his clients laugh.
Commentary: We had a great time judging the new talent for 2020. I involved my crew so everyone contributed their two cents of wisdom as well as a cross generational point of view. It is typical that with new talent, there is a widespread contrast of the maturity of the work. That being said, we saw a handful of great pieces and scored accordingly.

Joseph Saraceno | Photographer | Joseph Saraceno Photography
Biography: Toronto born commercial photographer Joseph Saraceno started taking photographs as a hobby, which quickly developed into a nagging obsession. Recognized not only in Toronto but also internationally, Joseph's work covers a broad spectrum. He takes a fluid approach to his work, letting the formal qualities of an object drive the creative direction. Strong directional lighting, contrasting textures, and bold angles are signatures of his work, which has been featured editorially in Sharp Magazine, Scentury Magazine, ELLE Magazine, and The Globe and Mail, plus advertisements for Holt Renfrew, Hudson's Bay Beauty, and SDM Beauty.
Commentary: I'm overall very impressed with the level of quality of the work from the new talent division.

Mel White | Syracuse University, The Newhouse School | Dean: Mark Lodato | Pages: **19, 20**
Biography: Mel is a professor of practice of advertising-creative at Syracuse University's S.I. Newhouse School of Public Communications. From day one of teaching, Mel has made it a priority to make Newhouse student creative teams diverse. She focuses on teaching her students how to create visual solution advertising with strong, compelling ideas, as well as teaching a digital-first and experiential-first approach to advertising with the senior students. Over the past five years, there has been a rapid and exponential increase in the number of awards being won by Newhouse creative advertising students. After surveying student creative advertising award shows, she introduced them to the students, and incorporated competition briefs into her courses. Mel spent more than twenty-five years in the advertising industry – the last seventeen in NYC as a creative director/art director at Y&R, Ogilvy, Publicis, and DMB&B, working on a range of accounts such as Microsoft, Land Rover, MINI Cooper, Sony, Crest, Dannon, and American Express, and winning several industry awards. She began her advertising career after earning a BFA in advertising art direction from Syracuse University's College of Visual and Performing Arts.
Advice: 1) Increasing diversity in creative advertising agency departments can start in college by diversifying creative teams. These diverse creative teams have the potential to be hired together and can help change the industry.
2) Putting students together into diverse teams in college is important because it leads to diverse thinking, provides diverse voices in the team, and has been proven to lead to more innovative ideas.
3) Teach students a method to create ideas that can be repeated, because then, it can be replicated every time.
4) Challenge students, and they'll step up to meet them. The work in this Annual clearly shows that.

Taylor Shipton | Pennsylvania State University | Dean: Philip Choo | Page: **21**
Biography: Taylor Shipton is an assistant teaching professor within the graphic design program at Penn State. She has a background in experiential design, design photography, and communication design. Her work focuses on the interactive experiences of the user, applicable to both analog and digital design environments, and how these experiences influence the audience.
Advice: As a professor, Shipton strives for her students to not only succeed, but to push themselves further into creative innovation. She wants to create an exciting classroom where students are free to experiment and try new things. Ultimately, design needs to be successful, but Shipton believes a fear of failure often prevents students from wanting to explore outside of documented successes. She tells her students that there's nothing new or interesting about something that's already been proven successful. This has resulted in an impressive drive and desire to create. Shipton has found that treating her students as professional designers, and setting her expectations in accordance with that, has strengthened her student's approach to design problem solving.

Jay Marsen, Alexi Beltrone | School of Visual Arts | Dean: Gail Anderson | Pages: **22, 23**
Biography: Jay Marsen and Alexi Beltrone are instructors at the School of Visual Arts, where they are slowly earning back their tuition. Coincidentally, they are also graduates of the School of Visual Arts (class of 2007) where they earned their BFAs in advertising. Even more coincidentally, they initially met each other as students at the School of Visual Arts. They eventually did the fusion dance and formed the creative entity known as JayLex, a freelance advertising CD team in New York City. Over the past fourteen years, they have worked at a number of New York agencies, including McCann, FCB, adam&eveDDB, GREY, Pereira & O'Dell, JWT, DeVito/Verdi, TAXI, and Publicis, creating campaigns for clients like FOX Sports 1, realtor.com, New Era, Memorial Sloan Kettering Cancer Center, Smirnoff, Vonage, Kleenex, Partnership for a Drug-Free America, Crest, and Charmin. Such work has received awards and honors from organizations such as The One Show, Cannes, CLIO, Communication Arts, Lürzer's Archive, and Graphis.
Advice: Great ideas win. Bad ideas lose. Really bad ideas lose but insist they won.

Kevin O'Neill | Syracuse University, The Newhouse School | Dean: Mark Lodato | Pages: **24, 25**
Biography: Kevin O'Neill has fashioned a communications career of unusual dynamism and diversity: news reporter, fiction writer, award-winning copywriter and creative director, advertising agency president, creative consultant to leading corporations, and content developer and educator at America's leading school of communications. He is a graduate of Princeton University and earned an MA at Hollins College on a fiction-writing fellowship. He has been the senior creative executive at both globe-straddling advertising networks and creative boutiques on a glittering array of world-class brands including IBM, Johnson & Johnson, Sara Lee, Hanes, Panasonic, Lego, AT&T, and Bacardi. His work has been recognized by virtually every creative award competition and he was featured in the Wall Street Journal's Creative Leaders Series, a distinction limited to the advertising industry's most accomplished practitioners. His fiction has appeared in The New Yorker, The Carolina Quarterly, and been cited in The Best American Short Stories of the Year, published annually by Houghton-Mifflin. He has published in Sports Illustrated, Golf Magazine, Adweek, The Philadelphia Inquirer, and through Scripps-Howard newspapers. He is completing his twelfth year as a member of the advertising faculty of the S.I. Newhouse School of Public Communications at Syracuse University. His primary responsibilities include the Newhouse Portfolio program which is intended for those students seeking a career in the creative departments of advertising agencies.
Advice: My most urgent counsel is that they not let anyone outwork them. The business they're headed into is full of talented people and the people who prevail are those who go after it with more energy and commitment than anyone else. Talent's not enough.

David Stadttmüller | M.AD School of Ideas Berlin | Dean: Sabine Georg | Page: **73**
Biography: David is currently running a concepting class at Miami Ad School Berlin, where he has been a lecturer since 2012, and working as a freelance art and creative director. Before that, he started his career with internships at Scholz & Friends and BILD Berlin, then earning his diploma at Bauhaus University in 2007. He has worked as an art director at Wieden + Kennedy and DDB Berlin, and was a senior art director at Jung von Matt/Spree. In 2014 he was the creative director at Aimaq von Lobenstein, and in 2015 helped found the L7 Berlin music festival.

Sam Luo | Syracuse University, The Newhouse School | Dean: Mark Lodato | Pages: **19, 20, 24, 25**
Biography: Sam Luo is an art director student from Shanghai, and he currently studies advertising and art direction at S.I. Newhouse School of Public Communications at Syracuse University. With honors and recognition from world-renowned associations in creative advertising such as the One Club ADC, Communication Arts, and Creativity International, Sam is beyond grateful to add Graphis to the list. Using what he has learned and combining them with his own unique style and vision, Sam has been able to work with international brands such as McDonald's, T-Mobile, Huawei, Mercedes-Benz, etc. From experiences he gathered both in North America and Asia with global agencies such as Ogilvy, Saatchi & Saatchi, and Publicis, he is able to create visual solutions that are tailored to different cultures and audiences. Sam wants to thank Graphis for this recognition, and you can always find him at samluodehao.com.

Cassie Luzenski | Pennsylvania State University | Dean: Philip Choo | Page: **21**
Biography: Cassie Luzenski is a senior at Penn State majoring in graphic design. During her time at Penn State, the program gifted her with the opportunity to experiment, fail, and then grow as a designer. She discovered a passion in design photography, visual identity, and brand campaigns. She strives to create work that stretches boundaries, pushes design outside of its comfort zone, and strikes up a conversation. Cassie takes pride in promoting social issues and therefore approaches every design with purpose. She believes that the core of a great project begins with thorough research and strong conceptualization. Overall, Cassie's thoughtfulness and drive prepares her to take on any challenge that comes her way.

Junghoon Oh | School of Visual Arts | Dean: Gail Anderson | Pages: **22, 23**
Biography: Junghoon Oh was raised in South Korea and is currently enrolled as a junior at the School of Visual Arts, where he specializes in communication design. During his adolescent days, Junghoon lived in loneliness. He spent all his time alone and little could muster up the courage for living. Since discovering communication design, Junghoon's world became a box full of hopeful expectations, and he finally had the confidence to stand with himself and others. After he got motivation from this subject, Junghoon made it his goal to be an influential graphic designer in society. He established his aim to go to New York to learn useful knowledge and strategies to tackle the questions of graphic design.

Xinran Xiao | Syracuse University, The Newhouse School | Dean: Mark Lodato | Pages: **24, 25**
Biography: Born and raised in Beijing, China, Xinran is a recent graduate from Syracuse University's S.I. Newhouse School of Public Communications in Syracuse, NY. She has interned at DDB and Ogilvy as an art director, and is currently working at Bytedance. She is always passionate about generating new and crazy advertising ideas simply because she loves the "wow" comments when people see her ads. She also believes that the power of great advertising could change the way we think and eventually change the world.

Seine Kongruangkit | M.AD School of Ideas Berlin | Dean: Sabine Georg | Page: **73**
Biography: Seine Kongruangkit is an art director and audiovisual artist. Named after the river in Paris, Seine was born and raised in a city where people spit into the river; Bangkok. As a queer person of color, Seine strives to use her creativity to solve problems and empower people, and that has brought her into the advertising world. She enjoys every step of the process, from coming up with creative ideas to bringing them to life visually.

Every ad campaign is a formula. The trick is not to make them sound or look like one by just writing and art directing almost exactly the same execution each time.

Colin Corcoran, *Independent Copywriter, IndependentCopywriter.com*

I was pleasantly surprised by the thought and execution of all this new talent. They've transcended technology's trap and can use it to harness their ideas.

Carolyn Hadlock, *Executive Creative Director & Principal, Young & Laramore*

Visit our Credits & Commentary section in the back of the book to read about the full assignments, approaches, and results from this year's Platinum Winners.

Beauty & Fashion | Advertising

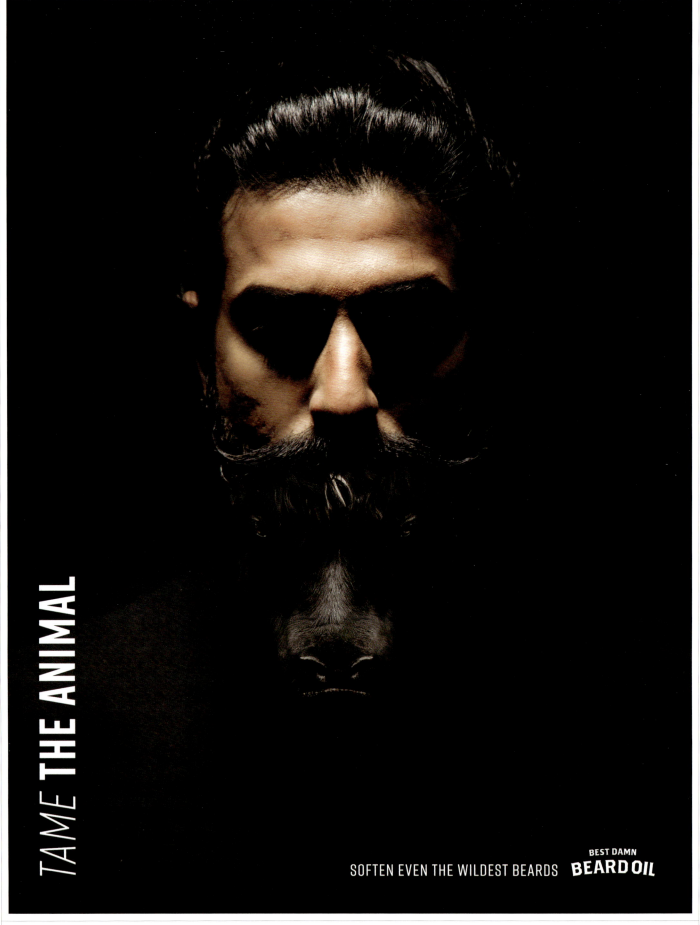

20 INSTRUCTOR **MEL WHITE** PLATINUM

Advertising | Beauty & Fashion

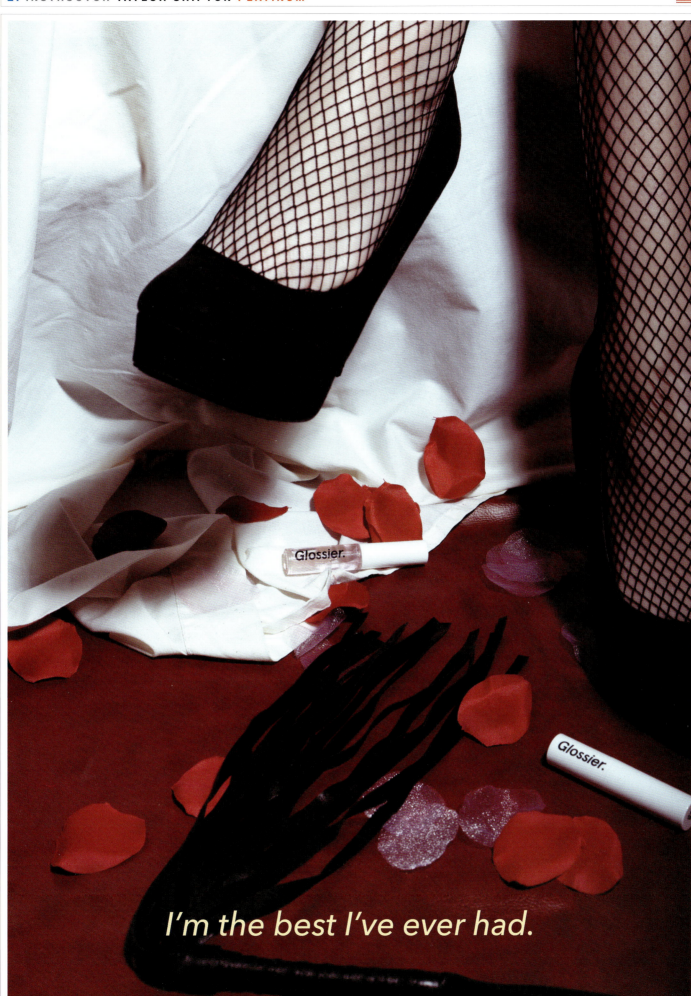

I'm the best I've ever had.

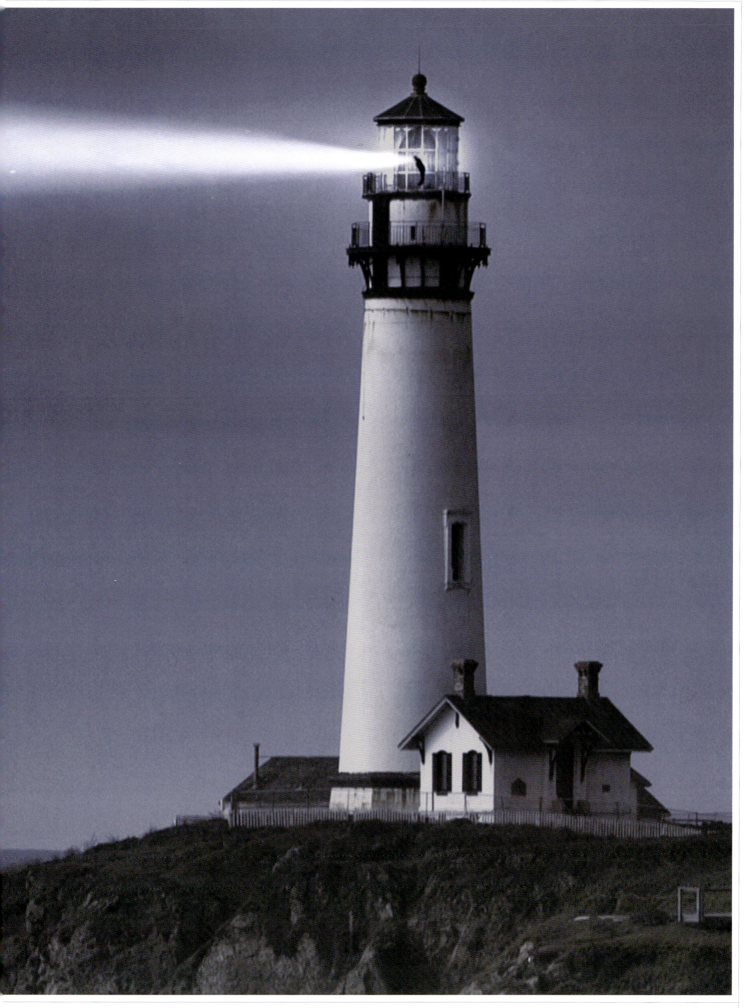

Student: Junghoon Oh | **School:** School of Visual Arts

P251: Credit & Commentary **Student:** Xinran Xiao | **School:** Syracuse University, The Newhouse School Images 1, 2 of 3

volkswagen, it's plugged-in

more power, no gas, volkswagen brand new all electric e-golf

full-charge power, it's volkswagen

more miles, no shortage, volkswagen brand new all electric e-golf

Automotive | Advertising

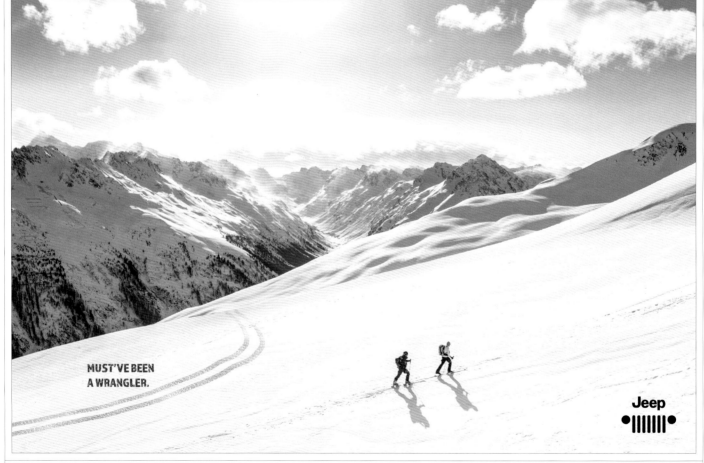

P251: Credit & Commentary **Student:** Benjamin Lin | **School:** Syracuse University, The Newhouse School Images 1, 2 of 3

YOU'RE NEVER TOO OLD TO PLAY IN THE MUD

Be Fearless.

Get out there and have some fun! Built to withstand the toughest conditions, this beast will guide you anywhere. Hop in a Toyota 4Runner and discover the adventurous capabilities of your off-road companion. *#4theFearless*

Copyright 2020 Toyota Industries – Toyota 4Runner – All Terrain Vehicle

Automotive | Advertising

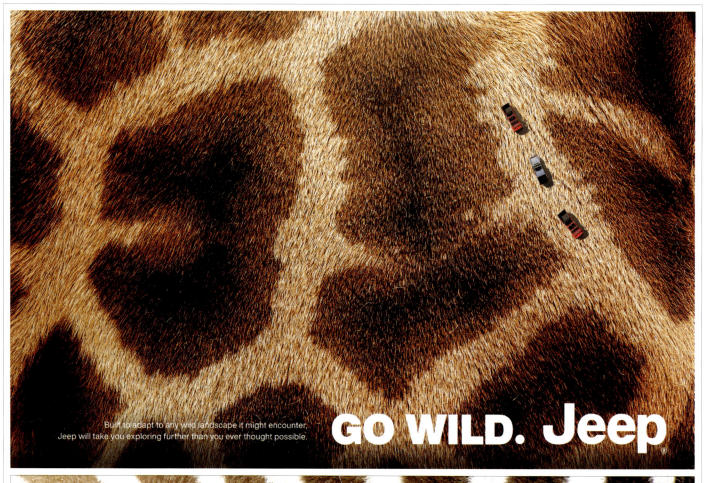

Built to adapt to any wild landscape it might encounter,
Jeep will take you exploring further than you ever thought possible.

GO WILD. Jeep

Built to adapt to any wild landscape it might encounter,
Jeep will take you exploring further than you ever thought possible.

GO WILD. Jeep

P251: Credit & Commentary **Student:** Sam Luo | **School:** Syracuse University, The Newhouse School Images 1, 2 of 3

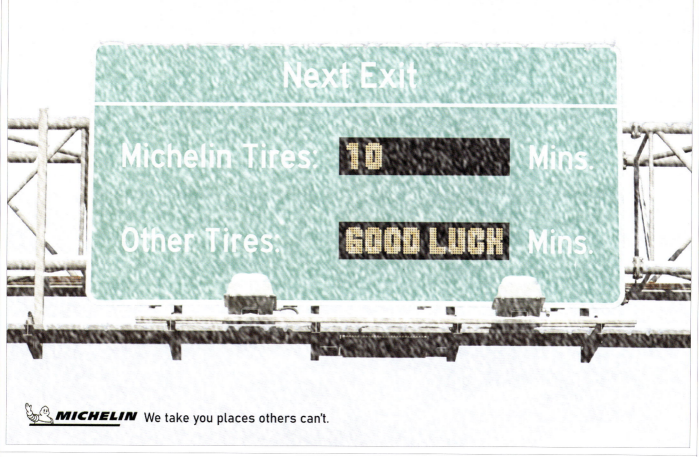

P251: Credit & Commentary **Student:** Derek Rosen | **School:** Syracuse University, The Newhouse School Images 1, 2 of 3

Automotive Products | Advertising

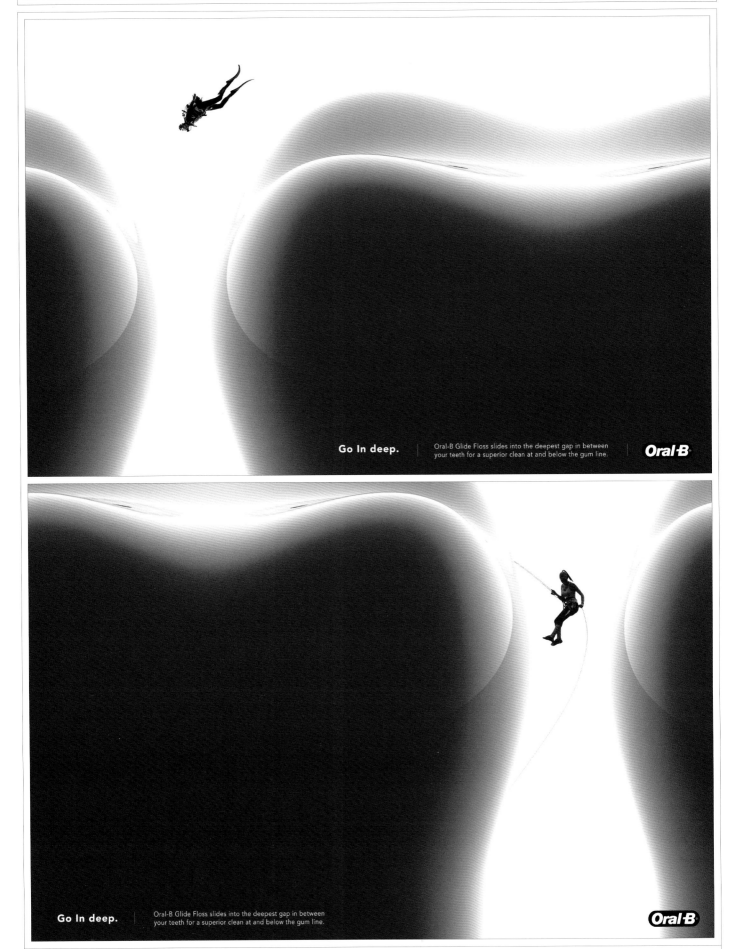

P251: Credit & Commentary Student: Sam Luo | School: Syracuse University, The Newhouse School Images 1, 2 of 3

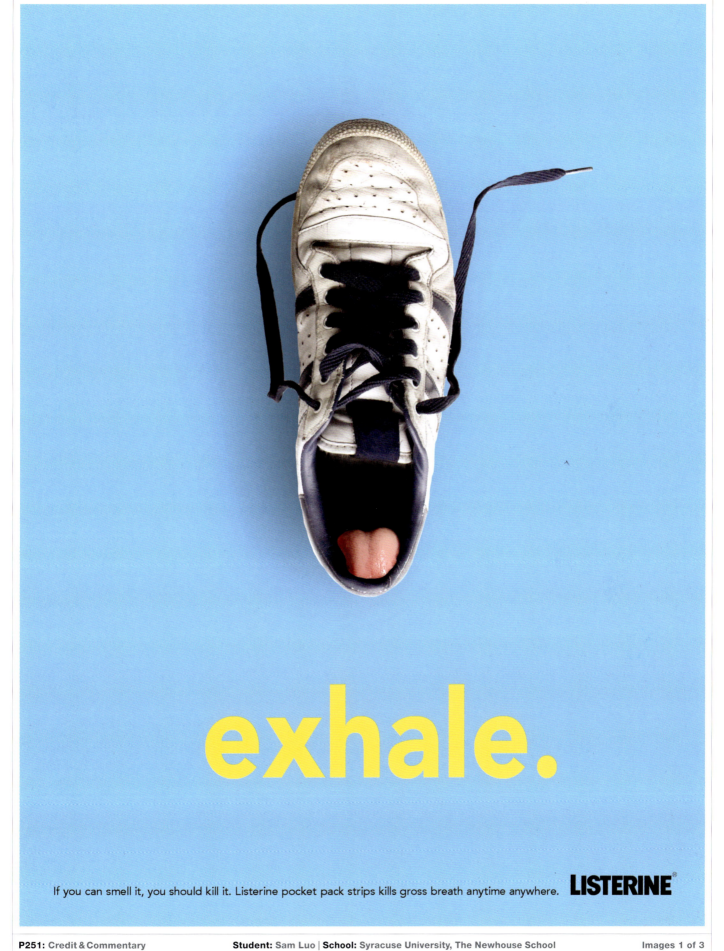

exhale.

If you can smell it, you should kill it. Listerine pocket pack strips kills gross breath anytime anywhere. **LISTERINE**®

Beauty & Fashion | Advertising

INSTRUCTOR **FRANK ANSELMO**

Miller Genuine Draft will rebrand itself as a beer that stands against racism. To tackle this widespread issue, MGD beer cans will be redesigned for consumers to cheers in the name of eliminating racist slurs.

P251: Credit & Commentary **Students:** Jasmine Espejo, Yoojin Jung | **School:** School of Visual Arts

INSTRUCTOR **MEL WHITE**

SEE BIGGER. *Canon Macro Lens enables the magnification you need to capture every small detail.* **Canon**

P251: Credit & Commentary **Student:** Sam Luo | **School:** Syracuse University, The Newhouse School

Inescapable.

Tile makes sure your items can't get away. Using GPS tracking, the Tile app can instantly locate any object within a 40-foot radius.

tile

Inescapable.

Tile makes sure your items can't get away. Using GPS tracking, the Tile app can instantly locate any object within a 40-foot radius.

tile

P251: Credit & Commentary **Student:** Jennifer Suhr | **School:** Syracuse University, The Newhouse School Images 1, 2 of 3

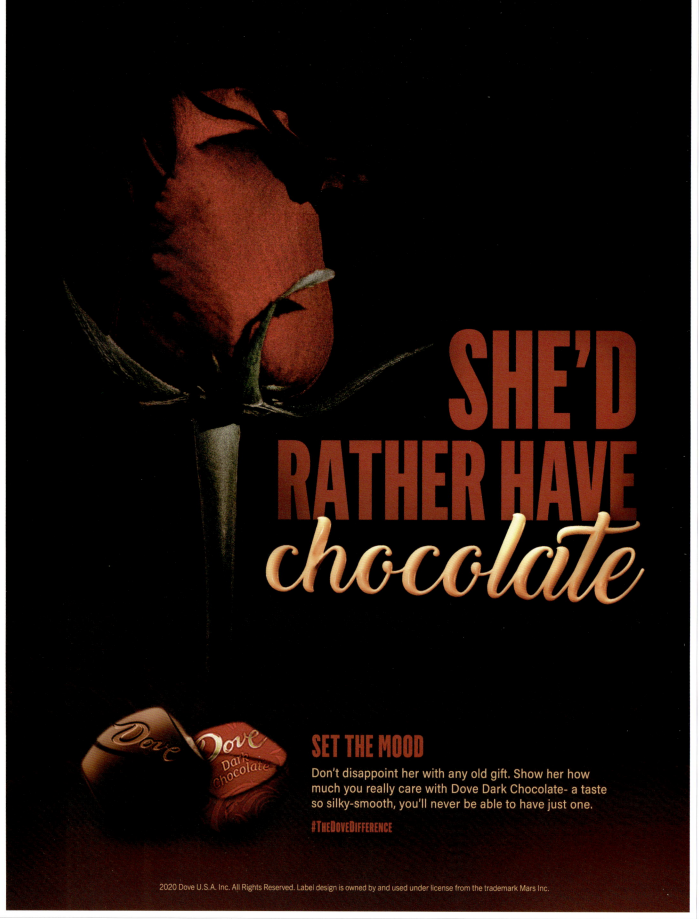

P251: Credit & Commentary **Student:** Courtney Shaw | **School:** Texas Christian University

INSTRUCTOR CLAUDIO LUIZ CECIM ABRAÃO FILHO

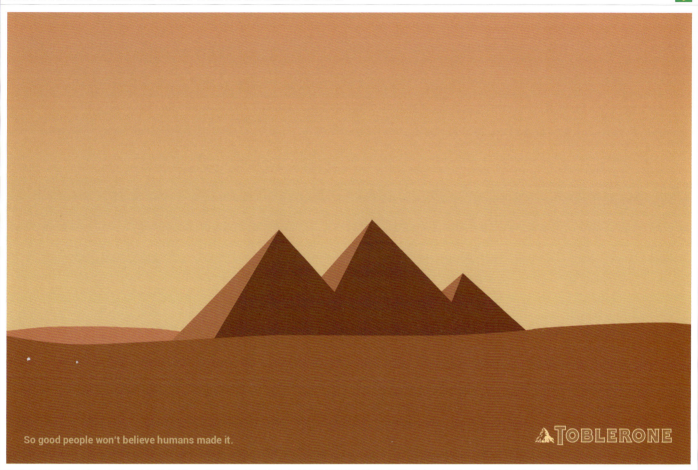

So good people won't believe humans made it.

P251: Credit & Commentary **Student:** João Victor Santos Eustachio | **School:** Faculdade Cásper Líbero Brazil

INSTRUCTOR BILL GALYEAN

Tomorrow's a dream away.

Sleep tight, dream big; your next adventure awaits.

P251: Credit & Commentary **Students:** Trevor Scott, Madi Grace Thornton | **School:** Texas Christian University Images 1 of 2

All great work start with a sketch. Every sketch starts with a great pen. MUJI

Perfect for smooth sketching and consistent writing thanks to Muji Pen's non-clogging ink. 無印良品

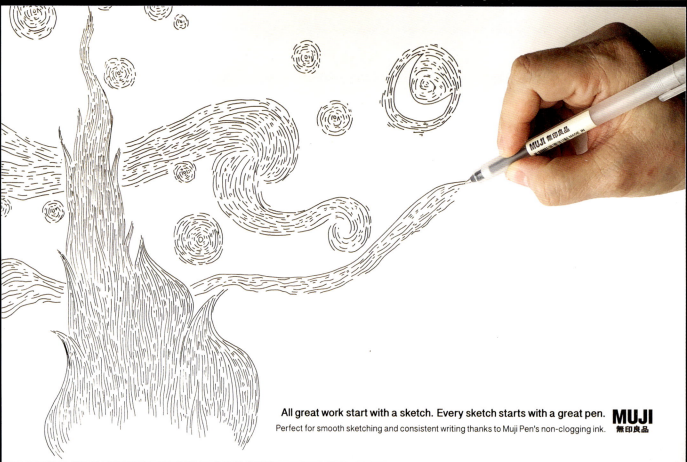

All great work start with a sketch. Every sketch starts with a great pen. MUJI

Perfect for smooth sketching and consistent writing thanks to Muji Pen's non-clogging ink. 無印良品

To them it's a beautiful butterfly.

Whatever your kid creates with Play-Doh, it'll be a masterpiece to be proud of.
Play-Doh allows kids to release their imagination in a safe and fun way.

#releaseyourimagination at playdoh.hasbro.com

@2020 Play-Doh Inc. All Rights Reserved. Label Design is owned by and used under license from the trademark Play-Doh

Product | Advertising

FOR THE OUTLAWS WRANGLERS THE ANGLERS RISKTAKERS CATTLEMEN AND BUCKAROOS, THIS ONES FOR YOU.'

Gear designed for those who live life in the uncomfortable.

YETI®

YETI.COM/GEARFORYOU

P252: Credit & Commentary **Student:** Madison Jones | **School:** Texas Christian University Images 1 of 3

Advertising | **Product**

Avoid the mess

Avoid the mess

P252: Credit & Commentary | **Student:** Rachel Hayashi | **School:** Syracuse University, The Newhouse School | Images 1, 2 of 3

INSTRUCTOR **MEL WHITE**

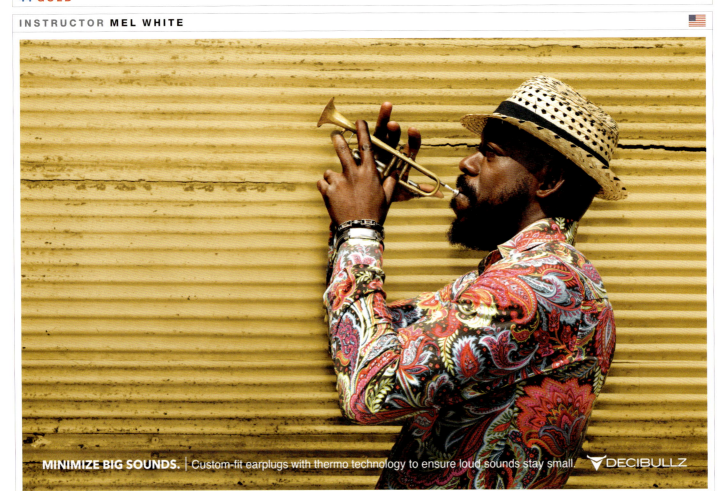

MINIMIZE BIG SOUNDS. | Custom-fit earplugs with thermo technology to ensure loud sounds stay small. ▼DECIBULLZ

P252: Credit & Commentary | **Student:** Allison Scherger | **School:** Syracuse University, The Newhouse School | Images 1 of 3

INSTRUCTOR **KEVIN O'NEILL**

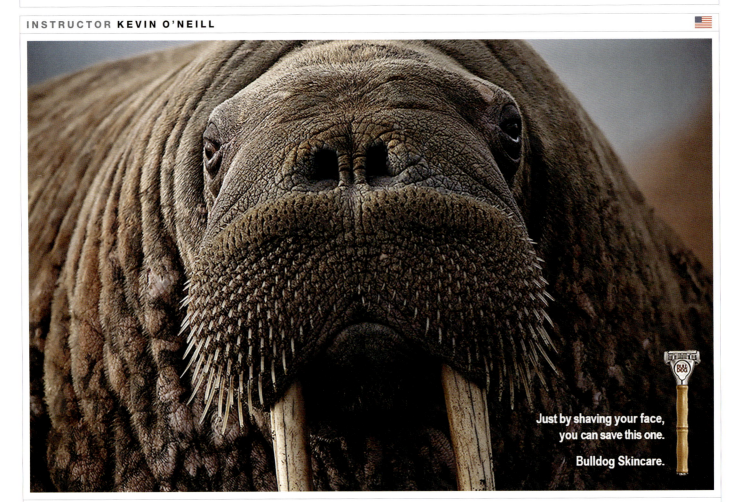

Just by shaving your face, you can save this one.

Bulldog Skincare.

P252: Credit & Commentary | **Student:** Jeffrey Robie | **School:** Syracuse University, The Newhouse School | Images 1 of 3

Advertising | Product

Advertising | Retail

Retail | Advertising

LOOK AT **YOU** **WHO ELSE** WOULD WANT YOU?

VERBAL ABUSE LEAVES INVISIBLE DAMAGE.

What's the difference between verbal abuse and a "normal" argument? Learn it on nomore.org. The national domestic violence organization.

NO MORE

P252: Credit & Commentary **Student:** Xinyue Chen | **School:** Syracuse University, The Newhouse School Images 1 of 3

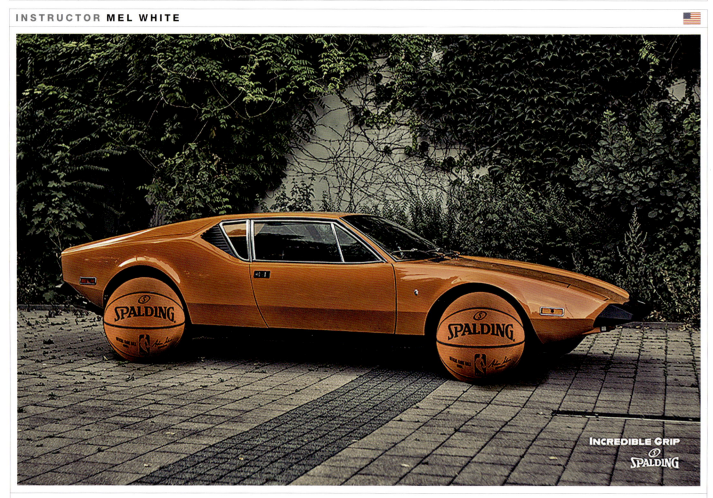

INCREDIBLE GRIP
SPALDING

P252: Credit & Commentary **Student:** Jeffrey Robie | **School:** Syracuse University, The Newhouse School Images 1 of 3

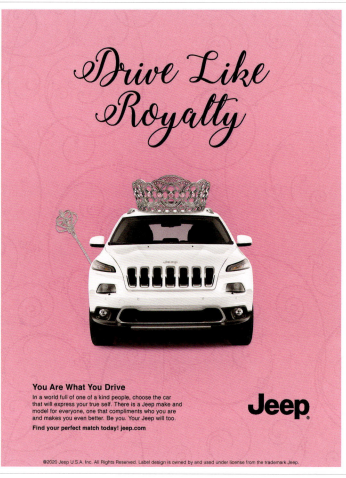

Student: Caroline Broadus | School: Texas Christian University

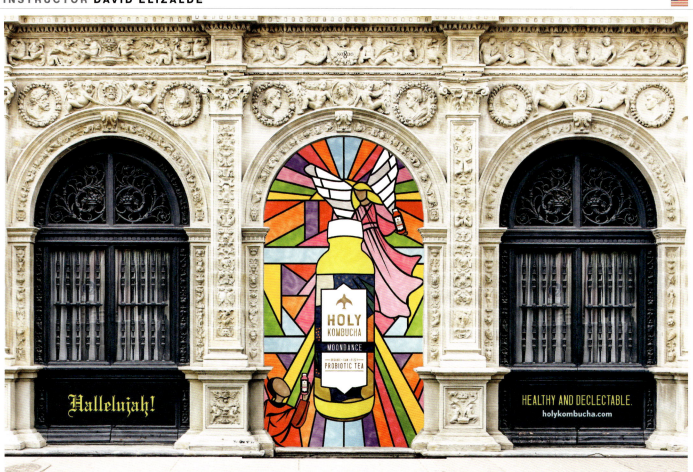

Student: Nicole Oesterreicher | School: Texas Christian University

INSTRUCTORS MARINA BELDI, JESSICA LOMASSON

Students: **Andrea Serrano Villaverde, Chris Chiarulli** | School: **M.AD School of Ideas Madrid**

INSTRUCTOR MEL WHITE

Student: **Jeffrey Robie** | School: **Syracuse University, The Newhouse School**

INSTRUCTOR MEL WHITE

Student: **Victoria Lin** | School: **Syracuse University, The Newhouse School**

INSTRUCTOR **MEL WHITE**

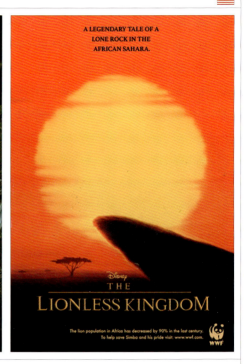

Student: Selin Akyurek | School: Syracuse University, The Newhouse School

INSTRUCTOR **JOSH EGE**

Student: Paige Carrera | School: Texas A&M University Commerce

INSTRUCTOR **MEL WHITE**

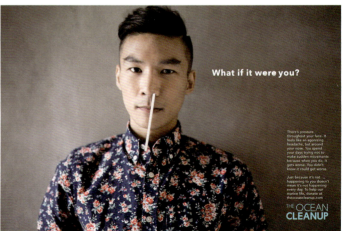

Student: Alye Chaisson | School: Syracuse University, The Newhouse School

INSTRUCTOR **MEL WHITE**

"It's the eye of the ."

Some things cannot be replaced. Help us save endangered species by using your voice to reach out to your local congresspeople to sign legislation to help prevent deforestation. For more information visit www.savethespecies.org

SIERRA CLUB

Student: Sierra Fentress | **School:** Syracuse University, The Newhouse School

INSTRUCTOR **KEVIN O'NEILL**

Try another perspective.
Oakley Prizm lenses have increased depth perception, more detail, and enhanced color that changes your perception while skiing.

OAKLEY PRIZM LENS TECHNOLOGY

Try another perspective.
Oakley Prizm lenses have increased depth perception, more detail, and enhanced color that changes your perception while playing football.

OAKLEY PRIZM LENS TECHNOLOGY

Student: Joe DeBlasio | **School:** Syracuse University, The Newhouse School

INSTRUCTOR MEL WHITE

Your favorite hiking boot and city shoe all wrapped up in one
Combat boot's full-grain leather is made from the strongest, most durable part of the animal hide, so it can handle weekdays in the city and weekends in the woods.

Students: Jack Lyons, Addie Christopher | School: Syracuse University, The Newhouse School

INSTRUCTOR KEVIN O'NEILL

YOU FINALLY GOT THOSE FRONT ROW, DREAM TICKETS TO RIHANNA. YOU GET TO THE ARENA. YOU TAKE YOUR SEAT. THAT'S WHEN HE SITS DOWN: THE 7-FOOT STRANGER IN FRONT OF YOU. AS THE MUSIC BEGINS, HE RISES. THE STAGE HAS DISAPPEARED. YOUR DREAMS: SHATTERED.

IT'S BETTER TO BE TALLER.

YOU'VE ARRIVED AT DISNEY WORLD, THIS TIME UNAFRAID OF ROLLERCOASTERS. YOU STAND IN LINE, BRAVE. AS THE END APPROACHES YOU REALIZE THAT YOU ARE TWO INCHES FROM REACHING THE "MUST BE THIS TALL TO RIDE" SIGN. YOU RETURN TO THE ENTRANCE, DEEPLY FANTASIZING OVER THE IDEA OF A SUDDEN GROWTH SPURT.

IT'S BETTER TO BE TALLER.

Student: Selin Akyurek | School: Syracuse University, The Newhouse School

Student: Daria Tucker | School: Texas A&M University Commerce

Student: Lynn Seah | School: Syracuse University, The Newhouse School

INSTRUCTOR **MEL WHITE**

Replace your unhealthy habit with a healthier one. Veggie Straws are so tasty you wouldn't believe they're better-for-you than french fries.

Student: Rachel Hayashi | School: Syracuse University, The Newhouse School

INSTRUCTOR **DAVID ELIZALDE**

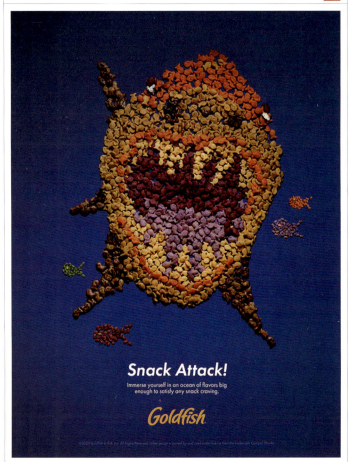

Student: Rebecca Lang
School: Texas Christian University

INSTRUCTOR **JOSH EGE**

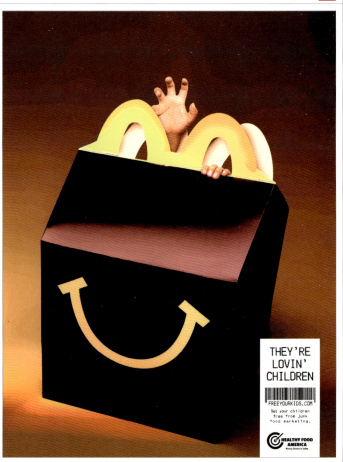

Students: Cosette De La Garza, Will Schlesinger, Daria Tucker
School: Texas A&M University Commerce

INSTRUCTOR **MEL WHITE**

Fruit so ugly
your dad
would let it take you out in his convertible without doubting you'd be home by curfew

Stop food waste by giving ugly fruit a chance. Visit MisfitsMarket.com to subscribe, and receive a box of imperfect yet perfectly delicious produce each month. **Misfits Market**

Fruit so ugly
you will promise
your friends
it looks better in person.

Stop food waste by giving ugly fruit a chance. Visit MisfitsMarket.com to subscribe, and receive a box of imperfect yet perfectly delicious produce each month. **Misfits Market**

Student: Grace Curran | **School:** Syracuse University, The Newhouse School

INSTRUCTOR **FRANK ANSELMO**

STANDARD PACKAGING

Barnum's Animal Crackers removes animals from both the inside & outside of their iconic packaging and replaces them with crackers of items those animals are being killed for.

ALLIGATOR RABBIT MINK FOX SNAKE

10 MILLION ANIMALS ARE KILLED FOR THEIR SKIN EVERY YEAR. HELP SAVE THEM AT WWF.ORG

Students: Yoojin Jung, Jasmine Espejo | **School:** School of Visual Arts

INSTRUCTOR UNATTRIBUTED

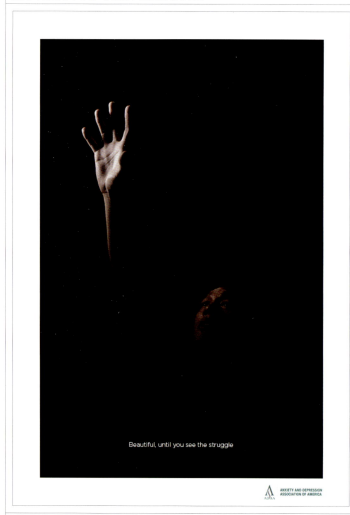

Beautiful, until you see the struggle

ANXIETY AND DEPRESSION
ASSOCIATION OF AMERICA

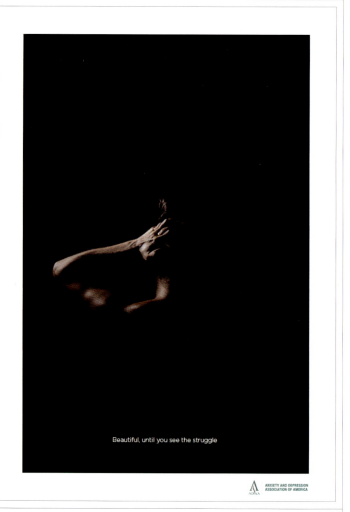

Beautiful, until you see the struggle

ANXIETY AND DEPRESSION
ASSOCIATION OF AMERICA

Student: Mitesh Addhate | **School:** M.AD School of Ideas Mumbai

INSTRUCTOR VERONICA VAUGHAN

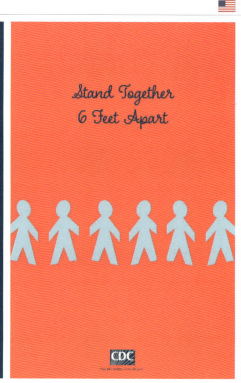

Student: Lauren Eudaley | **School:** Texas A&M University Commerce

INSTRUCTORS **DONG-JOO PARK, SEUNG-MIN HAN**

Students: **Hye Min Han, Se Ri Kwak**
School: **Hansung University, Design & Art Institute**

INSTRUCTOR **DAVID ELIZALDE**

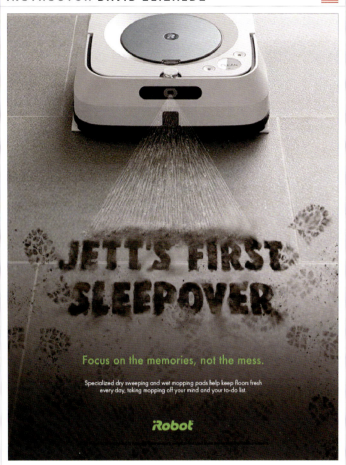

Student: **Kaylen Couch**
School: **Texas Christian University**

INSTRUCTOR **MINA MIKHAEL**

Students: **Yunxuan Wu, Daniel Kang** | School: **M.AD School of Ideas New York**

INSTRUCTOR **BILL GALYEAN**

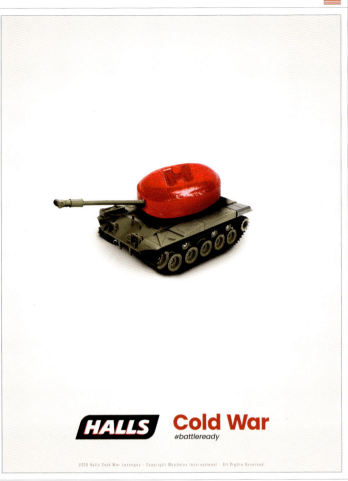

Student: Trevor Scott | **School:** Texas Christian University

INSTRUCTOR **FRANK ANSELMO**

The WWF teams up with Nike to demonstrate the horror thousands of helpless animals experience.

Every year, over 300,000 rabbits spend their entire lives in spaces this small before being slaughtered for their fur.

HELP SAVE THEM AT WWF.COM

Students: Yoojin Jung, Jasmine Espejo | **School:** School of Visual Arts

INSTRUCTOR MEL WHITE

Every great idea evolves from somewhere.

Post-it®
Notes

Student: Yuri Suh | **School:** Syracuse University, The Newhouse School

INSTRUCTOR KEVIN O'NEILL

Student: Benjamin Lin | **School:** Syracuse University, The Newhouse School

INSTRUCTOR DANIEL LOMBARDI

We can't get rid of the toxins in your life, like your nagging mother-in-law.

But at least your water is clean.

Live pure with **BRITA**

We can't get rid of the toxins in your life, like sneaky, cheating boyfriend.

But at least your water is clean.

Live pure with **BRITA**

Student: Emily Bright | **School:** Syracuse University, The Newhouse School

My Kid's X-box Won't Stop Blasting.

Now I Curse Like a Sailor.

I'm a Minister.

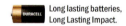

Long lasting batteries,
Long Lasting Impact.

My Kid's Boom Box is Always Blaring.

Now I Can Quote Miley Cyrus Lyrics.

I'm a Grown Man.

Long lasting batteries,
Long Lasting Impact.

Student: Derek Rosen | **School:** Syracuse University, The Newhouse School

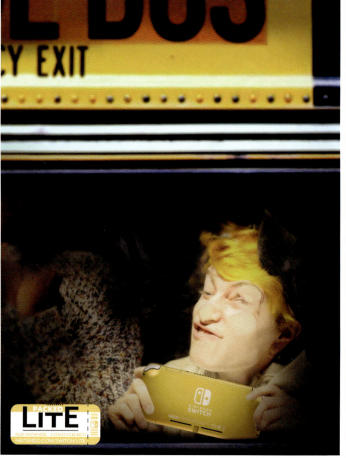

Student: Brandon Castelo | **School:** Texas A&M University Commerce

INSTRUCTOR **MEL WHITE**

Student: Jessica Mastorides | **School:** Syracuse Univ., The Newhouse School

INSTRUCTOR **DAVID ELIZALDE**

Student: Kirsten McFarlan | **School:** Texas Christian University

INSTRUCTOR **MEL WHITE**

Student: Sierra Outcalt | **School:** Syracuse University, The Newhouse School

INSTRUCTOR **MEL WHITE**

Student: Allison Scherger | **School:** Syracuse University, The Newhouse School

INSTRUCTOR **MEL WHITE**

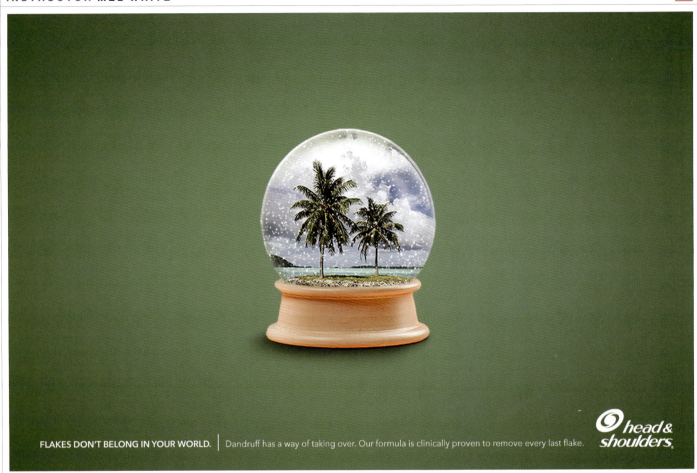

FLAKES DON'T BELONG IN YOUR WORLD. | Dandruff has a way of taking over. Our formula is clinically proven to remove every last flake.

Student: Talia Adler | **School:** Syracuse University, The Newhouse School

INSTRUCTOR **MEL WHITE**

Climb Mt. Kilimanjaro from your .

Student: Ashley Wachtfogel | **School:** Syracuse University, The Newhouse School

INSTRUCTOR **MEL WHITE**

DIVE INTO THE MUSIC
Enhance your strokes with music from your underwater MP3.

Student: Ashley Wachtfogel | **School:** Syracuse University, The Newhouse School

INSTRUCTOR **MEL WHITE**

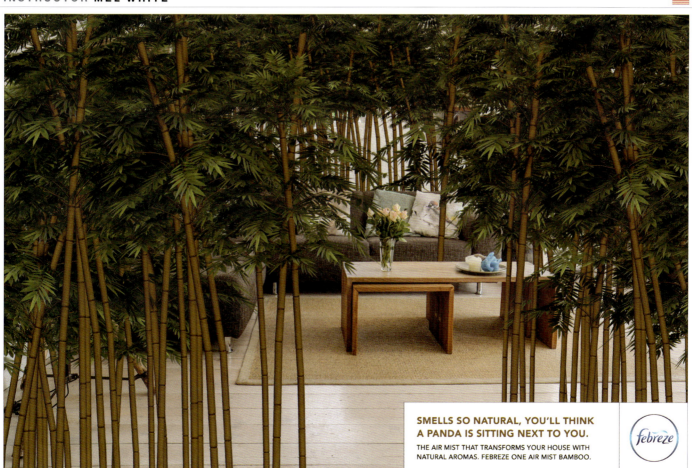

SMELLS SO NATURAL, YOU'LL THINK
A PANDA IS SITTING NEXT TO YOU.
THE AIR MIST THAT TRANSFORMS YOUR HOUSE WITH
NATURAL AROMAS. FEBREZE ONE AIR MIST BAMBOO.

febreze

Student: Sierra Outcalt | **School:** Syracuse University, The Newhouse School

INSTRUCTOR KEVIN O'NEILL

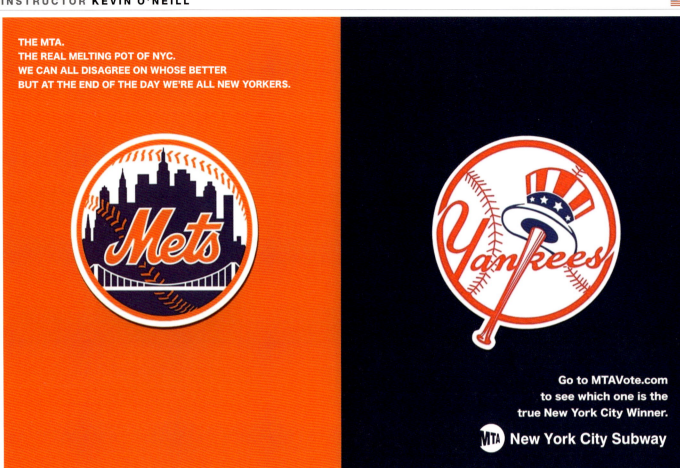

Student: Brian Chau | School: Syracuse University, The Newhouse School

INSTRUCTOR FRANK ANSELMO

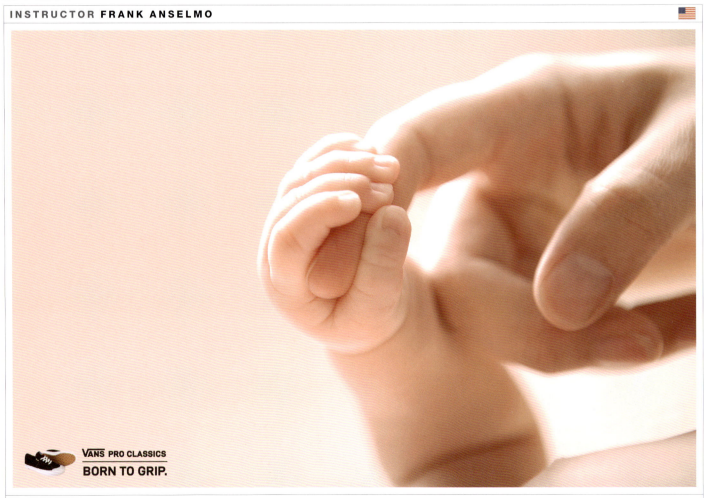

Students: Yoojin Jung, Jasmine Espejo | School: School of Visual Arts

INSTRUCTOR **DAVID ELIZALDE**

do a double take.

Within every beast is a pair of Puma's... or three.
Harness the sleekness of the world's most powerful cat
with a pair of Puma Roma sneakers. As a leader in street
style, prowl with Puma and showcase the wildcat within.

©2020 PUMA SE. All Rights Reserved. Label Design is owned by and used under license from the trademark PUMA SE.

Student: Lindsay Browne | **School:** Texas Christian University

INSTRUCTOR **EVANTHIA MILARA**

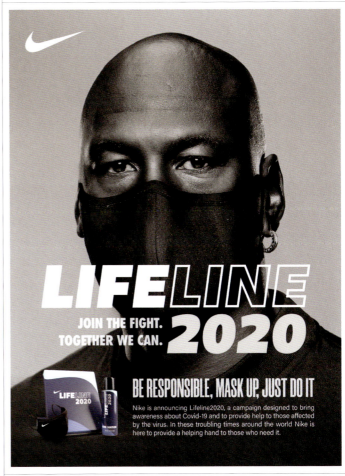

LIFELINE 2020

JOIN THE FIGHT.
TOGETHER WE CAN.

BE RESPONSIBLE, MASK UP, JUST DO IT

Nike is announcing Lifeline2020, a campaign designed to bring
awareness about Covid-19 and to provide help to those affected
by the virus. In these troubling times around the world Nike is
here to provide a helping hand to those who need it.

Student: Tony Flores | **School:** Columbia College Hollywood

INSTRUCTOR **KATHY MUELLER**

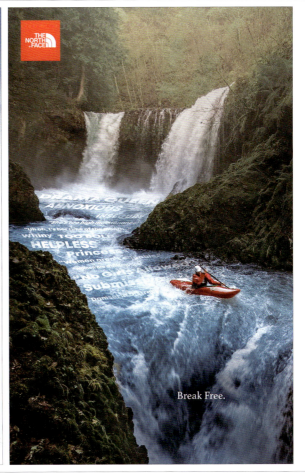

Student: Lilian Broyles | **School:** Temple University

INSTRUCTOR **UNAFFILIATED**

I'M READY FOR A GREAT FU**TUR**E WITH GREAT PEOPLE.
I WILL BRING UNIQUE E**NER**GY TO ANY ASSIGNMENT,
AND HELP FELLOW **DUC**KIES DO THE UNMISTAKABLE
WORK THAT TURNER DUC**KWO**RTH IS WORLD FAMOUS FOR.
I HOPE I'M WO**RTH** A SHOT ON YOUR TEAM.

Jean Quarcoopome Accra, Ghana
Jnr Art Director who Loves the Unmistakable

Student: Jean Quarcoopome | **School:** Ashesi University

INSTRUCTOR **KIRAN KOSHY**

Student: Will Schlesinger | **School:** Texas A&M University Commerce

INSTRUCTOR **MEL WHITE**

Student: Joe DeBlasio | **School:** Syracuse University, The Newhouse School

INSTRUCTORS **KEVIN O'NEILL, MEL WHITE**

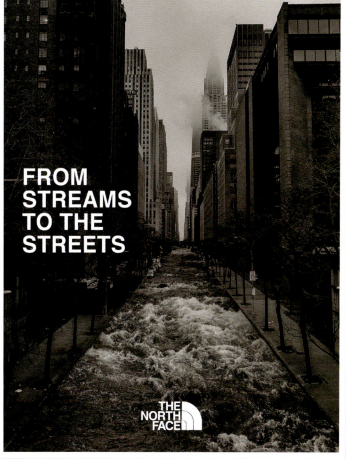

Student: Alex Mayeri | **School:** Syracuse University, The Newhouse School

INSTRUCTOR MEL WHITE

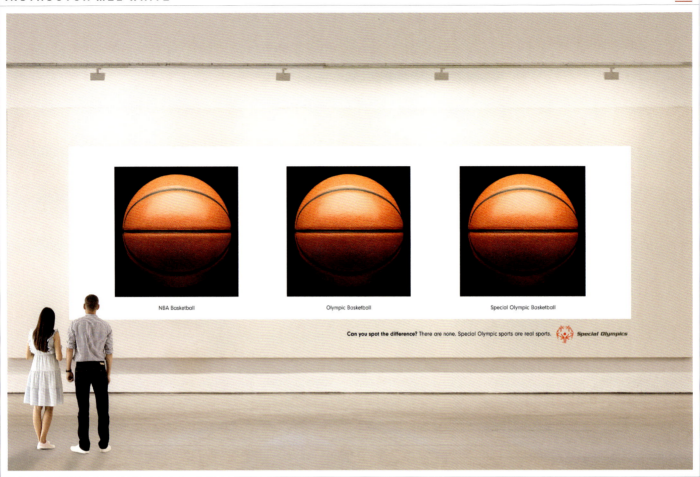

Student: Jennifer Suhr | **School:** Syracuse University, The Newhouse School

INSTRUCTOR MEL WHITE

Students: Sam Luo, Olivia Gormley | **School:** Syracuse University, The Newhouse School

INSTRUCTOR **KAREN KRESGE**

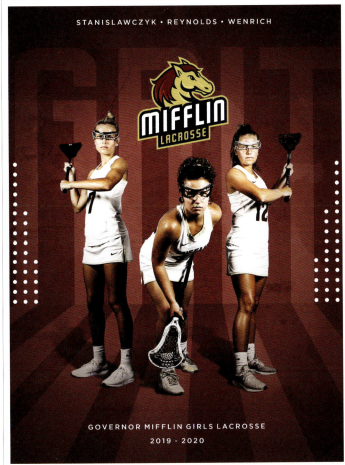

Student: Ilze Spilde | School: Kutztown University of Pennsylvania

INSTRUCTOR **JOSH EGE**

Student: Erick Estrada | School: Texas A&M University Commerce

INSTRUCTOR **MEL WHITE**

Student: Allison Scherger | School: Syracuse University, The Newhouse School

P253: Credit & Commentary **Students:** Seine Kongruangkit, Riya Dosani | **School:** M.AD School of Ideas Berlin

Assignment: Vision is the only way we emotionally connect with art. But for the blind or partially sighted, this is a barrier. They rely on audio descriptions that are too literal and flat, preventing them from creating a unique experience.
Approach: We realized sound also evokes emotions, so Berlinishe Galerie introduced The Invisible Museum, an exhibition of famous paintings with blank frames and sound translations of the original artwork. Moreover, we created a Spotify playlist of other artists and their works.
Results: The Invisible Museum garnered attention from the press across Thailand and increase the foot traffic at the museum by 50%.

INSTRUCTORS ENAS RASHWAN, YASSER GHONEIM

P253: C&C **Students:** Y. Radwan, M.Mohamed, H. Moustapha, H. E. Akad | **Schools:** Cairo Ad School Egypt, M.AD School of Ideas San Francisco

INSTRUCTOR MANOLO GARCIA

P253: C&C **Students:** Roselyn Grace, Hatem El Akad, Lee I, Ted Pedro | **School:** M.AD School of Ideas Toronto & San Francisco

INSTRUCTOR UNATTRIBUTED

P253: C&C **Students:** Gabs Samame, Samruddhi Pawar, Daniel Kang | **School:** M.AD School of Ideas New York

INSTRUCTORS SIDDHI RANADE, DEEP CHHABRIA

P253: C&C **Student:** Vidhi Agarwal | **School:** M.AD School of Ideas Mumbai

Advertising Film/Video | Commercial

INSTRUCTOR JORDAN HODGSON

P253: C&C **Student:** Nicolò Pavin | **School:** University of the Arts London

INSTRUCTOR AMAIA UGARTE

P253: C&C **Students:** Andrea Serrano Villaverde, Sergio Martin Mendez, Stefanie Salguero Say | **School:** M.AD School of Ideas Madrid

INSTRUCTOR RAJATH RAMAMURTHY

P253: C&C **Students:** Yunxuan Wu, Daniel Kang | **School:** M.AD School of Ideas New York

INSTRUCTORS PHILIP WOGART, SHANNON CHRISTIE

P253: C&C **Students:** Sukratti Jain, Paras Juneja, Justus Rozenkranz | **School:** M.AD School of Ideas Europe

INSTRUCTOR SABINE GEORG

P253: C&C Students: Paras Juneja, Sukratti Jain | School: M.AD School of Ideas Europe

INSTRUCTOR DEEP CHHABRIA

 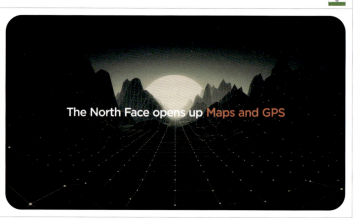

P253: C&C Student: Yashashree Samant | School: M.AD School of Ideas Mumbai

INSTRUCTOR MANOLO GARCIA

P253: C&C Students: J. Garicochea, M. Andrade, V. Orjuela, H. E. Akad | School: M.AD School of Ideas Miami & San Francisco

INSTRUCTORS MEL WHITE, KEVIN O'NEILL

P253: C&C Students: Derek Rosen, Joyee Lin | School: Syracuse University, The Newhouse School

Advertising Film/Video | Interactive

INSTRUCTOR FEDERICO GIRALDO

P254: C&C Students: Lucy Mullix, Teresa Silva | School: M.AD School of Ideas Miami

INSTRUCTOR MICHAEL LIPTON

P254: C&C Students: Yunxuan Wu, Ozzie Nunez | School: M.AD School of Ideas New York

INSTRUCTOR MEL WHITE

P254: C&C Students: Emily Babcock, Jordanna Drazin | School: Syracuse University, The Newhouse School

INSTRUCTOR MEL WHITE

P254: C&C Students: Joe Cutuli, Maia Baptiste | School: Syracuse University, The Newhouse School

INSTRUCTOR SABINE GEORG

Std.: M. P. Chaimoungkalo, S. Kongruangkit | Sch.: M.AD School of Ideas Europe

INSTRUCTOR JACK HWANG

Students: Soah Kim, You Hyun Jang | School: School of Visual Arts

INSTRUCTOR SABINE GEORG

Std.: P. Juneja, R. Dosani, S. Wajih, S. Jain | Sch.: M.AD School of Ideas Europe

INSTRUCTOR MANOLO GARCIA

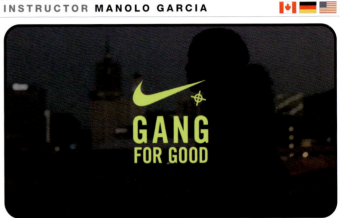

Students: H. E. Akad, R. Rico, L. I, T. Pedro | School: M.AD School of Ideas

INSTRUCTOR MANOLO GARCIA

Students: V. Orjuela, M. Andrade, H. E. Akad | School: M.AD School of Ideas

INSTRUCTOR UNATTRIBUTED

Student: Tássia Dias Valim Cunha | School: M.AD School of Ideas Miami

INSTRUCTOR YVONNE CAO

Student: Rae McCollum | School: Texas Christian University

INSTRUCTOR MANOLO GARCIA

Std.: P. E. Mohdar, R. Grace, P. Sacilotto, H. E. Akad | Sch.: M.AD School of Ideas

INSTRUCTOR **DANNELL MACILWRAITH**

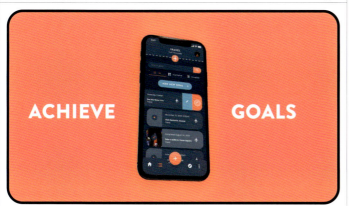

Student: Ilze Spilde | **School:** Kutztown University of Pennsylvania

INSTRUCTORS **KEVIN O'NEILL, MEL WHITE**

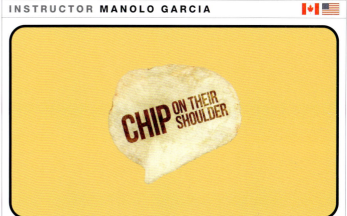

Std.: S. Krimsky, S. Depaz | **Sch.:** Syracuse Univ., The Newhouse School

INSTRUCTOR **YVONNE CAO**

Student: Kirsten McFarlan | **School:** Texas Christian University

INSTRUCTOR **MANOLO GARCIA**

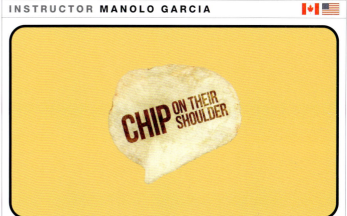

Students: P. E. M., Lee I, T. Pedro, H. E. Akad | **School:** M.AD School of Ideas

INSTRUCTOR **SABINE GEORG**

Student: Patrick Chase | **School:** M.AD School of Ideas Europe

INSTRUCTOR **JACK HWANG**

Students: Soah Kim, You Hyun Jang | **School:** School of Visual Arts

INSTRUCTOR **VIJAY KUMAR DUA**

Student: Nithika Romy | **School:** National Institute of Fashion Technology

INSTRUCTOR **JONATHAN HUNTER**

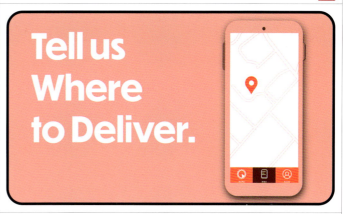

Student: Emil Miralda | **School:** Texas A&M University Commerce at Dallas

Tracey Shiffman | ArtCenter College of Design | Dean: Sean Adams | Page: 84

Biography: Tracey Shiffman, a graphic artist and educator who works and lives in Los Angeles, specializes in publication design for museums and cultural institutions. She's noted for bringing a distinctive visual poetry to her choreography of artists' materials in books, including monographs on Julie Mehretu, Frank Gehry, Robert Rauschenberg, and others. She has published internationally and has received numerous awards for her contribution to the field. In 2009, she joined forces with designer Alex Kohnke to form Shiffman & Kohnke. Tracey is currently full time faculty at ArtCenter College of Design.

Advice: There is going to be legit anxiety associated with uncertainty and the fear of failing as you enter into your practice, but remember this (a quote by James Michener): "Character consists of what you do on the third and fourth tries."

Ann Field | ArtCenter College of Design | Dean: Ann Field | Pages: 85, 86

Biography: Ann Field is chair of the illustration department at ArtCenter College of Design in Pasadena, CA. Born in the countryside and educated in Brighton in Sussex, England, Ann was mentored by British author and illustrator Raymond Briggs, creator of *The Snowman*. Ann is a founding president of ICON: The Illustration conference, a platform for the illustration community. Her fashion watercolors were honored with a gold medal from The Society of Illustrators in New York and her work is in the permanent collection of the Cooper Hewitt Smithsonian Design Museum.

Advice: Make drawings daily, as a way of thinking.

Paul Rogers | ArtCenter College of Design | Dean: Ann Field | Page: 86

Biography: Paul Rogers has worked as a freelance illustrator and designer since his graduation from ArtCenter College of Design, where he is now a faculty member. His clients include the Los Angeles County MTA, The New York Times, The New Yorker, NIKE, Pixar Pictures, Pentagram, the Playboy Jazz Festival, Salesforce, and Warner Bros. Studios. He has designed five postage stamps for the United States Postal Service and official posters for the New Orleans Jazz & Heritage Festival and Super Bowl XXXVII. Paul has collaborated on two books with Wynton Marsalis and a children's book, *Forever Young*, by Bob Dylan.

Advice: Learn the tradition of your craft. Be yourself. Make work that your teachers are not expecting.

David Tillinghast | ArtCenter College of Design | Dean: Ann Field | Page: 86

Biography: David Tillinghast is Director of Special Projects, Illustration Design Track Leader, and an associate professor at the Art-Center College of Design in Pasadena, CA. He's worked extensively in most major markets within the illustration industry, and is the recipient of numerous awards for illustration, graphic design, self-promotion, and art direction. His association with Designmatters, ArtCenter's social impact department, has taken him to the UN as lead delegate. He also serves as a volunteer climate reality leader under former US vice president Al Gore's Climate Reality Project.

Advice: I'd like to share what I wish I'd known when I graduated college: success in art and design is 10% talent and 90% tenacity and hard work. Enjoy the journey, take care to develop your personal character, and treat everyone with compassion and kindness.

Rob Clayton | ArtCenter College of Design | Dean: Ann Field | Page: 86

Biography: Rob Clayton, born in 1963, graduated with honors from the ArtCenter College of Design in 1988, where he is now working as a full time faculty member. Currently creating a new body of work, Rob is exploring the ideas of the self and processes of creating environmental, sculptural, and painted 'stories.' Utilizing skills learned over thirty years of art practice and twenty years of teaching, Rob recently started exploring unconventional means of fabrication driven by his curiosity in self-taught art forms. The focus of his new body of work is pushing the ideas and concepts of narrative and/or illustrative content.

Advice: Be aware of who you are, not what other people want you to be. Style isn't something you buy; it's something you have. Finding that is sometimes a lifelong journey.

Doug Thomas | Brigham Young University | Dean: Brent Barton | Page: 87

Biography: Douglas Thomas is a designer, type historian, and teacher. His design and writing explore the nexus of typography, design, and culture, especially via user experience design, publication design, and branding. His work has been featured in domestic and foreign publications such as Communication Arts, Print, Graphis, and Eye. He is the author of *Never Use Futura*, a cultural history of the typeface Futura. He is assistant professor of graphic design at Brigham Young University. He holds an MFA in graphic design from the Maryland Institute College of Art, where he also taught graphic design. He also holds an MA in social science from the University of Chicago.

Advice: One of the best things about graphic design is that it lets you explore almost any topic. A good designer makes connections everywhere. When you start a new project, the best ideas come from studying how other disciplines see the problem you're trying to solve.

Jeff Davis | Texas State University | Dean: John Fleming | Page: 87

Biography: "Jefe" to his friends is an award-winning graphic designer and design educator, teaching communication design at Texas State University since 1998. Jeff's focus is in human centered design, branding systems, and sustainability. Throughout his thirty year practice, he's worked in corporate identity design, publication design, and branding for clients ranging from Furtune 500 companies to 'mom-and-pop' businesses. Jeff also lends his time and talent for cause-based organizations and has received international recognition for his designs while raising awareness and funding for education, global conflict, environmental issues, cancer, human rights, universal healthcare, and marine preservation.

Justin Colt | School of Visual Arts | Dean: Gail Anderson | Page: 88

Biography: Justin Colt is a co-founder of The Collected Works, a design studio who works with clients rooted in music, art, and technology. He was formerly a designer for Milton Glaser in New York City, NY, and graduated from The School of Visual Arts with a masters in design. Justin is also an adjunct professor at the School of Visual Arts, where he teaches design and typography in both the undergraduate and graduate programs.

Reneé Seward | University of Cincinnati, DAAP | Dean: Tim Jachna | Page: 89

Biography: Reneé is an associate professor and program coordinator of the communication design program at the University of Cincinnati's College of Design, Architecture, Art, and Planning. She graduated from DAAP in 2002, received her master from North Carolina State in 2008, and has been teaching typography, exhibition design, and graphic design for the last fourteen years. Her students have won countless awards from Graphics, Graphic Design USA, and Creative Communication Awards Design competitions. Reneé herself is a Cincy Innovates winner and has been acknowledged as a Rising Tech star by ComSpark, awarded by the Business Courier Best Software of the Year, and is the University of Cincinnati Emerging Entrepreneur of the Year. Reneé has also been named a winner in the Graphic Design USA Design competition for the poster she developed for the AIGA to promote voting. Currently, she has a company that sells her reading tool called See Words Reading®. Additionally, she is working in a collaborative research team to develop a tool to help correct speech problems in children.

Advice: Don't be afraid to fail.

Seung-Min Han | Hansung University, Design & Art Institute | Dean: Dong-Joo Park | Page: 90

Biography: Seung-Min Han was born in Korea in 1976, and is a graphic designer, illustrator, visual artist, and educator based in Seoul. He's a professor at Hansung University's Design & Arts Institute. He received a MFA at Kookmin University in Korea and a BA in visual communication at KvB Institute of Technology in Australia. He's been awarded more than forty prizes, including ten Silver, two Gold, and three New Talent Annual Instructor Platinums from Graphis. He's had twenty solo exhibitions and more than sixty selected exhibitions, and served as an editorial committee member of Asia-Pacific Design No.12 in Guangzhou, China. Most recently, he was a judge for the Korea, China, and Japan Illustration Contest.

Advice: It's important to keep thinking about how to turn the design into a special value and how to make it into a special visual language.

Dong-Joo Park | Hansung University, Design & Art Institute | Dean: Dong-Joo Park | Page: 90
Biography: Dong-Joo Park was born in Korea in 1979, and is a graphic designer based in Seoul. She's the head of the department at Hansung University's Design & Arts Institute. She received a MFA in visual communication design at Ewha Woman's University in Korea, then worked as a marketing director for KT & G affiliate Youngjin Corporation and for Ilshin New Drug Corporation's advertising department. She has won awards such as the Graphis New Talent Annual Instructor Platinum, Graphis Silver, IDA Awards Gold, and the Creativity International Design Awards Silver. Most recently, she was a judge for the Korea, China, and Japan Illustration Contest.
Advice: Feel free to try with expressive ideas and experimental methods through design-based thinking.

Taylor Shipton | Pennsylvania State University | Dean: Philip Choo | Page: 91 | See Page 17.

Bill Galyean | Texas Christian University | Dean: Richard C. Gipson | Page: 92
Biography: Bill Galyean is a graduate of the University of Louisiana at Lafayette. Prior to joining academia, he spent thirty years as a art director/creative director with such firms as Tracy-Locke Advertising, D'ArcyMcManus & Masius, and as a partner at Pierce, DeDitius, & Galyean. His experience has been in the creation of marketing and brand development for organizations ranging from Fortune 100 companies, emerging start ups, and non-profits. Bill's expertise has crossed all facets of communication in the field of advertising and design while serving on accounts such as Johnson & Johnson Medical, Frito-Lay, Hilton Hotels, Frontier and American Airlines, IBM, Neiman-Marcus, and Phillips Petroleum, which afforded him the opportunity to produce an animated commercial with the Richard Williams Studio in London. He has also taught international advertising at Regent's University in London. His work has been recognized locally and nationally and has appeared in The Journal of Communication Arts-CA Magazine.
Advice: Don't compare yourself to anyone, anytime, anywhere. God has placed something special in each of us that no one else has and this is what sets us apart from everyone.

Hank Richardson | M.AD School of Ideas at Portfolio Center | Dean: Hank Richardson | Page: 92
Biography: Hank Richardson is the director of design at M.AD School of Ideas at Portfolio Center, and the program coordinator of the Furman University/ M.AD Masters of Arts in Strategic Design program. He is an AIGA FELLOW and recipient of the NY Art Director's Club Grandmaster Teacher's Award. He's the 2018 recipient of the Educator of the Year Golden Apple Award from the Dallas Society of Visual Communicators, National Student Conference. He's a director of the Museum of Design Atlanta and has served on the AIGA National Board and the board of The Society of Typographic Aficionados. He's contributed to such books as *Design Wisdom, The Education of a Graphic Designer, Becoming a Graphic Designer, Design for Communications, The Education of a Typographer, Graphis,* and *Teaching Graphic Design.*
Advice: Your long term success in life will come from three things: perseverance, commitment, and patience, particularly with yourself. Real success is finding work in the things you love. PLAY!

Miguel Lee | ArtCenter College of Design | Dean: Ann Field | Page: 225
Biography: Miguel is a motion designer and educator based in Los Angeles. He is an associate instructor at the ArtCenter College of Design as well as the founder and executive creative director of Midnight Sherpa, a multi-disciplinary creative studio focused on creating brand experiences and motion content for a diverse range of brands and applications.
Advice: Many students feel the pressure to be well-rounded in being able to wield different disciplines, but I believe you should identify the one ability you really excel in and double down on it. Chances are, this will evolve into the primary skillset that people will be drawn to whether you're looking for a job or making your mark in the world. The ability doesn't have to be limited to your craft—it can range from being an amazing researcher, a good communicator, or just having great taste.

Justin Abadilla | California State Polytechnic University, Pomona | Dean: Anthony Acock | Page: 226
Biography: Justin Abadilla is an agency-bred 3D experiential designer and educator from Los Angeles. A university alumnus turned instructor for the Cal Poly Pomona Visual Communication Design BFA program, Justin strives to foster an exploratory, open-ended learning environment tailored to helping students realize their creative vision while integrating effective communication strategies and contemporary best practices.
Advice: Contribute to the discussion. Propose new ideas. Make the most of your seat at the table. Otherwise, you'll only ever find yourself carrying out someone else's agenda.

Brent Barson | Brigham Young University | Dean: Brent Barson | Page: 227
Biography: Brent Barson is a graphic design professor at BYU, and specializes in 2D and 3D motion design. He is currently serving as department chair of the department of design, and looks forward to returning to teaching and research full time. He is very interested in moving typography and the fusion of art, science, light, nature, and technology. His supportive wife, Jill, and their five children all live together in seldom-controlled, beautiful chaos. A native of Carlsbad, CA, he received his BFA in graphic design from BYU, and his MFA in media design from ArtCenter College of Design.
Advice: Give your mind time to rest, and listen to nothing every once in a while. Hide your phone far from you, and meditate. Read paper books, and sleep whenever you can. Then come back and fearlessly attack your design problems.

DESIGN PLATINUM AWARD-WINNING STUDENTS

Xiaoying Ding | ArtCenter College of Design | Dean: Ann Field | Page: 84
Biography: Xiaoying Ding is a graphic designer. For seven years, she's studied human geography (a subject about the relationships between humans and environments) at Zhejiang University, one of the top schools in China. During that time, she fostered a great ability to conduct research, analyze data, and solve problems. After earning both her bachelor and master there, Xiaoying decided to explore more creative outlets for her work, and is presently earning her graphic design master at ArtCenter College of Design. She combines her research skills with design knowledge to create branding strategies for real clients like Xiami Music, Typo Berlin, and the Tournament of Roses. More importantly, Xiaoying has found her voice and uses graphic design to demonstrate her view of society and the world. She believes that form follows function, but she isn't confined to what's normally used in graphic design. Now, her range of subjects includes illustration, coding, handcraft, and toy design.

Grace Park | ArtCenter College of Design | Dean: Ann Field | Page: 85
Biography: Grace Park was born in South Korea and moved to Canada when she was ten years old. She has a BFA in illustration from the ArtCenter College of Design, where she learned to focus on creating stories and evoking empathy. She likes making relatable images, and she often incorporates small details that enhance each piece. As a freelance illustrator, she strives to tell stories that console people and bring warmth into their lives. Apart from drawing, Grace loves playing with her two dogs, Coffee and Dooly, and traveling to different places; she hopes to visit various countries around the world one day.

Haley Jiang | ArtCenter College of Design | Dean: Ann Field | Page: 86
Biography: Haley graduated from ArtCenter College of Design with a BFA in illustration. Her work takes inspiration from the mythological stories and fables she read when she was a child. Haley creates decorative and fantasy-based illustrations with rhythmic lines and organic shapes. She often incorporate cultural and historical elements in her illustrations as she believe they're important to a good story. Haley draw birds for fun because they're fun to draw. She love nature and enjoys drinking tea. In her free time, you can find Haley catching up on movies and musicals she's missed, meditating with a tree, and figuring out the ultimate recipe for a perfect cheesecake.

Sam Verdine | **Brigham Young University** | **Dean: Brent Barton** | **Page: 87**
Biography: Sam is from Portland, OR. The creative culture and natural landscape helped him fall in love with design, but he wouldn't be a designer without his parents and wife. Sam's dad is also a designer and kept Sam involved in it at an early age, while his mom raised him to be happy-go-lucky and find joy in everything. Sam's wife actually believes in him more than he does, and pushes him to be better than ever. As he continues working in this field, he's learned design is a means to communicate truth and has allowed him to explore and see through others' experiences. Design is a global language and Sam is grateful he can play a role within it.

Mikayla Stump | **Texas State University** | **Dean: John Fleming** | **Page: 87**
Biography: Mikayla Stump is a visual designer with a passion for creating various brand identities. Born and raised mostly in Texas, when she's not at her desk furthering her design skills, you can find Mikayla re-watching her favorite films, playing RPG games, or smothering her dog in hugs. Mikayla has had an affinity for all things creative. The concepts for each of her projects stem from her own personal experiences or from prior knowledge that are then turned into a solid design. She enjoys every moment of it—from the research to finally putting all of it together! Her methods include thinking outside of the box and considering the impact it will have on the audience all while keeping the end goal in mind.

Junghoon Oh | **School of Visual Arts** | **Dean: Gail Anderson** | **Page: 88** | See page 18.

Ryan Page | **University of Cincinnati, DAAP** | **Dean: Tim Jachna** | **Page: 89**
Biography: Ryan Page is currently a student at the University of Cincinnati and is enrolled in the College of Design, Architecture, Art, and Planning (DAAP) program, majoring in communication design. He's always had a love for creating, but it wasn't until he was older that he realized he really loved the process of developing a visual story. Creating a narrative and conveying a message through imagery and graphics is the aspect of design that inspires Ryan the most, and the possibility that he could have a career communicating through this process motivates him to work harder every day. He loves what he's learning and is so grateful he gets to learn it. While Ryan knows he still have skills to obtain, that doesn't faze him since exploring the many avenues and branches of design, and then turning that passion into a job, outweighs any obstacles or hardships.

Sang Hee Han | **Hansung University, Design & Art Institute** | **Dean: Dong-Joo Park** | **Page: 90**
Biography: Sang Hee Han was born in South Korea and has been interested in typography ever since she was a young girl. She finds beauty in many different types of letters, and focuses on and enjoys designing them to express that beauty. Her favorite type of work is anything delicate and focused, so that people who see her designs can feel its neatness and meticulousness. Her goal is to create work that maximizes and shows off her skills.

Scotti Everhart | **Pennsylvania State University** | **Dean: Philip Choo** | **Page: 91**
Biography: Scotti Everhart is twenty years old and from a small town in Pennsylvania. She grew up on a tiny farm in the middle of the woods, making nature a source of continuous inspiration for her. She's currently studying graphic design at Pennsylvania State University, and will be graduating in 2022. Scotti has always loved the arts, constantly drawing and snapping photos when she was young. By the time she was fourteen, her illustration skills were fine tuned, and she won several art awards before graduating high school. College has provided Scotti with so many new artistic learning experiences, and she can't wait to see where her journey takes her next!

Rose Hoover | **Texas Christian University** | **Dean: Richard C. Gipson** | **Page: 92**
Biography: Rose Hoover is from Wheaton, IL, and currently lives in Fort Worth, TX. She'll soon graduate from the design program at Texas Christian University with a BFA. Although she came into college undecided on her choice of major, Rose discovered her zeal for art direction and design as a freshman and hasn't looked back. She's been recognized on the local and national competition level and continues pushing to find creative solutions. Upon graduating, Rose is planning on beginning her career as a designer and hopes to become a creative director in the future.

Dimitri Ferreira | **M.AD School of Ideas at Portfolio Center** | **Dean: Hank Richardson** | **Page: 92**
Biography: Dimitri Ferreira was born in Russia and adopted in the United States at a young age. He grew up drawing characters, still life illustrations, and making up stories. He played soccer throughout high school and got a lacrosse scholarship to college, where he realized his love for graphic design. Upon graduation, he decided to pursue a master degree in strategic design at Furman University/M.AD School of Ideas, and just recently graduated. Storytelling is something that drives Dimitri's thinking and problem solving, which he uses for his work today. As he continues to step into the professional field, his memories, experiences, and passion for creating will keep following him.

Quinta Yu | **ArtCenter College of Design** | **Dean: Ann Field** | **Page: 225**
Biography: Quinta Yu is an award-winning motion graphic designer based in Los Angeles. She is currently working at Midnight Sherpa as an animator and designer. She recently graduated from ArtCenter College of Design with a BFA in graphic design. She believes that creating beautiful yet relatable and practical designs is a means to evoke emotional responses—the key to effective communication. From researching to visualization, she keeps exploring unique solutions to solve problems, tell stories, and inspire audiences.

Tiffany Shen | **ArtCenter College of Design** | **Dean: Ann Field** | **Page: 225**
Biography: Tiffany Shen is a multidisciplinary designer based in Los Angeles, CA, with a focus in motion and branding design. She is currently a student at the ArtCenter College of Design and is also a gold medalist for Promax Spark for her project, Deuce. As a designer, she seeks to move viewers emotionally through her creative problem-solving. She is also an explorer who loves applying new experiences in her life to her work.

Kayley Wang | **ArtCenter College of Design** | **Dean: Ann Field** | **Page: 225**
Biography: Kayley Wang is a freelance motion graphic designer who has recently worked with Imaginary Forces as a motion design intern. Her specialties include 3D modeling and animation. Born and raised in Arcadia, CA, Kayley was first inspired to become a motion designer many years ago while she was observing the animators during a studio tour at Rhythm & Hues and learning about the entertainment industry. She received her BFA in graphic design with a focus in motion design from the ArtCenter College of Design. She is also a proud Promax Spark Award recipient.

Michelangelo Barbic | **California State Polytechnic University, Pomona** | **Dean: Anthony Acock** | **Page: 226**
Biography: Michelangelo Barbic is a soon-to-be-graduate pursuing a BFA in visual communication design at California State Polytechnic University, Pomona, specializing in video production and motion graphics. He is passionate about the power and expression art provides an individual and a strong advocate for sharing that with others. With a strong background in computer hardware and visual communication, Michelangelo aims to leverage these interests in producing narrative driven content that uses digital mediums and, in the future, to create immersive environments. His hobbies include tinkering with electronics, coffee and tea tasting, attending design conferences, and playing with his dog Kingston.

Hunter Young | **Brigham Young University** | **Dean: Brent Barson** | **Page: 227**
Biography: Hunter Young is a graphic designer from Portland, OR, who specializes in typography, publication, branding, motion design, and web design. Hunter is currently obtaining a BFA in graphic design from the Brigham Young University Department of Design. He's recently been awarded with the 2020 Communication Arts Design Annual and the 2021 Communication Arts Typography Annual awards of excellence. More of his work can be found at www.hunteryoung.work

P254: Credit & Commentary **Student:** Grace Park | **School:** ArtCenter College of Design

INSTRUCTOR DOUG THOMAS

P254: Credit & Commentary | **Student:** Sam Verdine | **School:** Brigham Young University | Images 1 of 7

INSTRUCTOR JEFF DAVIS

P254: Credit & Commentary | **Student:** Mikayla Stump | **School:** Texas State University

THE HFZ & Bijarke Ingels INC.

Building dedication ceremony

Team
Agne Rapkeviciute
Alana Goldwit
Ali Chen
Amir Mikhail
Benjamin Caldwell
Christopher David White
Christopher Farm
Daniella Eskildsen

76th 11Ave, New York, NY 10011

15. 10. 2020

Design | Poster

소리 X 글자 : 한글디자인

SOUNDS X HANGEUL : VARIATION OF THE KOREAN ALPHABET

제2회 한글실험프로젝트
THE 2nd Hangeul Design Project

국립한글박물관 기획전시실

국립
한글
박물관

2018
4.9
- 6.3

INSTRUCTOR BILL GALYEAN

P255: Credit & Commentary **Student:** Rose Hoover | **School:** Texas Christian University

INSTRUCTOR HANK RICHARDSON

P255: Credit & Commentary **Student:** Dimitri Ferreira | **School:** M.AD School of Ideas at Portfolio Center

INSTRUCTOR PABLO DELCAN

P255: Credit & Commentary **Student:** Justin Wong | **School:** School of Visual Arts Images 1 of 5

INSTRUCTOR EMILY BURNS

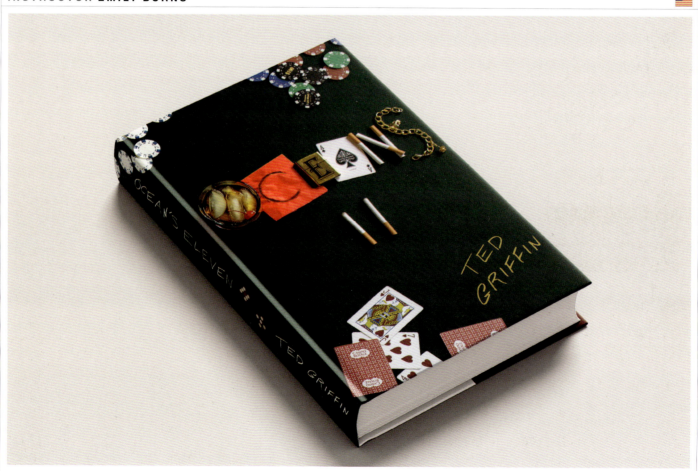

P255: Credit & Commentary **Student:** Rachel Smith | **School:** Pennsylvania State University

P255: Credit & Commentary **Student:** Yeojin Chun | **School:** School of Visual Arts Images 1 of 2

Books | Design

INSTRUCTOR BRAD BARTLETT

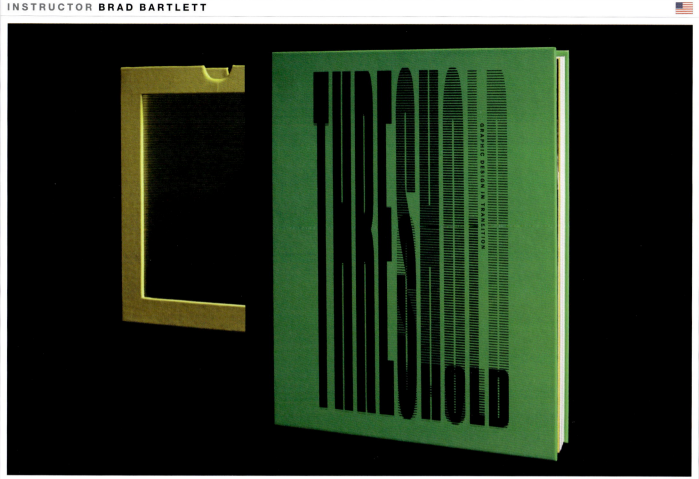

P255: Credit & Commentary **Student:** Shiang-jye Yang | **School:** ArtCenter College of Design Images 1 of 7

INSTRUCTOR ZACHARY VERNON

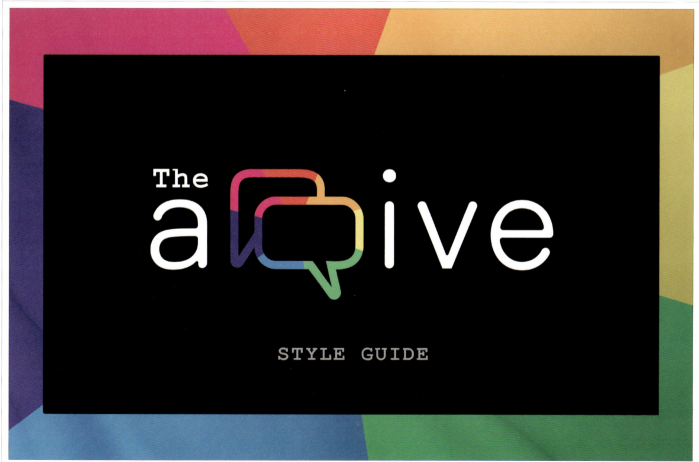

P255: Credit & Commentary **Student:** Liz Sweeney | **School:** CalState LA Images 1 of 5

INSTRUCTOR LEWIS GLASER 🇺🇸

P255: Credit & Commentary **Student:** Madeleine Alff | **School:** Texas Christian University Images 1 of 5

INSTRUCTOR CAROLYN KILDAY 🇺🇸

P255: Credit & Commentary **Student:** Olivia Romero | **School:** Texas State University Images 1 of 7

Branding | Design

James Glazzer,

Emerging in Europe after the architecture travelled unevenly but globally via the printed page. The establishment of what came to be called the International Style could not happened without photography. Moreover it is often argued that it was through Modernism that architecture became profoundly perhaps irreversibly complicit withe camera image. Architects began to design with photographic representation in mind and for good or bad the public began to understand the built world around them in photographic.

We should remember photography attraction to architecture goes back to the very earliest camera pictures. View from the window at was a lucid demonstration of the new consummate translation of three dimensions into two, although it lacked the detail that soon became so characteristic of them.

The perfection and fidelity of the pictures are such that on examining them by microscopic power details are discovered which are not perceivable to the naked eye in the original objects but which when searched for there by the aid of opt.

Emerging in Europe after the architecture travelled unevenly but globally via the printed page without photography. More over it is often argued that it was through Modernism that architecture became profoundly perhaps them irreversibly complicit with its camera image.

Architects began to design with photographic representation in mind and for good or bad the them in photographic. View from the window at was a lucid demonstration of the new for consummate translation of three dimensions into two.

Sincerely,

Taro Arai

1530 J Street #150
Sacramento, CA 95814

MikuniSushi.com
Mikuni@Mikuni.com
812 - 232 - 7874

Open Every Day
5 PM to 12 PM

James Glazzer
720 Horncastle Ave.
Sacramento, CA 95747

1530 J Street #150
Sacramento, CA 95814

Taro Arai
Head Sushi Chef
TaroArai@Mikuni.com
800 - 230 - 0923

Branding | Design

Design | Branding

Branding | Design

P256: Credit & Commentary | **Students:** Olivia Larsen, Chiara Barbagallo | **School:** San Diego City College | Images 1, 2 of 6

Design | Packaging

Student: Audrey Hancock | School: Brigham Young University

Branding | Design

INSTRUCTOR DAEKI SHIM

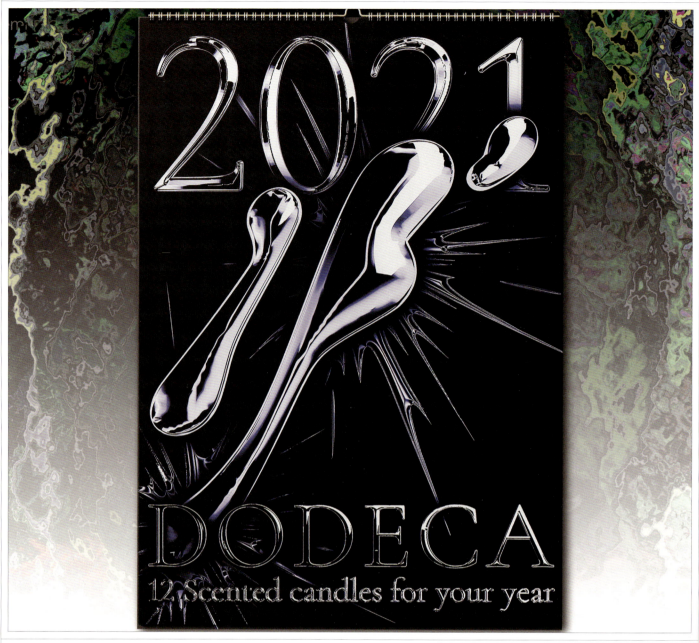

P256: Credit & Commentary Student: **Huiyun Jung** | School: **Hongik University** Images 1 of 7

INSTRUCTOR ERIC BAKER

P256: Credit & Commentary Student: **Hyupjung Lee** | School: **School of Visual Arts** Images 1 of 7

Illustration | Design

P257: Credit & Commentary **Student:** Grace Park | **School:** ArtCenter College of Design

Design | Illustration

P257: Credit & Commentary **Student:** Alex Kupczyk | **School:** ArtCenter College of Design

INSTRUCTORS SEAN BACON, BRADFORD PRAIRIE

P257: Credit & Commentary **Student:** Olivia Larsen | **School:** San Diego City College Images 1 of 3

INSTRUCTOR KAREN DORFF

P257: Credit & Commentary **Student:** Ashley Owen | **School:** University of North Texas

INSTRUCTOR **GENARO SOLIS RIVERO**

P257: Credit & Commentary **Student:** Hannah Tanner | **School:** Texas State University

INSTRUCTOR **GENARO SOLIS RIVERO**

P257: Credit & Commentary **Student:** Allison Satterfield | **School:** Texas State University

INSTRUCTOR **DOUGLAS MAY**

P257: Credit & Commentary **Student:** Hana Snell | **School:** University of North Texas

INSTRUCTOR **GENARO SOLIS RIVERO**

P257: Credit & Commentary **Student:** Roy Resendez | **School:** Texas State University

INSTRUCTOR **GENARO SOLIS RIVERO**

P257: Credit & Commentary **Student:** Ronaldo Mundo | **School:** Texas State University

P257: Credit & Commentary **Student:** Andres Meza | **School:** Texas State University

P257: Credit & Commentary **Student:** Kierra Simmons | **School:** Texas State University

P257: Credit & Commentary **Student:** Felipe Rodriguez | **School:** Texas State University

P257: Credit & Commentary **Student:** Daniela Dunman | **School:** Texas State University

P257: Credit & Commentary **Student:** Robert Warrix | **School:** Texas State University

Design | Packaging

P258: Credit & Commentary **Student:** Kaitlin Deutsch | **School:** Texas A&M University Commerce **Images 1, 2 of 3**

Packaging | Design

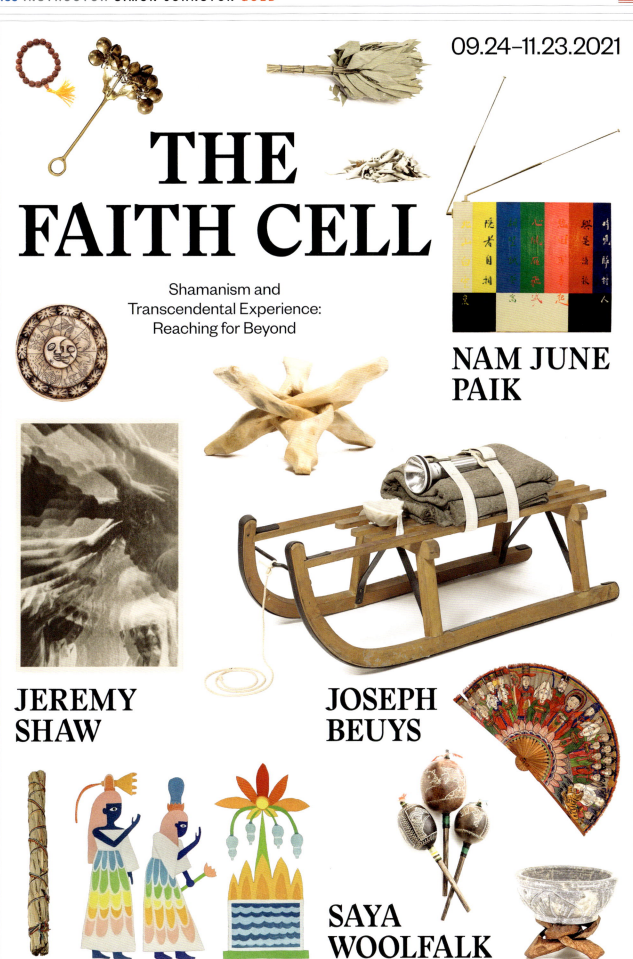

09.24–11.23.2021

THE FAITH CELL

Shamanism and
Transcendental Experience:
Reaching for Beyond

NAM JUNE PAIK

JEREMY SHAW

JOSEPH BEUYS

SAYA WOOLFALK

moma.org 11 W 53rd St, New York, NY 10019 **MoMA**

P258: Credit & Commentary **Student:** Ying Chun Chen | **School:** National Taiwan University of Science and Technology Images 1 of 3

Design | Poster

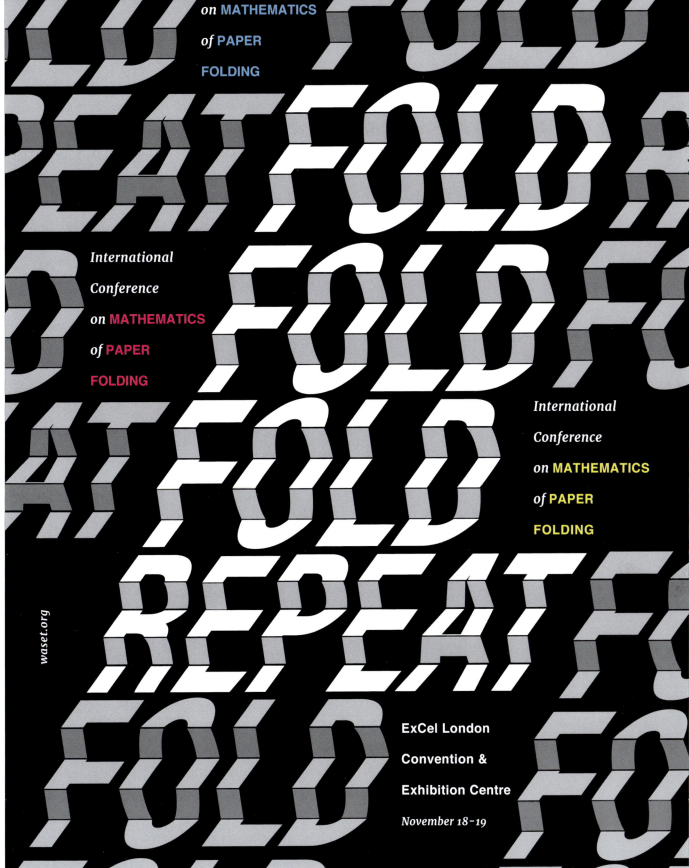

International
Conference
on MATHEMATICS
of PAPER
FOLDING

International
Conference
on MATHEMATICS
of PAPER
FOLDING

International
Conference
on MATHEMATICS
of PAPER
FOLDING

waset.org

ExCel London
Convention &
Exhibition Centre

November 18–19

MARLON BRANDO AL PACINO ROBERT DUVALL

DIRECTED BY FRANCIS COPPOLA

THE GODFATHER

Poster | Design

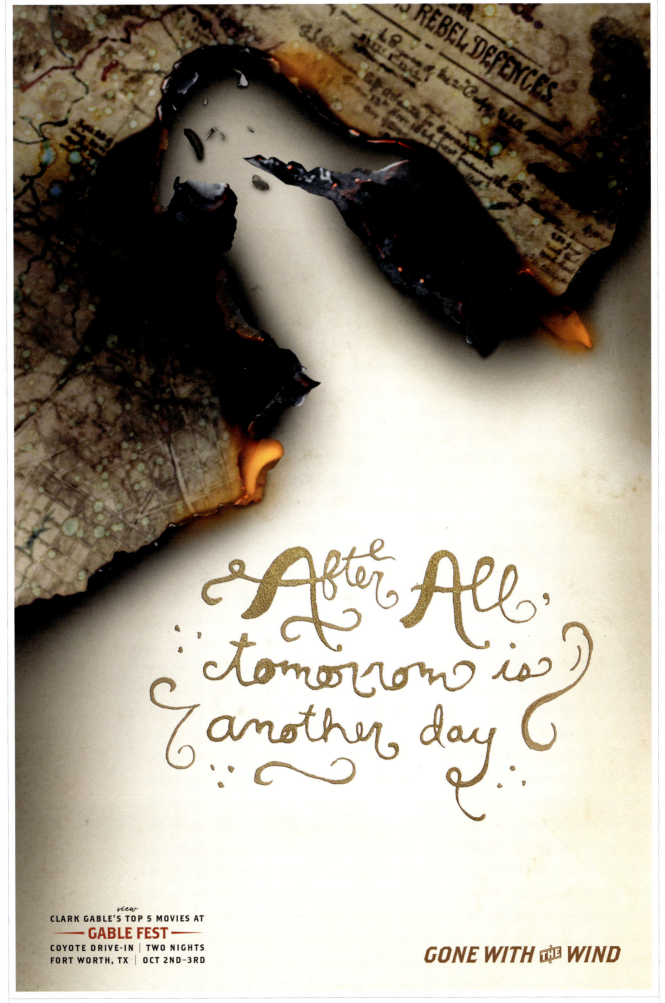

Student: Trevor Scott | **School:** Texas Christian University

Poster | Design

如此众多的中国人被口罩遮盖住，以抵抗令人窒息的空气
It's time to unmask our beauty

P258: Credit & Commentary **Student:** Kaitlin Deutsch | **School:** Texas A&M University Commerce Images 1 of 3

featuring:
North By Northwest
Showing November 18th at 9:00 PM
In the L. A. Theatre
Visit: www.writersguildofamerica.org

WRITER'S GUILD FESTIVAL

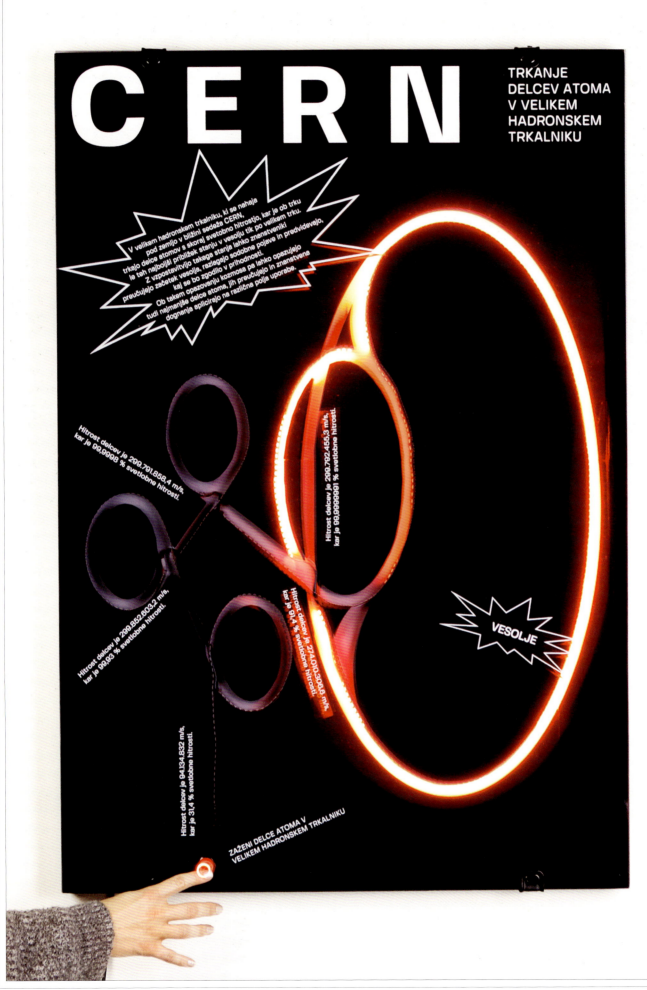

P259: Credit & Commentary **Student:** Ana Valenko | **School:** University of Ljubljana, Academy of Applied Arts and Design Images 1 of 4

Design | Poster

INSTRUCTOR GINNY DIXON

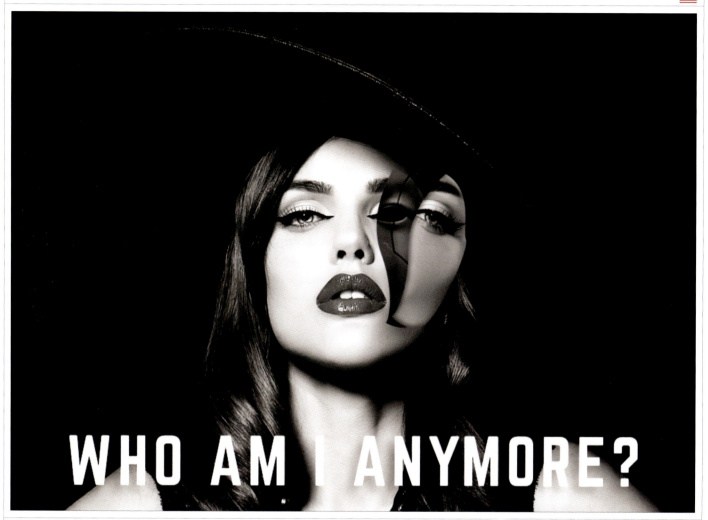

P259: Credit & Commentary **Student: Keerthikeyan Dakshinamurthy | School: M.AD School of Ideas Miami**

INSTRUCTOR KEVIN O'CALLAGHAN

P259: Credit & Commentary **Student: Zhuoyuan Li | School: School of Visual Arts**

Poster, Product Design | Design

P259: Credit & Commentary **Student: Johannes von Schoenebeck | School: Royal College of Art** Images 1 of 7

INSTRUCTOR **HANK RICHARDSON**

P259: Credit & Commentary **Student: Dimitri Ferreira | School: M.AD School of Ideas at Portfolio Center**

P259: Credit & Commentary **Student:** Andre Gomez | **School:** California State University, Fullerton Images 1 of 4

Design | Promotion

MAZDA 2035 Sagitta Concept

taylor chen

P259: Credit & Commentary Student: **Taylor Chen** | School: **ArtCenter College of Design**

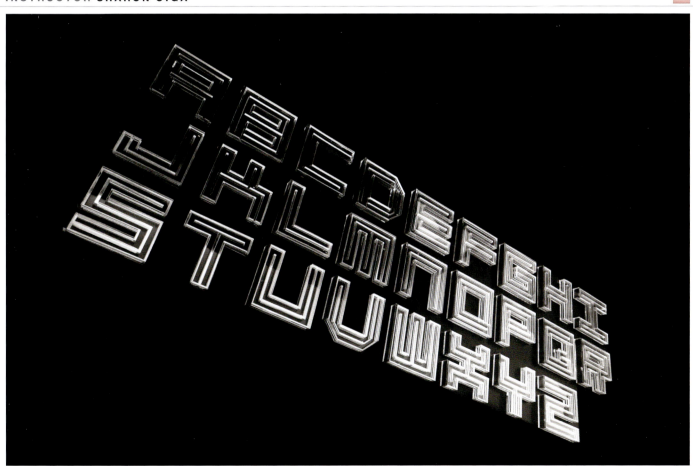

P259: Credit & Commentary Student: **Nada Abourashed** | School: **University of Illinois at Chicago** Images 1 of 7

ALPHABET

TWIST REGULAR
48PT

Typography | Design

P259: Credit & Commentary **Student:** Giorgi Woolford | **School:** University of Texas at Arlington

Design | Typography

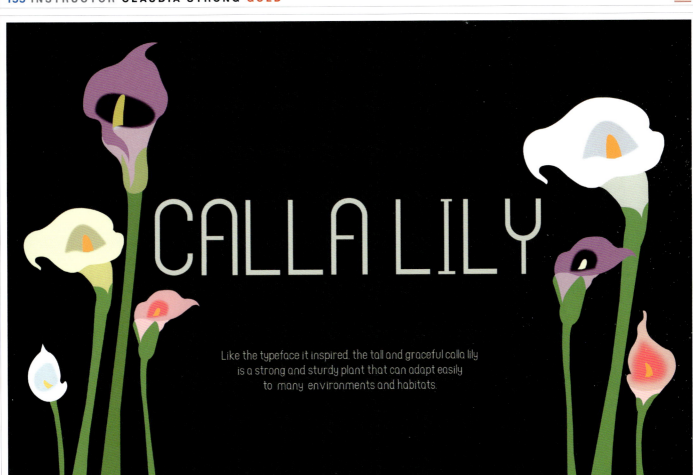

CALLA LILY

Like the typeface it inspired, the tall and graceful calla lily
is a strong and sturdy plant that can adapt easily
to many environments and habitats.

Uppercase

ABCDEFGHIJKLMN
OPQRSTUVWXYZ

Lowercase

abcdefghijklmn
opqrstuvwxyz

Numbers

1234567890

punctuation marks and symbols

(,.":;#$&!?/@\'*)

Typography | Design

P259: Credit & Commentary **Student:** Javier Ruiz Navarro | **School:** University of North Texas Images 1 of 6

INSTRUCTOR PAULINE HUDEL SMITH

Student: Dan Pham | School: University of Texas Arlington

INSTRUCTOR DAVID HAKE

Student: Ruonan Hu | School: Academy of Art University

INSTRUCTOR ADRIAN PULFER

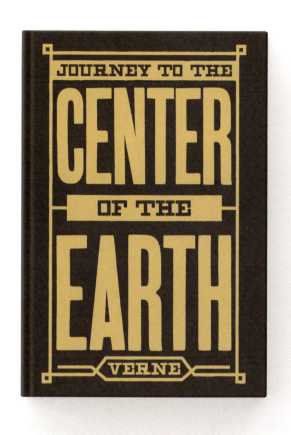

Student: Wil Osborne | **School:** Brigham Young University

INSTRUCTOR TAYLOR SHIPTON

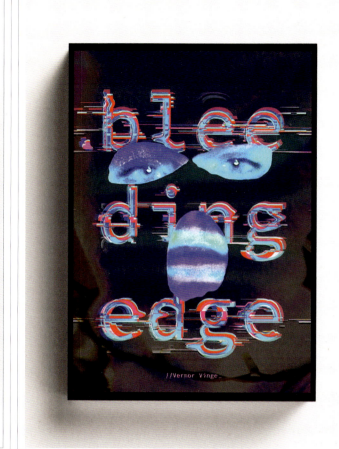

Student: Ronald Feinberg | **School:** Pennsylvania State University

INSTRUCTOR TAYLOR SHIPTON

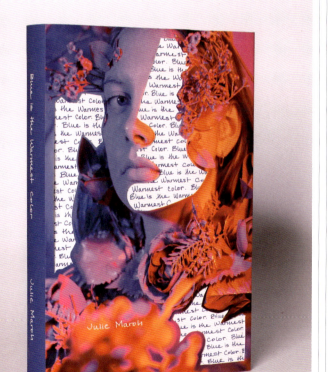

Student: Jackie Siry | **School:** Pennsylvania State University

INSTRUCTOR ADRIAN PULFER

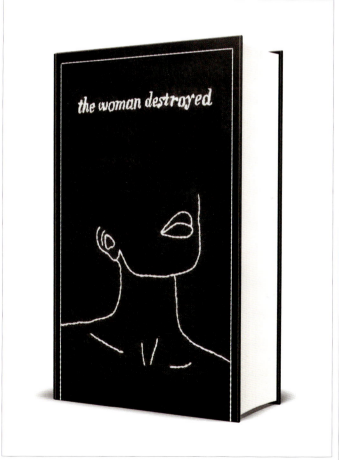

Student: Monica Mysyk | **School:** Brigham Young University

INSTRUCTOR ELLEN LUPTON

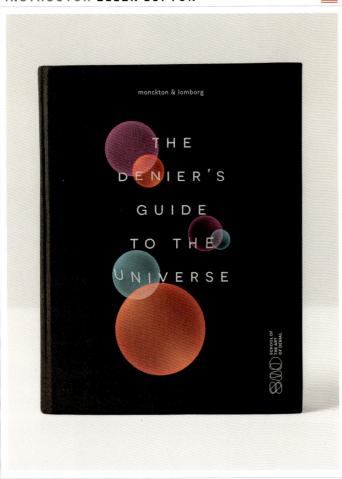

Student: Anjali Nair | School: Maryland Institute College of Art

INSTRUCTOR ADRIAN PULFER

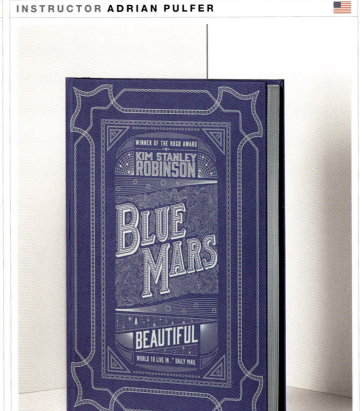

Student: Ben Law | School: Brigham Young University

INSTRUCTOR NELSON CARNICELLI

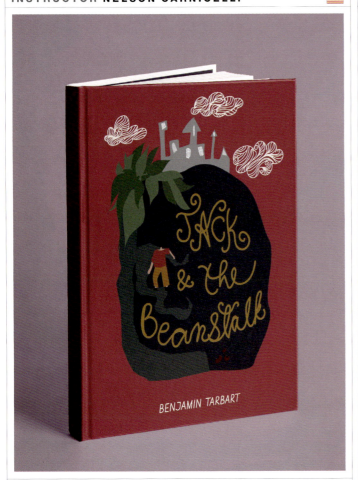

Student: Aarti Thamma | School: M.AD School of Ideas San Francisco

INSTRUCTOR CHERI GRAY

Student: Eun Jung Bahng | School: ArtCenter College of Design

INSTRUCTOR ADRIAN PULFER

Student: Deb Figueroa | School: Brigham Young University

INSTRUCTOR ADRIAN PULFER

INSTRUCTOR DAVID ELIZALDE

Student: Gracie Nicholas | School: Brigham Young University

Student: Trevor Scott | School: Texas Christian University

INSTRUCTOR OLGA MEZHIBOVSKAYA

INSTRUCTOR RIVER JUKES-HUDSON

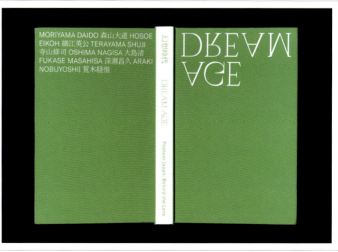

Student: Zona Guan | School: School of Visual Arts

Student: Jingping Xiao | School: ArtCenter College of Design

INSTRUCTOR **BETH SHIRRELL** 🇺🇸

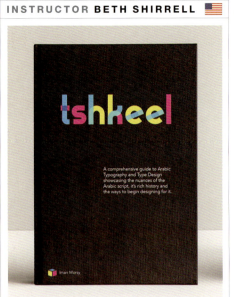

Student: Iman Morsy
School: Thomas Jefferson University

INSTRUCTOR **ADRIAN PULFER** 🇺🇸

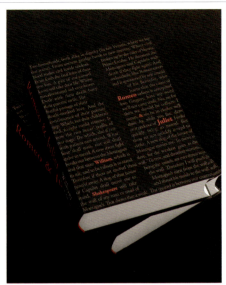

Student: Marie Oblad
School: Brigham Young University

INST. **VASSOULA VASILIOU** 🇺🇸

Student: Tássia Dias Valim Cunha
School: M.AD School of Ideas Miami

INSTRUCTOR **OLGA MEZHIBOVSKAYA** 🇺🇸

Student: Fangzhao Zhou | **School:** School of Visual Arts

INSTRUCTOR **SIMON JOHNSTON** 🇺🇸

Student: Eun Jung Bahng | **School:** ArtCenter College of Design

INSTRUCTOR **DAVID ELIZADE** 🇺🇸

Student: Annika Ballestro | **School:** Texas Christian University

INSTRUCTOR **DAVID ELIZALDE** 🇺🇸

Student: Lindsay Browne | **School:** Texas Christian University

INSTRUCTOR **CHERI GRAY**

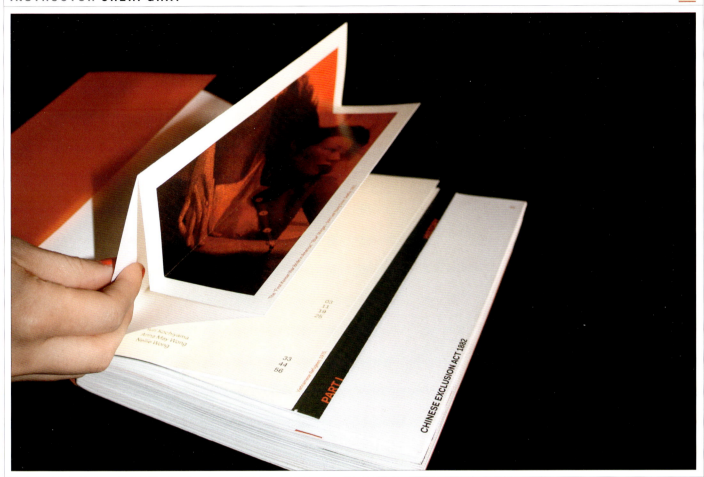

Student: Chelsea Le | **School:** ArtCenter College of Design

INSTRUCTOR **BRAD BARTLETT**

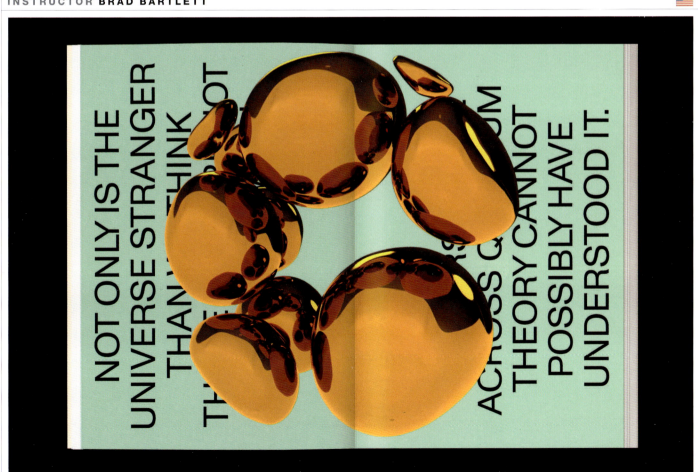

Student: Kenneth Kuh | **School:** ArtCenter College of Design

2.2

"I have forced myself to contradict myself in order to avoid conforming to my own taste." – Marcel Duchamp

Dada or Dadaism was an art movement of the European avant-garde in the early 20th century, with early centers in Zürich, Switzerland, at the Cabaret Voltaire (circa 1916); New York Dada began circa 1915, and after 1920 Dada flourished in Paris. Developed in reaction to World War I, the Dada movement consisted of artists who rejected the logic, reason, and aestheticism of modern capitalist society, instead expressing nonsense, irrationality, and anti-bourgeois protest in their works. The art of the movement spanned visual, literary, and sound media, including collage, sound poetry, cut-up writing, and sculpture. Dadaist artists expressed their discontent with violence, war, and nationalism, and maintained political affinities with the radical far-left. Dada was an informal international movement, with participants in Europe and North America. The beginnings of Dada correspond to the outbreak of World War I. For many participants, the movement was a protest against the bourgeois nationalist and colonialist interests, which many Dadaists believed were the root cause of the war, and against the cultural and intellectual conformity—in art and more broadly in society—that corresponded to the war.

Art & Dadaism

11.
Not to Be Reproduced (1937)
René Magritte

Dadaism as Art

The roots of Dada lie in pre-war avant-garde. The term anti-art, a precursor to Dada, was coined by Marcel Duchamp around 1913 to characterize works which challenge accepted definitions of art. Cubism and the development of collage and abstract art would inform the movement's detachment from the constraints of reality and convention. The work of French poets, Italian Futurists and the German Expressionists would influence Dada's rejection of the tight correlation between words and meaning. Works such as Ubu Roi (1896) by Alfred Jarry, and the ballet Parade (1916–17) by Erik Satie would also be characterized as proto-Dadaist works. The Dada movement's principles were first collected in Hugo Ball's Dada Manifesto in 1916.

Dadaist movement included public gatherings, demonstrations, and publication of art/literary journals; passionate coverage of art, politics, and culture were topics often discussed in a variety of media. Key figures in the movement included Hugo Ball, Marcel Duchamp, Emmy Hennings, Hans Arp, Sophie Taeuber-Arp, Raoul Hausmann, Hannah Höch, Johannes Baader, Tristan Tzara, Francis Picabia, Huelsenbeck, George Grosz, John Heartfield, Man Ray, Beatrice Wood, Kurt Schwitters, Hans Richter, Max Ernst, and Elsa von Freytag-Loringhoven among others. The movement influenced later styles like the avant-garde and downtown music movements, and groups including Surrealism, nouveau réalisme, pop art and Fluxus.

32 33

Student: Haozhe Li | School: ArtCenter College of Design

Student: Sara Nguyen | School: Capilano University

INSTRUCTOR KAREN KRESGE

Student: Rebecca Schupp | School: Kutztown University of Pennsylvania

INSTRUCTOR ADRIAN PULFER

Student: Lauren Canizales | School: Brigham Young University

INSTRUCTOR EDUARD ČEHOVIN

Std.: Ana Valenko | Sch.: Univ. of Ljubljana, Acad. of Fine Arts & Design

INSTRUCTOR STEPHEN ZHANG

Student: Tama Higuchi-Roos | School: University of North Texas

INSTRUCTOR YVONNE CAO

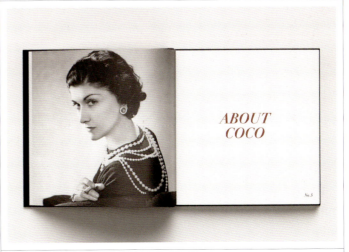

Student: Cassie Schmidt | School: Texas Christian University

INSTRUCTOR YVONNE CAO

Student: Rae McCollum | School: Texas Christian University

INSTRUCTORS CHERI GRAY, ANGAD SINGH

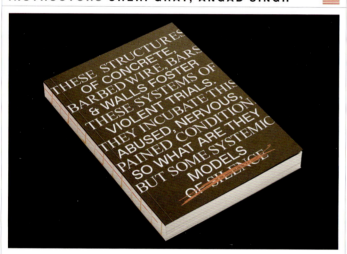

Student: Jack Moore | School: ArtCenter College of Design

INSTRUCTOR GENARO SOLIS RIVERO

Student: Seth Jones | School: Texas State University

INSTRUCTOR EDUARD ČEHOVIN

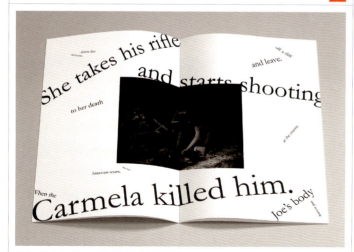

Std.: Ana Karlin | Sch.: Univ. of Ljubljana, Academy of Fine Arts & Design

INSTRUCTOR UNATTRIBUTED

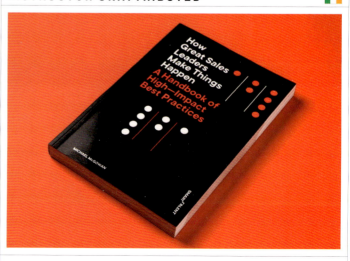

Student: Finán Callaghan | School: TU Dublin

Student: Miki Isayama | School: School of Visual Arts

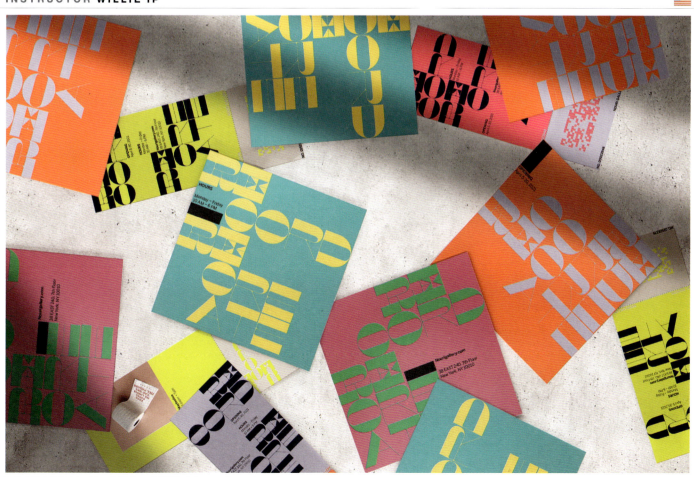

Student: Alicia Liu | School: School of Visual Arts

INSTRUCTOR CHERI GRAY 🇺🇸

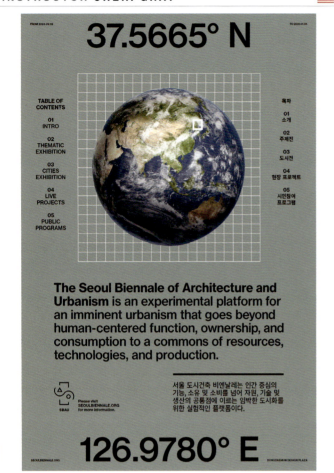

Student: Eun Jung Bahng | School: ArtCenter College of Design

INSTRUCTORS DONG-JOO PARK, SEUNG-MIN HAN 🇰🇷

Student: Gi Hyeon Kim | School: Hansung University, Design & Art Institute

INSTRUCTOR GENARO SOLIS RIVERO 🇺🇸

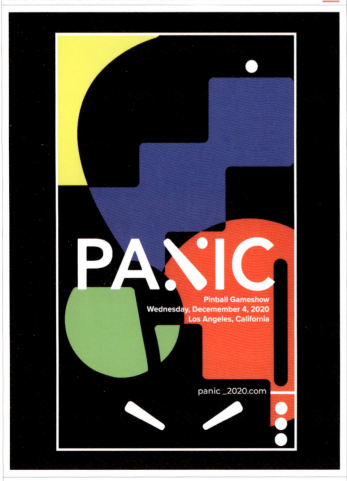

Student: Jennifer Garza | School: Texas State University

INSTRUCTOR NATHAN SAVAGE 🇺🇸

Student: Spencer Olson | School: Portland Community College

INSTRUCTOR **ADRIAN PULFER** 🇺🇸

Student: Brenna Vaterlaus | **School:** Brigham Young University

INSTRUCTOR **JAN BALLARD** 🇺🇸

Student: Sarah Cuttic | **School:** Texas Christian University

INSTRUCTORS **GERARDO HERRERA, JAMES CHU** 🇺🇸

Student: Jack Moore | **School:** ArtCenter College of Design

INSTRUCTOR **JON NEWMAN** 🇺🇸

Student: Justin Wong | **School:** School of Visual Arts

INSTRUCTOR **SCOTTY REIFSNYDER** 🇺🇸

Student: Chuck Scott | **School:** West Chester University

INSTRUCTOR **CAROLYN KILDAY** 🇺🇸

Student: Colby Gill | **School:** Texas State University

INSTRUCTOR RUDY MANNING

Student: Haozhe Li | **School:** ArtCenter College of Design

INSTRUCTOR BRAD BARTLETT

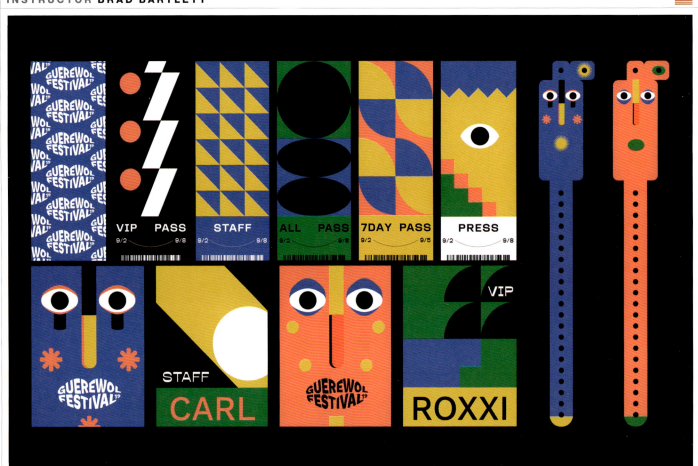

Student: Kenneth Kuh | **School:** ArtCenter College of Design

INSTRUCTOR ERIC BAKER

Student: Junyu Chen | **School:** School of Visual Arts

INSTRUCTORS ROS KNOPOV, GRAYDON KOLK

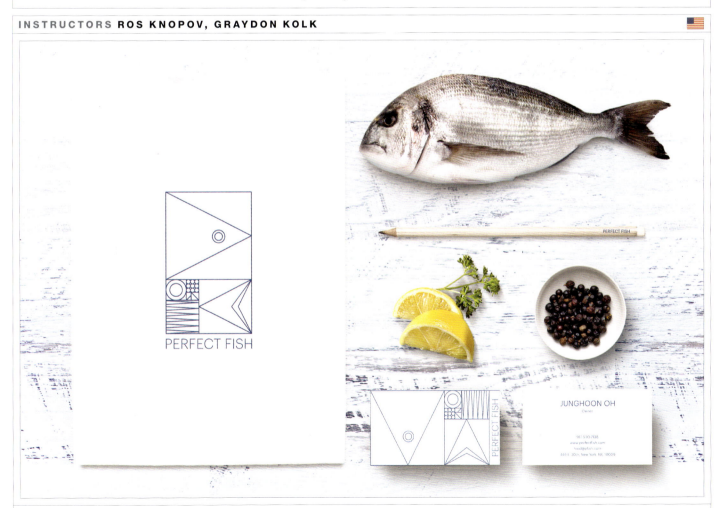

Student: Junghoon Oh | **School:** School of Visual Arts

INSTRUCTOR BALÁZS VARGHA

Std.: Ágoston Hajdú | **Sch.:** Moholy-Nagy Univ. of Art & Design Budapest

INSTRUCTOR DOUGLAS MAY

Student: Taylor Minth | **School:** University of North Texas

INSTRUCTOR DAVID ELIZALDE

Student: Rebecca Lang
School: Texas Christian University

INSTRUCTOR HOLLY STERLING

Students: Megan Myles, Chantal Lesley, Nathanael Loden, Jack Parker
School: Texas State University

INSTRUCTORS DAVID FRANKEL, SHAWN HASTO

Student: Jiin Choi | **School:** School of Visual Arts

INSTRUCTOR ADRIAN PULFER

Student: Bram Linkowski | **School:** Brigham Young University

INSTRUCTOR UNATTRIBUTED

Student: Jean Quarcoopome | School: Ashesi University

INSTRUCTOR JOHN DUFRESNE

Student: Fuechee Thao | School: Concordia University

INSTRUCTOR ADRIAN PULFER

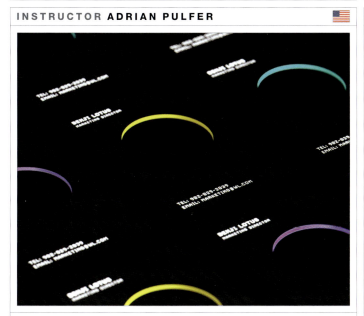

Student: Ben Law
School: Brigham Young University

INSTRUCTOR ABBY GUIDO

Students: Olivia Colacicco, Josephine Kostusiak, Wenqing Liu, Tara Ryan
School: Temple University, Tyler School of Art & Architecture

INSTRUCTOR CAROLYN KILDAY

Student: Carolina Martinez | School: Texas State University

INSTRUCTOR ELLEN LUPTON

Student: Celi Monroe | School: Maryland Institute College of Art

INSTRUCTOR CHERI GRAY

Student: Jaiwon Lee | **School:** ArtCenter College of Design

INSTRUCTOR LINDA REYNOLDS

Students: Monica Mysyk, Audrey Hancock, Dominique Mossman | **School:** Brigham Young University

INSTRUCTOR BRAD BARTLETT

Student: Kenneth Kuh | School: ArtCenter College of Design

INSTRUCTOR ADRIAN PULFER

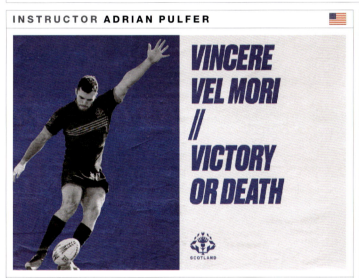

Student: Bethany Coates | School: Brigham Young University

INSTRUCTOR RUDY MANNING

Student: Yicen Liu | School: ArtCenter College of Design

INSTRUCTOR BRAD BARTLETT

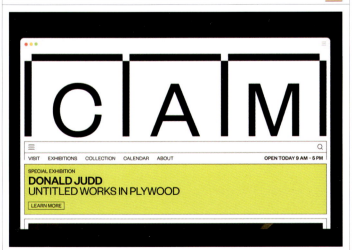

Student: Jisu Kim | School: ArtCenter College of Design

INSTRUCTOR ADRIAN PULFER

Student: Lauren Canizales | School: Brigham Young University

Student: Xinmeng Yu | School: Maryland Institute College of Art

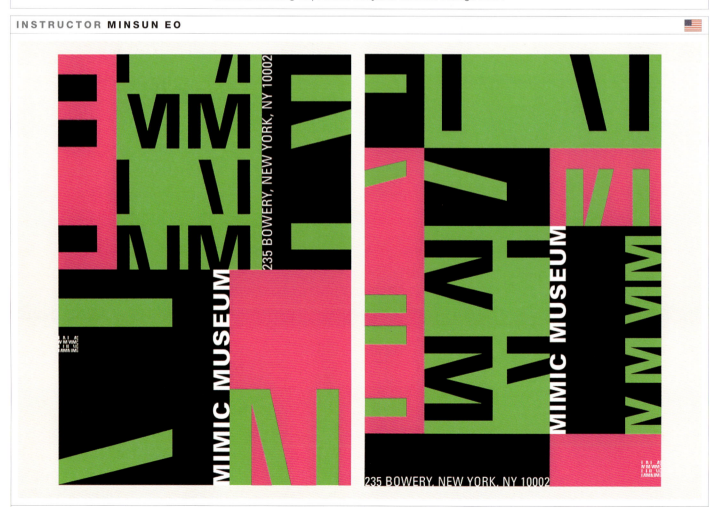

Student: Xizhong Zhang | School: Maryland Institute College of Art

INSTRUCTOR **GENARO SOLIS RIVERO**

Student: Kara Watterson
School: Texas State University

INSTRUCTORS **DONG-JOO PARK, SEUNG-MIN HAN**

Students: Ji Young Moon, Yoon Ki Lee
School: Hansung University, Design & Art Institute

INSTRUCTOR **BILL BRAMMAR**

Student: Kenzie Ashley | **School:** Texas Christian University

INSTRUCTOR **DAVID ELIZALDE**

Student: Gretchen Rea | **School:** Texas Christian University

INSTRUCTOR **CAROLYN KILDAY**

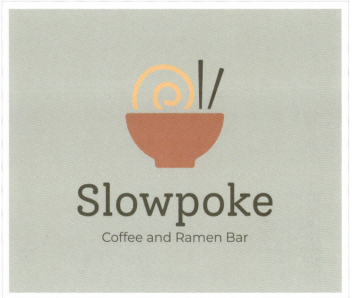

Student: Kristen Todorovich | **School:** Texas State University

INSTRUCTOR **YVONNE CAO**

Student: Nicole Oesterreicher | **School:** Texas Christian University

INSTRUCTOR **DOUGLAS MAY**

Student: Andrew Ashton | School: University of North Texas

INSTRUCTOR **ADRIAN PULFER**

Student: Brenna Vaterlaus | School: Brigham Young University

INSTRUCTORS **COURTNEY GOOCH, RORY SIMMS**

Student: Miki Isayama | School: School of Visual Arts

INSTRUCTOR CHERI GRAY

Student: Yanwen Hang | **School:** ArtCenter College of Design

INSTRUCTOR EVANTHIA MILARA

Std.: Helen Curtin, Steven Rhodes | **Sch.:** Columbia College Hollywood

INSTRUCTOR NATHAN SAVAGE

Student: Sari Field | **School:** Portland Community College

INSTRUCTOR DOUGLAS MAY

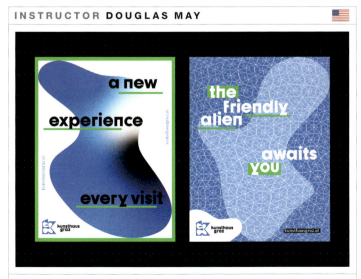

Student: Javier Ruiz | **School:** University of North Texas

INSTRUCTOR JEFF DAVIS

Students: Brooke Holle, Chantal Lesley | **School:** Texas State University

INSTRUCTOR ADRIAN PULFER

Student: Madi Jackson | **School:** Brigham Young University

INSTRUCTOR ANNIE HUANG LUCK

Student: Sunny Tianqing Li | **School:** ArtCenter College of Design

INSTRUCTOR EDUARD ČEHOVIN

Student: Polona Kačič | **School:** University of Ljubljana, Academy of Fine Arts and Design

INSTRUCTOR GEOFF GERMAN

Student: Camryn Hezeau | **School:** Texas A&M University Commerce

INSTRUCTOR DOUGLAS MAY

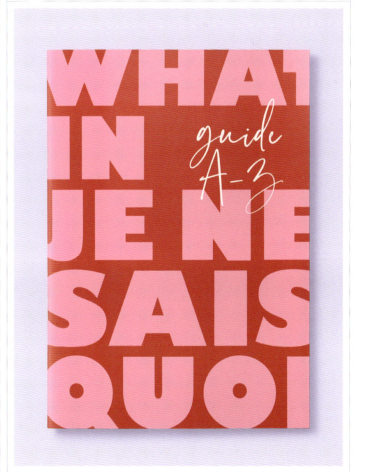

Student: Hana Snell | **School:** University of North Texas

INSTRUCTOR JOHN DUFRESNE

Student: Jorge Vázquez Tejeda | **School:** Concordia University

INSTRUCTOR UNATTRIBUTED

Student: Yunyang Li | **School:** School of Visual Arts

INSTRUCTOR STEPHEN SERRATO

Student: Phoebe Hsu | **School:** ArtCenter College of Design

INSTRUCTOR THERON MOORE

Student: Nathaniel Ramirez | **School:** California State University, Fullerton

INSTRUCTOR NATHAN SAVAGE

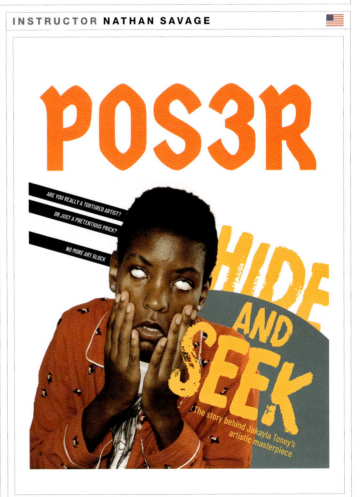

Student: Charlie Dulaney | **School:** Portland Community College

Student: Sydney Chiles | **School:** Brigham Young University

INSTRUCTOR **ADRIAN PULFER**

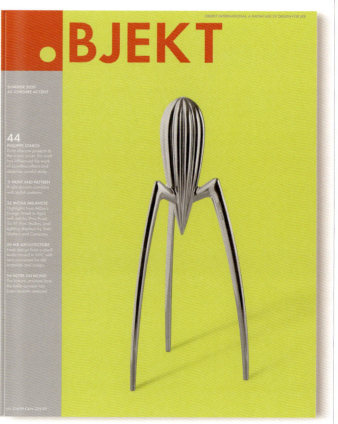

Student: Wil Osborne | **School:** Brigham Young University

INSTRUCTORS ADRIAN PULFER, RYAN MANSFIELD

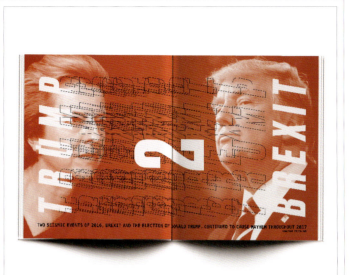

Student: Zoë Hart-Wagstaff | School: Brigham Young University

INSTRUCTOR CHERI GRAY

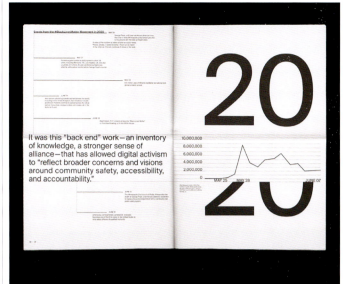

Student: Phoebe Hsu | School: ArtCenter College of Design

INSTRUCTOR GAIA HWANG

Student: Hsiao-Wen Hu | School: Pratt Institute

INSTRUCTOR EMILY BURNS

Student: Scotti Everhart | School: Pennsylvania State University

INSTRUCTOR NATHAN SAVAGE

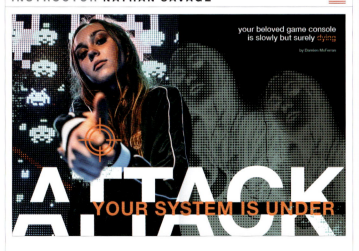

Student: Kristofer McRae | School: Portland Community College

INSTRUCTOR ANNIE HUANG LUCK

Student: Yanwen Hang | School: ArtCenter College of Design

INSTRUCTOR ANNIE HUANG LUCK

Student: Ellis Yu | **School:** ArtCenter College of Design

INSTRUCTOR ANNIE HUANG LUCK

Student: Yuchen Xie | **School:** ArtCenter College of Design

INSTRUCTOR UNATTRIBUTED

Student: Nila Nejad
School: Syracuse University, College of Visual & Performing Arts

INSTRUCTOR YVONNE CAO

Student: Elizabeth Ireland
School: Texas Christian University

INSTRUCTOR YVONNE CAO

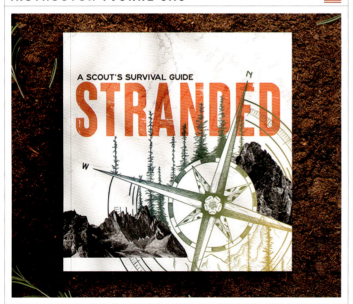

Student: Elizabeth Ireland | **School:** Texas Christian University

INSTRUCTOR THERON MOORE

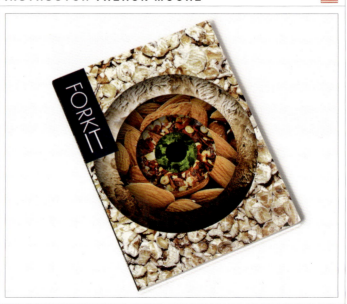

Student: Ada Loong | **School:** California State University, Fullerton

INST. THERON MOORE

Student: Sarah Fong
School: California State University, Fullerton

INST. G. VILLA, JR., B. EDGERTON

Student: Janessa Torres
School: Columbia College of Chicago

INST. YVONNE CAO

Student: Madeleine Alff
School: Texas Christian University

INSTRUCTOR ROBERT BEST

Student: Mingxin Cheng | School: School of Visual Arts

INST. ANNIE HUANG LUCK

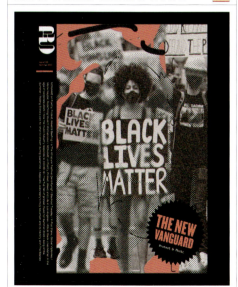

Student: Jack Moore
School: ArtCenter College of Design

INST. MARK WILLIE

Student: Ashley Wiederspahn
School: Drexel University

INST. YVONNE CAO

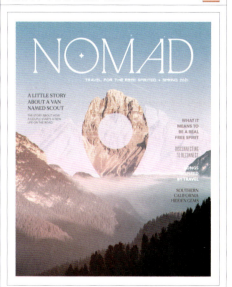

Student: Elizabeth Ireland
School: Texas Christian University

INSTRUCTOR TAYLOR SHIPTON

Student: Taylor Mazzarella | **School:** Pennsylvania State University

INSTRUCTOR ADRIAN PULFER

Student: Deb Figueroa | **School:** Brigham Young University

INSTRUCTOR ADRIAN PULFER

Student: Marie Oblad | **School:** Brigham Young University

INSTRUCTOR JERRI JOHNSON

Haus am Bäumle

Vertical Living
Bernardo Bader Architects

PHOTOS BY ADOLF BEREUTER

This tall, gabled house by Bernardo Bader Architekten is covered in lengths of blackened timber and stands on the edge of a small stream in Lochau, Austria. While the blackened timber cladding is intended to resonate with traditional rural architecture in Austria, the lighter-toned window frames and corresponding internal finishes lend it a contemporary edge.

Jessica Mairs

36

Student: Brendan Irving | **School:** George Brown College

INSTRUCTORS ABBY GUIDO, JENNY KOWALSKI

Student: Alex Kim | School: Temple University

INSTRUCTOR DAEKI SHIM

Student: Hangeul Lee | School: Hongik University

INSTRUCTOR MELISSA KUPERMINC

Student: Kexin Chen | School: Savannah College of Art and Design

INSTRUCTOR CHUCK PRIMEAU

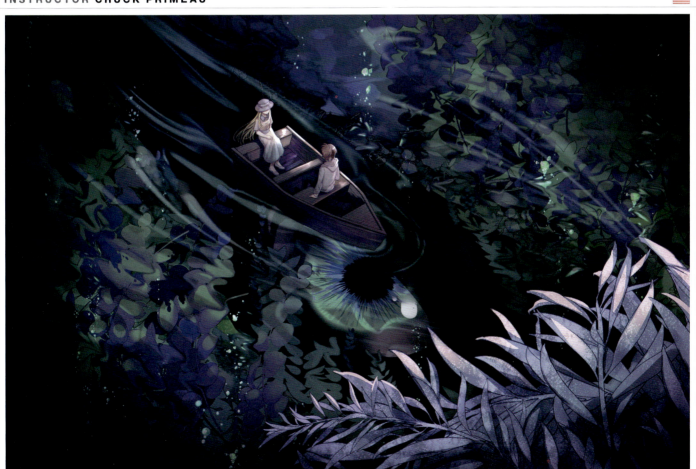

Student: Kexin Fan | School: Savannah College of Art and Design

INSTRUCTORS **ANN FIELD, CHRISTINE NASSER** 🇺🇸

Student: Grace Park
School: ArtCenter College of Design

INSTRUCTORS **DONG-JOO PARK, SEUNG-MIN HAN** 🇰🇷

Students: Gwak Se Ri, Mary Kim, Jeon Su Jin
School: Hansung University, Design & Art Institute

INSTRUCTORS **ANN FIELD, PAUL ROGERS** 🇺🇸

Student: Haley Jiang | **School:** ArtCenter College of Design

INSTRUCTORS **BRIAN REA, PAUL ROGERS** 🇺🇸

Student: Grace Park | **School:** ArtCenter College of Design

INSTRUCTOR JASON HOLLEY 🇺🇸

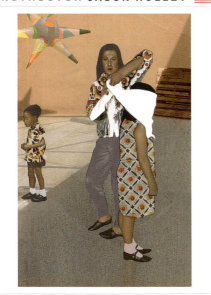

Student: Dominic Bodden
School: ArtCenter College of Design

INSTRUCTOR UNATTRIBUTED 🇺🇸

Student: Hyunjeong Yi
School: ArtCenter College of Design

INSTRUCTORS D. PARK, S. HAN 🇰🇷

Student: Hyeeji Kim
School: Hansung Univ., Design & Art Institute

INST. ANN FIELD, PAUL ROGERS 🇺🇸

Student: Haley Jiang
School: ArtCenter College of Design

INST. ANN F., PAUL R., DAVID T., ROB C. 🇺🇸

Student: Haley Jiang
School: ArtCenter College of Design

INST. ANN FIELD, PAUL ROGERS 🇺🇸

Student: Haley Jiang
School: ArtCenter College of Design

INSTRUCTOR UNATTRIBUTED 🇺🇸

Student: Hyunjeong Yi | **School:** ArtCenter College of Design

INST. JIM SALVATI 🇺🇸

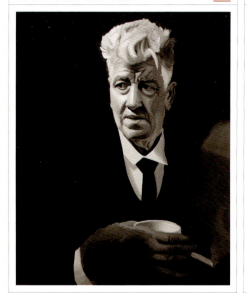

Student: Alex Kupczyk
School: ArtCenter College of Design

INST. PAUL ROGERS, BRIAN REA 🇺🇸

Student: Haley Jiang
School: ArtCenter College of Design

INST. DAVID TILLINGHAST 🇺🇸

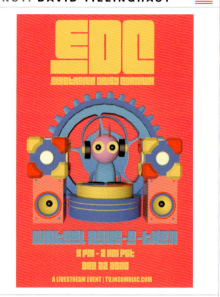

Student: Brian Lee
School: ArtCenter College of Design

INSTRUCTOR GAYLE DONAHUE 🇺🇸

Student: Grace Park | **School:** ArtCenter College of Design

INSTRUCTORS BRIAN REA, PAUL ROGERS 🇺🇸

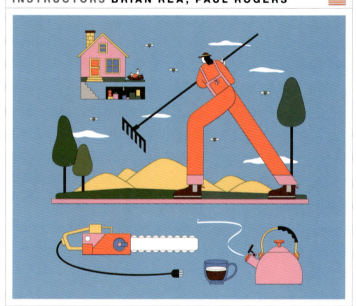

Student: Grace Park | **School:** ArtCenter College of Design

INST. DAVID TILLINGHAST, ROB CLAYTON 🇺🇸

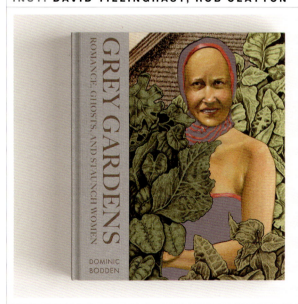

Student: Dominic Bodden | **School:** ArtCenter College of Design

INST. R. MCKELVEY, N. KILLIAN, O. MCHARDY 🇺🇸

Student: Feixue Mei | **School:** Virginia Commonwealth University

INSTRUCTOR **STEVE TURK**

Student: Hyunjeong Yi | School: ArtCenter College of Design

INSTRUCTOR **MARK TODD**

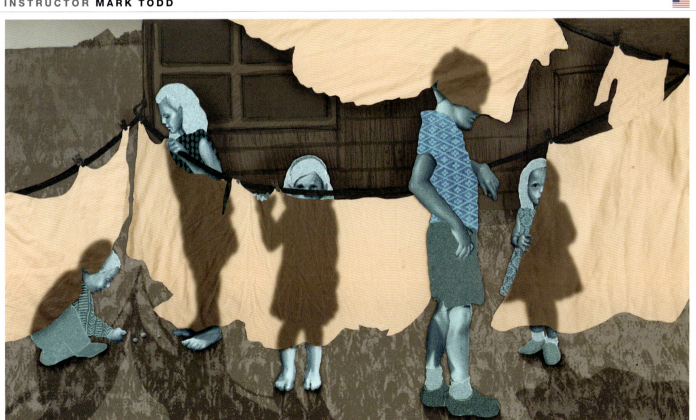

Student: Dominic Bodden | School: ArtCenter College of Design

Student: Grace Park | **School:** ArtCenter College of Design

INSTRUCTOR **OWEN FREEMAN**

Student: Garrett Daniels | **School:** ArtCenter College of Design

INSTRUCTOR **LI ZHANG**

Student: Tayler Wullenweber | **School:** Purdue University

INSTRUCTOR **DOUG THOMAS**

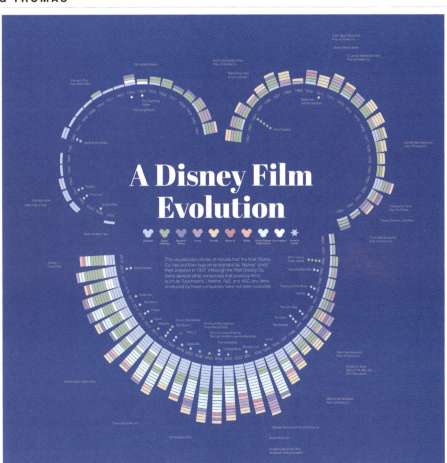

Student: Kaitlyn Richardson | **School:** Brigham Young University

INSTRUCTOR AARON SHURTLEFF

Student: Sam Verdine | **School:** Brigham Young University

INSTRUCTOR EVANTHIA MILARA

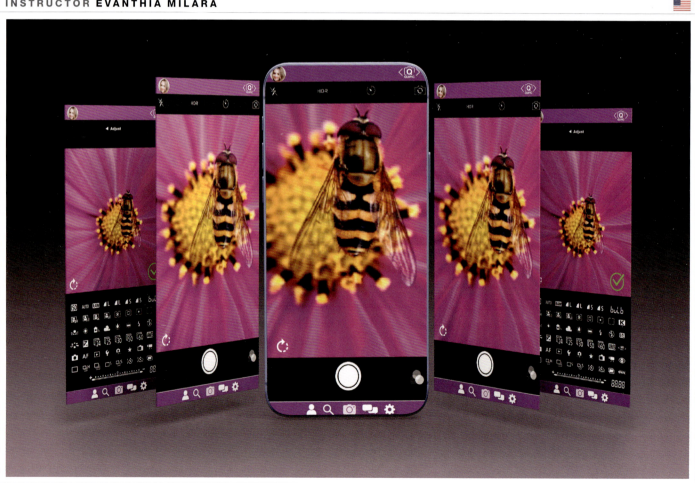

Student: Morgan Moehlenkamp | **School:** Columbia College Hollywood

INST. GENARO SOLIS RIVERO 🇺🇸

Student: Elisabeth Klein
School: Texas State University

INST. GENARO SOLIS RIVERO 🇺🇸

Student: Alondra Vazquez
School: Texas State University

INST. GENARO SOLIS RIVERO 🇺🇸

Student: Dondi Aguirre
School: Texas State University

INST. GENARO SOLIS RIVERO 🇺🇸

Student: Katelen Jennings
School: Texas State University

INSTRUCTOR ABBY GUIDO 🇺🇸

Student: Katie Fish | **School:** Temple University,
Tyler School of Art and Architecture

INSTRUCTOR KEN KOESTER 🇺🇸

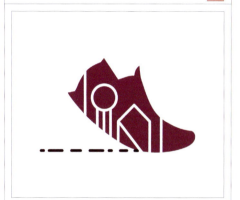

Student: Melissa Camacho
School: Texas A&M University Commerce

INST. GENARO SOLIS RIVERO 🇺🇸

Student: Blaik Romo
School: Texas State University

INST. GENARO SOLIS RIVERO 🇺🇸

Student: Victoria Nieves
School: Texas State University

INST. GENARO SOLIS RIVERO 🇺🇸

Student: Spencer Critendon
School: Texas State University

INSTRUCTOR SAL DEVITO 🇺🇸

Student: Yanira Janes Parsons
School: School of Visual Arts

INST. GENARO SOLIS RIVERO 🇺🇸

Student: Isidora Beskorovajni
School: Texas State University

INSTRUCTOR DOUGLAS MAY 🇺🇸

Student: Taylor Minth
School: University of North Texas

INSTRUCTOR JOSHUA EGE 🇺🇸

Student: Julio Reyes
School: Texas A&M University Commerce

INST. GENARO SOLIS RIVERO 🇺🇸

Student: Mikayla Stump
School: Texas State University

INST. GENARO SOLIS RIVERO 🇺🇸

HOTTAH SPIRIT

Student: Cynthia Murray
School: Texas State University

INST. GENARO SOLIS RIVERO 🇺🇸

Student: Christina Nguyen
School: Texas State University

INSTRUCTOR KAREN DORFF 🇺🇸

Student: Taylor Minth
School: University of North Texas

INST. GENARO SOLIS RIVERO 🇺🇸

Student: Hannah Morehead
School: Texas State University

INST. GENARO SOLIS RIVERO 🇺🇸

FLAMES
PRIME SEAFOOD

Student: Hannah Morehead
School: Texas State University

INST. GENARO SOLIS RIVERO 🇺🇸

Pearl Street

Student: Grace Hayes
School: Texas State University

INST. GENARO SOLIS RIVERO 🇺🇸

Student: Grace Hayes
School: Texas State University

INST. GENARO SOLIS RIVERO 🇺🇸

zippo

Student: Daniela Dunman
School: Texas State University

INST. GENARO SOLIS RIVERO 🇺🇸

ELEGANT
ARCHITECTURE

Student: Jaret Smith
School: Texas State University

INST. GENARO SOLIS RIVERO 🇺🇸

NINTH
NINPO

Student: Cheyenne Carrasco
School: Texas State University

INST. GENARO SOLIS RIVERO 🇺🇸

Student: Jaret Smith
School: Texas State University

INST. GENARO SOLIS RIVERO 🇺🇸

Student: Andres Meza
School: Texas State University

INSTRUCTOR DOUGLAS MAY 🇺🇸

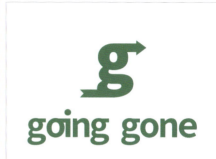

Student: Andrea Garoutte
School: University of North Texas

INST. GENARO SOLIS RIVERO 🇺🇸

Student: Kylee Palmer
School: Texas State University

INST. DAVID ELIZALDE 🇺🇸

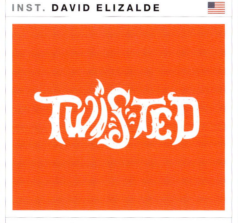

Student: Trevor Scott
School: Texas Christian University

INST. GENARO SOLIS RIVERO 🇺🇸

going gone

Student: Ashlea Wood
School: Texas State University

INST. GENARO SOLIS RIVERO 🇺🇸

OCTOCLEAN

Student: Hannah Morehead
School: Texas State University

INST. J. DAVIS, G. S. RIVERO 🇺🇸

GRANDER

Student: Aspen Walter
School: Texas State University

INST. GENARO SOLIS RIVERO 🇺🇸

Nocturno

Student: Ronaldo Mundo
School: Texas State University

INST. GENARO SOLIS RIVERO 🇺🇸

Student: Kylee Palmer
School: Texas State University

INSTRUCTOR DOUGLAS MAY 🇺🇸

Student: Alexis Houser
School: University of North Texas

INST. GENARO SOLIS RIVERO 🇺🇸

techboy

Student: Giang Pham
School: Texas State University

INST. GENARO SOLIS RIVERO 🇺🇸

Student: Kayla McKee
School: Texas State University

INSTRUCTOR DOUGLAS MAY 🇺🇸

Student: Andrea Chavez
School: University of North Texas

INST. GENARO SOLIS RIVERO 🇺🇸

Student: Andres Meza
School: Texas State University

INSTRUCTOR UNATTRIBUTED 🇧🇦

Student: Stefan Mijić
School: Unattributed

INSTRUCTOR DOUGLAS MAY 🇺🇸

Student: Andrew Galvan
School: University of North Texas

INST. GENARO SOLIS RIVERO 🇺🇸

Student: Erin Ckodre
School: Texas State University

INST. GENARO SOLIS RIVERO 🇺🇸

Student: Cheyenne Carrasco
School: Texas State University

INST. CAROLYN KILDAY 🇺🇸

Student: Nathanael Loden
School: Texas State University

INSTRUCTOR KAREN DORFF 🇺🇸

Student: Kristina Armitage
School: University of North Texas

INST. GENARO SOLIS RIVERO 🇺🇸

Student: Joel Nieto
School: Texas State University

INST. GENARO SOLIS RIVERO 🇺🇸

Student: Erin Ckodre
School: Texas State University

INSTRUCTOR KAREN DORFF 🇺🇸

Student: Holden Pizzolato
School: University of North Texas

INSTRUCTOR **BILL GALYEAN**

Student: Elizabeth Ireland | **School:** Texas Christian University

INSTRUCTOR **CAROLYN KILDAY**

Student: Jasmine Garcia | **School:** Texas State University

INSTRUCTOR VIDA JURCIC

Student: Kathrin Teh | School: Capilano University

INSTRUCTOR DAVID JONES

Student: Madison Argo | School: West Chester University

INSTRUCTOR JERRI JOHNSON

Student: Giovanna Ragali | School: George Brown College

INSTRUCTOR CAROLYN KILDAY

Student: Addison Wittler | School: Texas State University

INSTRUCTOR GARRETT OWEN

Student: Gabrielle Melendez | School: Texas A&M University Commerce

INSTRUCTOR JERRI JOHNSON

Student: Mike Deinum | School: George Brown College

INSTRUCTOR **ADRIAN PULFER**

Student: Ben Law | **School: Brigham Young University**

INST. **SEAN BACON, BRADFORD PRAIRIE**

Student: Heather Yancey | **School: San Diego City College**

INSTRUCTOR **YVONNE CAO**

Student: Caroline Fischer | **School: Texas Christian University**

INSTRUCTOR **ADRIAN PULFER**

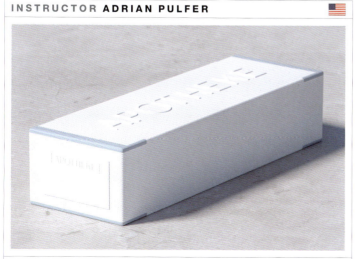

Student: Ben Law
School: Brigham Young University

INSTRUCTOR **SARAH BUGGLE**

Students: Seine Kongruangkit, Riya Dosani, Yamen Emad
School: M.AD School of Ideas Berlin

INSTRUCTOR **BILL GALYEAN**

Student: Caroline Fischer | **School:** Texas Christian University

INSTRUCTOR **DAN HOY**

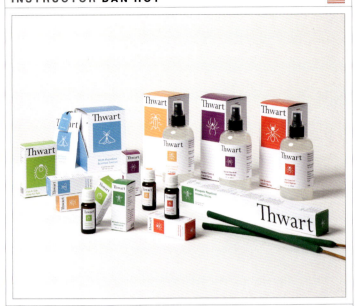

Student: Eun Jung Bahng | **School:** ArtCenter College of Design

INSTRUCTOR **YVONNE CAO**

Student: Rose Hoover | **School:** Texas Christian University

INSTRUCTOR **JERRI JOHNSON**

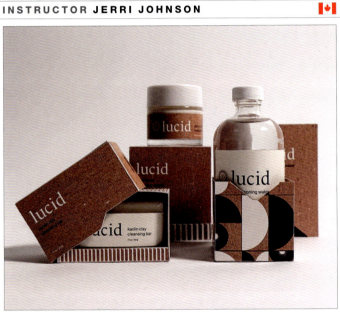

Student: Jenni Filman | **School:** George Brown College

INSTRUCTOR **CAROLYN KILDAY**

Student: Nathanael Loden | **School:** Texas State University

INSTRUCTOR **JON NEWMAN**

Student: Justin Wong | **School:** School of Visual Arts

INSTRUCTOR ADRIAN PULFER

Student: Lauren Canizales | **School:** Brigham Young University

INSTRUCTOR JODY GRAFF

Student: Matthew Barnett | **School:** Drexel University

INSTRUCTOR SCOTTY REIFSNYDER

Student: Tori Evert | **School:** West Chester University

INSTRUCTOR **KAREN DORFF** 🇺🇸

Student: Hana Snell
School: University of North Texas

INSTRUCTOR **KAREN KRESGE** 🇺🇸

Student: Carly Kozacheck
School: Kutztown University of Pennsylvania

INSTRUCTOR **CAROLYN KILDAY** 🇺🇸

Student: Alyssa Sullivan
School: Texas State University

INSTRUCTOR **JOSH EGE** 🇺🇸

Student: Nathan Essary | **School:** Texas A&M University Commerce

INSTRUCTOR **CAROLYN KILDAY** 🇺🇸

Student: Rachel Arthur | **School:** Texas State University

INSTRUCTOR **GENARO SOLIS RIVERO** 🇺🇸

Student: Kaitlin McCall | **School:** Texas State University

INSTRUCTOR **CAROLYN KILDAY** 🇺🇸

Student: Roy Ramirez | **School:** Texas State University

INSTRUCTOR **SCOTT BUSCHKUHL**

Student: Jiin Choi | **School:** School of Visual Arts

INSTRUCTOR **UNATTRIBUTED**

Student: Audrey Stevens | **School:** Syracuse University

INSTRUCTOR **BILL GALYEAN**

Student: Caroline Fischer | **School:** Texas Christian University

INSTRUCTOR **UNATTRIBUTED**

Student: Elese Gaydos | **School:** Syracuse University

INSTRUCTOR **DONG-JOO PARK**

Std.: Kim Ji Eun | **Sch.:** Hansung University, Design and Art Institute

INSTRUCTOR **KAREN KRESGE**

Student: Jen Pepper | **School:** Kutztown University of Pennsylvania

INSTRUCTOR **TOM WEDELL**

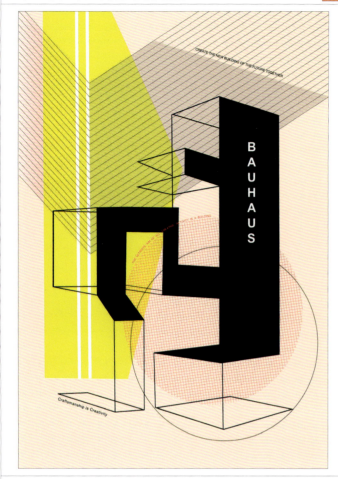

Student: Xinmeng Yu | School: Maryland Institute College of Art

INSTRUCTOR **DOUGLAS RICCARDI**

Student: Jihyun Lee | School: School of Visual Arts

INSTRUCTOR **GLENDA DREW**

Student: Alireza Vaziri Rahimi | School: University of California, Davis

INSTRUCTOR **SCOTT BUSCHKUHL**

Student: Jiin Choi | School: School of Visual Arts

INSTRUCTOR **SAM EKERSLEY** 🇺🇸

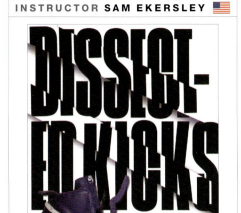

Student: Zach Stremmel
School: Savannah College of Art and Design

INSTRUCTOR **RENEÉ SEWARD** 🇺🇸

Student: Marisa Thoman
School: University of Cincinnati, DAAP

INSTRUCTOR **JUSTIN COLT** 🇺🇸

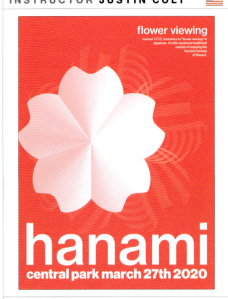

Student: Junghoon Oh
School: School of Visual Arts

INSTRUCTOR **KAREN WATKINS** 🇺🇸

Student: Sophia DiDonato
School: West Chester University

INSTRUCTOR **UNATTRIBUTED** 🇧🇦

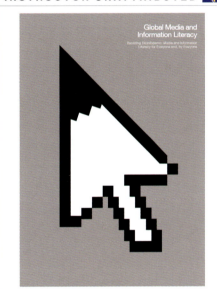

Student: Stefan Mijić
School: Unattributed

INSTRUCTORS **D. PARK, S. HAN** 🇰🇷

Student: Yeji Kim
School: Hansung University, Design & Art Institute

INSTRUCTOR **RENEÉ SEWARD** 🇺🇸

Student: Eddie Loughran
School: University of Cincinnati, DAAP

INSTRUCTOR **DAVID ELIZALDE** 🇺🇸

Student: Kaylen Couch
School: Texas Christian University

INSTRUCTOR **JOSH EGE** 🇺🇸

Student: Prajoo Shrestha
School: Texas A&M University Commerce

INSTRUCTOR KAREN WATKINS 🇺🇸

Student: Jhade Gales
School: West Chester University

INST. CONSTANTINE CHOPIN 🇺🇸

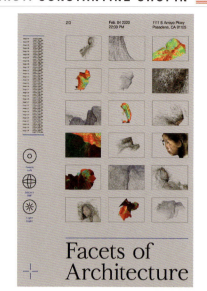

Student: Eun Jung Bahng
School: ArtCenter College of Design

INST. P. AHMADI, M. FERRILL 🇺🇸

Students: Nour Zaki, Ola Alsarraj (+17 students)
School: Univ. of Illinois at Chicago

INST. REBEKAH ALBRECHT 🇺🇸

Student: Nya Walker
School: Woodbury University

INSTRUCTOR KEN KOESTER 🇺🇸

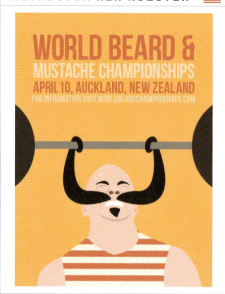

Student: Tyler Devitt
School: Texas A&M University Commerce

INSTRUCTOR RENEÉ SEWARD 🇺🇸

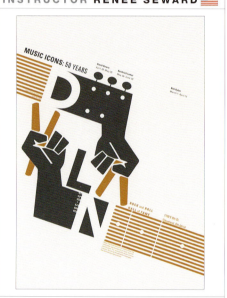

Student: Riley Best
School: University of Cincinnati, DAAP

INSTRUCTORS DONG-JOO PARK, SEUNG-MIN HAN 🇰🇷

Student: Yujeong Son | **School:** Hansung University, Design & Art Institute

INSTRUCTOR RENEÉ SEWARD 🇺🇸

Student: Stephanie Krekeler | **School:** University of Cincinnati, DAAP

INSTRUCTOR LEWIS GLASER

Cool Hand Luke
Coyote Drive-In
November 15th & 16th
www.thepaulnewmanfestival.com

Student: Tryn Woessner | School: Texas Christian University

INSTRUCTOR DOUG THOMAS

Are color-emotion associations personal?

Initial Color Chart and Frequency of Selection
This chart contains the 197 Pantone colors presented to individuals. Each number notes how many times a color was selected.

Student: Morgan Shreenan | School: Brigham Young University

INSTRUCTOR LEE HACKETT

National Train Show
★ ★ Dome America Center ★ ★
St. Louis, MO
July
17-19
2021

Student: Nathan Essary | School: Texas A&M University Commerce

INSTRUCTOR KEVIN O'CALLAGHAN

Student: Tae Gyung Kang | **School:** School of Visual Arts

INSTRUCTOR UNATTRIBUTED

Std.: Sarah Noll | **Sch.:** Syracuse Univ., College of Visual & Performing Arts

INSTRUCTOR LEE SANG JIN

Student: Kim Seong Je | **School:** Seoul National University of Science and Technology

INSTRUCTOR DOMINIQUE WALKER

Student: Sharleen Ramos | School: Capilano University

INSTRUCTOR VERONICA VAUGHAN

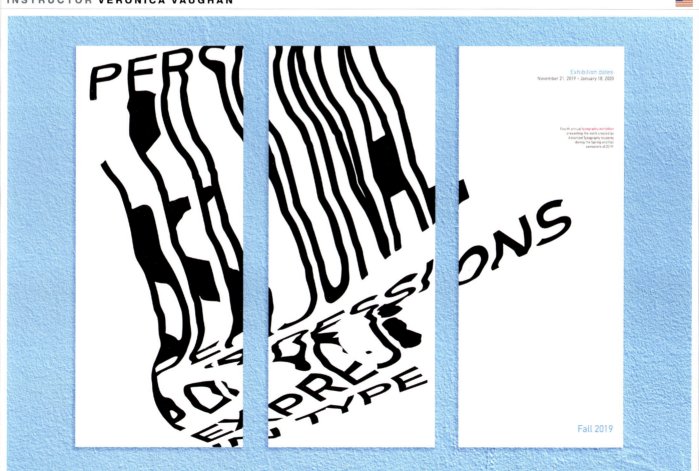

Student: Paula Hoke | School: University of Texas at Arlington

Student: Xinjian Li | School: Temple University, Tyler School of Art & Architecture

INSTRUCTOR **DAEKI SHIM**

Student: Jinhyung Seo | School: Hongik University

INSTRUCTORS SEAN BACON, BRADFORD PRAIRIE

Student: Parker Anne Poole | **School:** San Diego City College

INSTRUCTORS DAVID ELIZALDE, DUSTY CROCKER

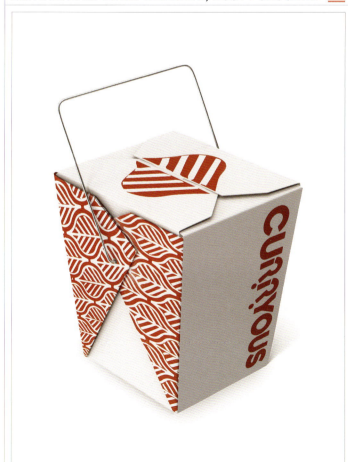

Student: Clair Levisay | **School:** Texas Christian University

INSTRUCTOR THERON MOORE

Student: Andre Gomez | **School:** California State University, Fullerton

INSTRUCTOR CLAUDIA STRONG

Student: Shannon Kirkpatrick
School: Syracuse University, The Newhouse School

INSTRUCTOR JEAN-BENOIT LEVY

Students: 25 students from course DSGD63
(Fundamental Graphic Visualization) | School: San Jose State University

INSTRUCTOR CLAUDIA STRONG

Student: Huiru Yu | School: Syracuse University, The Newhouse School

INSTRUCTOR PETER WONG

Student: Kexin Chen | School: Savannah College of Art and Design

INSTRUCTOR **JOHN KRSTESKI**

Student: Taylor Chen | School: ArtCenter College of Design

INSTRUCTOR **CLAUDIA STRONG**

ABCDEFGHIJKLM
NOPQRSTUVWXYZ
abcdefghijklm
nopqrstuvwxyz
1234567890
:;,.?!/\\()*&'"-–—%$@

Student: Meghan Gulley | School: Syracuse University, The Newhouse School

INSTRUCTOR CLAUDIA STRONG 🇺🇸

ABCDEFGHI
JKLMNOPQ
RSTUVWXYZ

abcdefghijklm
nopqrstuvwxyz

Std.: Natalia Deng Yuan | **Sch.:** Syracuse University, The Newhouse School

INSTRUCTOR CLAUDIA STRONG 🇺🇸

ABCDEFGHIJKLM
NOPQRSTUVWXYZ
abcdefghijklm
nopqrstuvwxyz
1234567890
: ; . , ! ? () { } / \ ` ' "
° * % & $ # @ - - — + =

Std.: Elizabeth Wolf | **Sch.:** Syracuse University, The Newhouse School

INSTRUCTOR JUSTIN COLT 🇺🇸

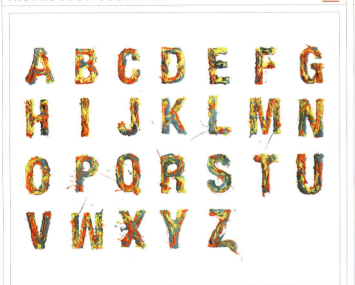

Student: Junghoon Oh
School: School of Visual Arts

INSTRUCTOR DAEKI SHIM 🇰🇷

ABCDEFGHIJKLM
NOPQRSTUVWXYZ

abƀcdddēfghħñijkKlm
noppqgrstuvwxyz

0123456789

!?@#$/.^&*()_+

Student: Jeonghyo Park
School: Seoul National University of Science and Technology

INSTRUCTOR SHARON OIGA 🇺🇸

Student: Jonathan Pacheco | **School:** University of Illinois at Chicago

INSTRUCTOR TRAVIS SIMON 🇺🇸

Student: Barbara Cadorna | **School:** School of Visual Arts

INSTRUCTOR ERIC GILLET

Student: Morgan Shreenan | School: Brigham Young University

INSTRUCTOR SIMON JOHNSTON

Student: Eun Jung Bahng | School: ArtCenter College of Design

INSTRUCTOR LINDSEI BARROS

Student: Yashashree Samant
School: M.AD School of Ideas Mumbai

INSTRUCTOR UNATTRIBUTED

Student: Karin Rošker
School: University of Ljubljana, Academy of Fine Arts and Design

P263: Credit & Commentary | **Students: Quinta Yu, Tiffany Shen, Kayley Wang** | **School: ArtCenter College of Design**

Assignment: The film *Hidden Figures* highlights the accomplishments of three black women who were given little opportunity in a male-dominated and unequal society. We wanted to honor these women by creating a title sequence that was visually classic and inspiring.

Approach: We studied the film's elements and used analog methods to figure out how to convey our message and determine the story's flow. We wanted the shift of scenery from space to an office to accentuate the women's accomplishments.

Results: Our project was submitted to the Fall 2019 ArtCenter Hillside Student Gallery and selected for submission in the Promax Awards.

Animation | Design Film/Video

P263: Credit & Commentary **Student:** Michelangelo Barbic | **School:** California State Polytechnic University, Pomona

Assignment: This project entailed portraying the twelve principles of animation outlined by Disney animators Ollie Johnston and Frank Thomas. Requirements were to display each principle with text and an accompanying animation.

Approach: I made a narrative-driven short with a robot. I sketched thumbnails and a storyboard, then made models in Blender 3D. Afterwards, I exported the renders and piped the playblasts into Adobe After Effects. The sound was added with Adobe Premiere Pro.

Results: I received high praise for going above and beyond the project requirements. For my first attempt at 3D animation, this was fun to do.

AND TO THE

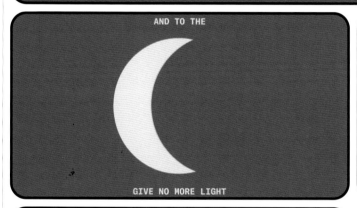

GIVE NO MORE LIGHT

ANS DRY RU
ANS DRY RU
ANS DRY RU
ANS DRY RU

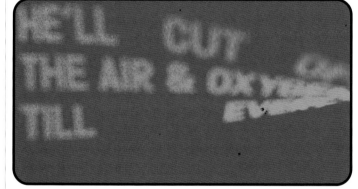

FOR	IF
SURE	FAIRNESS
HE	WAS
WILL BE	HIS
JUSTIFIED	GAIN

HE CARRIES

AND ME

PROVIDING

BUT WHAT A MESS
ALL BE
WE'LL IN TIME

P263: Credit & Commentary **Student:** Hunter Young | **School:** Brigham Young University

Assignment: Create an animated video based off a recorded poem given by a homeless man living in the cold winter New York City streets.
Approach: The strict use of typography and the greyscale color theme were chosen as to not distract from the message of the poem and to represent the contrast between the enlightening words and the harsh street environment that this man lives in.
Results: The video shines a light on this man's experiences and gives an opportunity for everyone to listen and reflect.

Motion Graphics | Design Film/Video

INSTRUCTOR **CALEB HORN**

P264: Credit & Commentary Student: **Chantal Lesley** | School: **Texas State University**

INSTRUCTOR **ORI KLEINER**

P264: Credit & Commentary Student: **Wenxin Yuan** | School: **School of Visual Arts**

INSTRUCTOR **JUSTEN M. RENYER**

P264: Credit & Commentary Student: **Do Kim** | School: **Oklahoma State University**

INSTRUCTOR **ORI KLEINER**

P264: Credit & Commentary Student: **Bruno Pasi Bergallo** | School: **School of Visual Arts**

INSTRUCTOR **NICOLE KILLIAN**

P264: Credit & Commentary **Student:** Feixue Mei | **School:** Virginia Commonwealth University

INSTRUCTORS **FLORIAN WEITZEL, SABINE GEORG**

P264: Credit & Commentary **Students:** Quynh Tran, Seine Kongruangkit | **School:** M.AD School of Ideas Berlin

INSTRUCTOR **RYAN RUSSELL**

P264: Credit & Commentary **Student:** Taylor Mazzarella | **School:** Pennsylvania State University

INSTRUCTOR **BRENT BARSON**

P264: Credit & Commentary **Student:** Wil Osborne | **School:** Brigham Young University

Animation, Film Title | Design Film/Video

INSTRUCTOR JEREMY HOLMES

 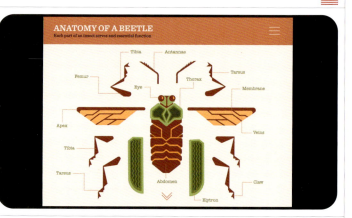

P264: Credit & Commentary **Student:** Chuck Scott | **School:** West Chester University

INSTRUCTOR JEREMY HOLMES

P264: Credit & Commentary **Student:** Kevin Mesquite | **School:** West Chester University

INSTRUCTOR UNATTRIBUTED

P264: Credit & Commentary **Student:** Jean Quarcoopome | **School:** Ashesi University/M.AD School of Ideas Miami/Seneca College

INSTRUCTOR DAEKI SHIM

 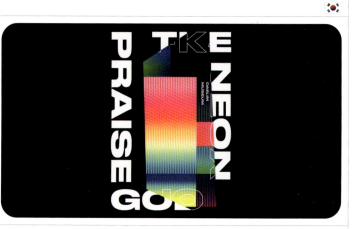

P264: Credit & Commentary **Students:** Yujin Cho, Junhaeng Lee | **School:** Sejong University

Design Film/Video | Interactive, Motion Graphics

INSTRUCTOR **ORI KLEINER**

Student: Junyu Chen | **School:** School of Visual Arts

INSTRUCTOR **CHRISTINA MALONEY**

Student: Evan Eggers | **School:** Savannah College of Art and Design

INSTRUCTOR **KAREN WATKINS**

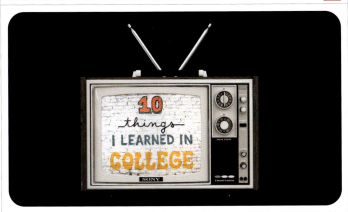

Student: Tori Evert | **School:** West Chester University

INSTRUCTOR **MANOLO GARCIA**

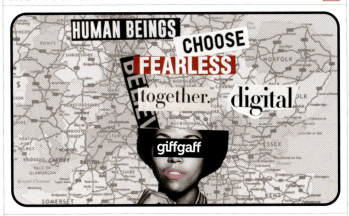

Std.: P. E. Mohdar, R. Grace, P. Sacilotto, H. E. Akad | **Sch.:** M.AD School of Ideas

INSTRUCTOR **YVONNE CAO**

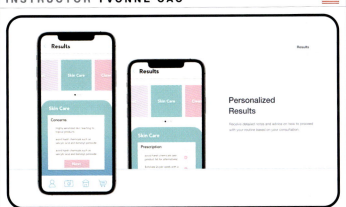

Student: Cassie Schmidt | **School:** Texas Christian University

INSTRUCTOR **ORI KLEINER**

Student: So Youn Chun | **School:** School of Visual Arts

INSTRUCTOR **YVONNE CAO**

Student: Derek Bowers | **School:** Texas Christian University

INSTRUCTOR **DAEKI SHIM**

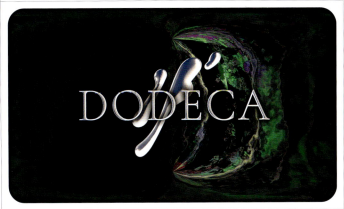

Student: Huiyun Jung | **School:** Hongik University

INSTRUCTOR **ORI KLEINER**

Student: So Youn Chun | School: School of Visual Arts

INSTRUCTOR **DUSTY CROCKER**

Student: Brooke Honcharik | School: Texas Christian University

INSTRUCTOR **DAVID WOLSKE**

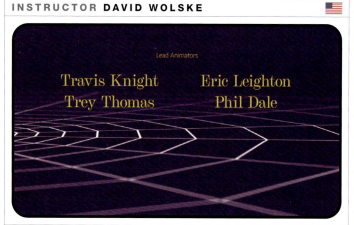

Student: Julia Pamer | School: University of North Texas

INSTRUCTOR **DAVID WOLSKE**

Student: Javier Ruiz Navarro | School: University of North Texas

INSTRUCTOR **ORI KLEINER**

Student: Bruno Pasi Bergallo | School: School of Visual Arts

INSTRUCTOR **CALEB HORN**

Student: Laura Ortiz | School: Texas State University

INSTRUCTOR **DAVID WOLSKE**

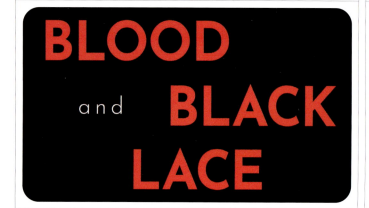

Student: Cecilia Ontiveros | School: University of North Texas

INSTRUCTOR **RYAN RUSSELL**

Student: Amber Lai | School: Pennsylvania State University

INSTRUCTOR DAVID WOLSKE 🇺🇸

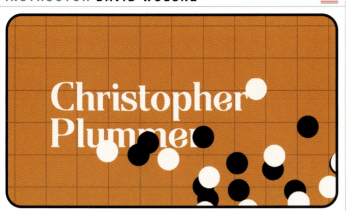

Student: Andrew Ashton | **School:** University of North Texas

INSTRUCTOR ABBY GUIDO 🇺🇸

Std.: Reyna Hixton | **Sch.:** Temple Univ., Tyler School of Art & Architecture

INSTRUCTOR ELAINE ALDERETTE 🇺🇸

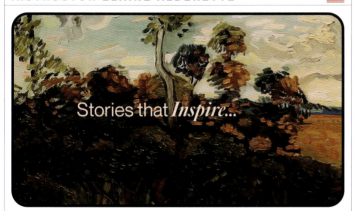

Student: Jingping Xiao | **School:** ArtCenter College of Design

INSTRUCTOR YVONNE CAO 🇺🇸

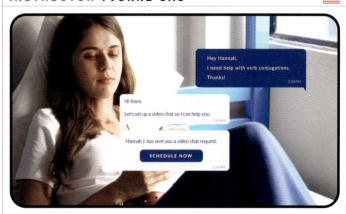

Student: Kenzie Ashley | **School:** Texas Christian University

INSTRUCTOR ABBY GUIDO 🇺🇸

Std.: Alex Kim | **Sch.:** Temple Univ., Tyler School of Art & Architecture

INSTRUCTORS OLGA MEZHIBOVSKAYA, NADA RAY 🇺🇸

Student: Zona Guan | **School:** School of Visual Arts

INSTRUCTOR PETER AHLBERG 🇺🇸

Student: So Youn Chun | **School:** School of Visual Arts

INSTRUCTORS OLGA MEZHIBOVSKAYA, NADA RAY 🇺🇸

Student: Zona Guan | **School:** School of Visual Arts

Photography | Editorial

Portraits | Photography

INSTRUCTOR DUSTY CROCKER

P265: Credit & Commentary **Student:** Kaylen Couch | **School:** Texas Christian University

INSTRUCTOR DUSTY CROCKER

P265: Credit & Commentary **Student:** Madison Jones | **School:** Texas Christian University

Photography | Portraits

Still Life | Photography

INSTRUCTOR DAVID ELIZALDE

Student: Madi Grace Thornton | **School:** Texas Christian University

INSTRUCTOR JASON REED

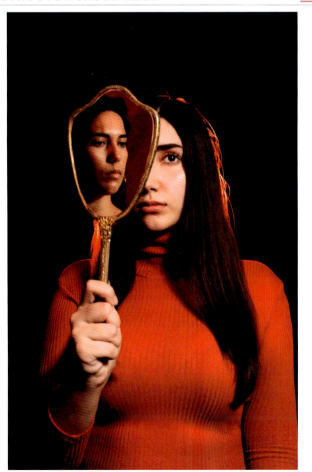

Student: Chantal Lesley | **School:** Texas State University

INSTRUCTOR DUSTY CROCKER

Student: Madi Grace Thornton | **School:** Texas Christian University

INSTRUCTOR **DUSTY CROCKER**

Student: Trevor Scott | **School:** Texas Christian University

INSTRUCTOR **DUSTY CROCKER**

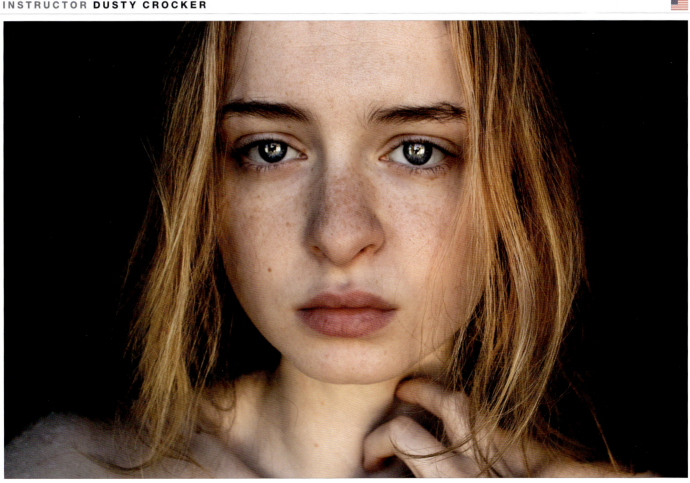

Student: Tryn Woessner | **School:** Texas Christian University

INSTRUCTOR DUSTY CROCKER

Student: **Gretchen Rea** | School: **Texas Christian University**

INSTRUCTOR DUSTY CROCKER

Student: **Julia Reedy** | School: **Texas Christian University**

INSTRUCTOR MIKE DAVIS

Std.: **Gabrielle Cavallaro** | Sch.: **Syracuse University, The Newhouse School**

INSTRUCTOR CRAIG BROMLEY

Std.: **Sheneatra McCoy** | Sch.: **M.AD School of Ideas at Portfolio Center**

INSTRUCTOR MARC MONTPLAISIR

Student: Adam Nigro | **School:** Dawson College

INSTRUCTOR DUSTY CROCKER

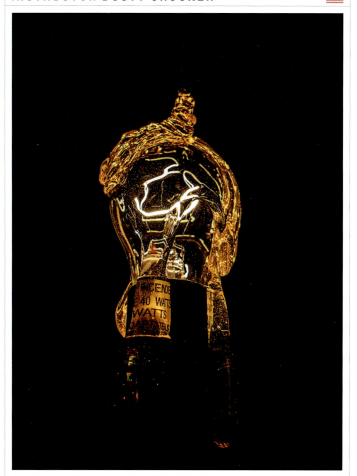

Student: Kaitlyn Kurtz | **School:** Texas Christian University

INSTRUCTOR DUSTY CROCKER

Student: Sawyer Tucker | **School:** Texas Christian University

Credits&Commentary

2011 PLATINUM ADVERTISING WINNERS:

7 POST IT | School: School of Visual Arts
Instructor/Professor: John Mariucci | Student: Hez Kim

8 VISINE - NO RED EYES CAMPAIGN | School: School of Visual Arts
Instructor/Professor: Vinny Tulley | Student: Michael MacKay

8 NATIONAL GEOGRAPHIC | School: School of Visual Arts
Instructors/Professors: Robert MacKall, John Mariucci | Student: Eun Haee Cho

9 IDEA | School: School of Visual Arts
Instructor/Professor: Frank Anselmo | Student: Young Wook Kim

10 MUSEUM IDENTITY | School: School of Visual Arts
Instructor/Professor: Carin Goldberg | Student: Yoon Bin Lee

11 CURTAIN CALL | School: EFET (Ecole Française d'Enseignement Technique)
Instructor/Professor: Yves Michel Chatrain | Student: Michael Mohr

12 CURTAIN CALL | School: EFET (Ecole Française d'Enseignement Technique)
Instructor/Professor: Yves Michel Chatrain | Student: Michael Mohr

PLATINUM ADVERTISING WINNERS:

19, 20 TAME THE ANIMAL | School: Syracuse University, The Newhouse School
Instructor/Professor: Mel White | Student: Sam Luo
Assignment: Create a print campaign for Best Damn Beard Oil that shows its benefit of softening even with the wildest beards.
Approach: I compared men's beards to animals, showing how wild beards can grow.

21 GLOSSIER SOCIAL MEDIA CAMPAIGN | School: Pennsylvania State University
Instructor/Professor: Taylor Shipton | Student: Cassie Luzenski
Assignment: The goal was to create a social media campaign that used a play on words to promote a brand or product. I chose to promote the brand, Glossier.
Approach: I researched Glossier's brand mission and what they stood for which revolved around the idea of self love and natural beauty. I wanted to compare the similarities between glossier's mission to bdsm in order show how both can make one can feel comfortable and confident in their own skin.
Results: The final product is a series of five photographs that work cohesively to portray the concept of loving yourself.

22, 23 ADVERTISING_CREST 3D WHITE STRIPS | School: School of Visual Arts
Instructors/Professors: Jay Marsen, Alexi Beltrone | Student: Junghoon Oh
Assignment: Crest 3D White Strips advertising
Approach: This product makes teeth brighter and brighter.

24 KEEP FRESH | School: Syracuse University, The Newhouse School
Instructor/Professor: Kevin O'Neill | Student: Xinran Xiao

25 MCDELIVERY | School: Syracuse University, The Newhouse School
Instructor/Professor: Kevin O'Neill | Student: Sam Luo
Assignment: Create a print campaign for McDelivery to showcase McDonald's capability to reach you quickly wherever you are.
Approach: I used the classic golden arches to bridge the restaurant and your home.
Results: Golden arches can reach your home whenever ever you are, wherever you are.

GOLD ADVERTISING WINNERS

27 THE NEW E-GOLF | School: Syracuse University, The Newhouse School
Instructor/Professor: Mel White | Student: Sam Luo
Assignment: Create a print campaign for volkswagen e-golf, which is all electric.
Approach: Through visual metaphors, showing the target audience that the new e-golf is all electric, energy efficient, and powerful.
Results: I visually compared the car key to a plug, a LED light bulb, and a battery.

28 MUST'VE BEEN A WRANGLER | School: Syracuse University, The Newhouse School
Instructor/Professor: Kevin O'Neill | Student: Benjamin Lin
Assignment: Create a print campaign for the Jeep Wrangler.
Approach: I did research and found out that Jeep Wrangler's pride themselves in being all terrain. So I came up with a visual print campaign that showcases Jeep tire-prints in strange and out-of-the-ordinary locations. The tag says "must've been a Wrangler" implying that the only car capable of driving in such terrain is a Jeep Wrangler.
Results: My professor loved this campaign!

29 TOYOTA 4RUNNER | School: Texas Christian University
Instructor/Professor: Bill Galyean | Student: Trevor Scott
Assignment: To design an advertisement for our "lovemark," or brand that we, as consumers, would struggle to live without. I own a Toyota 4Runner and use it frequently, so I was excited to design something that was targeted to my interests. The goal with the design and concept was to highlight the off-road capabilities of the Toyota 4Runner.
Approach: Blending serious and fun aspects together was the main point. Using bold, sans-serif typography for the headline complemented the vehicle being advertised. However, the message softens the tone. To avoid typical off-road vehicle advertising clichés, I turned the vehicle into a "grown-up toy": even though you have to grow up, it doesn't mean you can't have fun. Targeted towards a younger audience, I wanted this ad to make the 4Runner appeal to adventurous people who are taking the step to purchase a vehicle.
Results: This was well received by professors and peers.

30 GO WILD | School: Syracuse University, The Newhouse School
Instructor/Professor: Kevin O'Neill | Student: Sam Luo
Assignment: Create a campaign that shows the landscape adaptability of jeep cars.
Approach: I used animal prints to show the wild landscape.
Results: By using wild animals prints, I made a visual metaphor to exaggerate the benefit of how adaptable jeep can be, no matter what road you're on.

31 NOTICEABLE BENEFITS | School: Syracuse University, The Newhouse School
Instructors/Professors: Kevin O'Neill, Mel White | Student: Derek Rosen
Assignment: I was tasked to create a campaign for Michelin snow tires.
Approach: People are reluctant to buy Michelin snow tires because they are more expensive, so I showed that by investing a little more cash, Michelin customers gain a lot more noticeable benefits.
Results: I created three print ads to demonstrate the benefits of Michelin snow tires.

32 GO IN DEEP | School: Syracuse University, The Newhouse School
Instructor/Professor: Mel White | Student: Sam Luo

Assignment: Create a print campaign for Oral-b Glide floss that shows its benefit of getting all the way down to the deepest spaces in between teeth.
Approach: Through visual metaphor, showing our target audience how Oral-b Glide floss can slide into teeth gaps easily.

33 EXHALE! | School: Syracuse University, The Newhouse School
Instructor/Professor: Mel White | Student: Sam Luo
Assignment: Create a print campaign for Listerine pockpack Strips that shows its benefit of removing bad breath anywhere.
Approach: This visual metaphor shows that bad breath can happen anywhere..

34 MGD RETIRE RACISM | School: School of Visual Arts
Instructor/Professor: Frank Anselmo | Students: Jasmine Espejo, Yoojin Jung
Assignment: While Miller Genuine Draft is a beer company that is seeking a new brand identity, researchers have found that people are more racist when they're drunk. The goal of this project is to have MGD speak up for what's right with a new beer can design.
Approach: Miller Genuine Draft will rebrand itself as a beer that stands against racism. To tackle this widespread issue, MGD beer cans will be redesigned for consumers to cheer in the name of eliminating racist slurs.
Results: The new MGD beer can design reminds the public to not say racial slurs.

34 SEE BIGGER | School: Syracuse University, The Newhouse School
Instructor/Professor: Mel White | Student: Sam Luo
Assignment: Create a print ad for Canon Macro Lens that shows its benefit of magnifying small objects with crisp details.
Approach: Visually exaggerating the benefit of magnifying.

35 SONY PORTABLE HANDYCAM | School: Syracuse University, The Newhouse School
Instructor/Professor: Mel White | Student: Catarina Baumgart de Melo
Assignment: Create a print ad for Sony Portable Handycam showing how the product keeps cherished memories safe.
Approach: The "now" won't last forever but the memories will.
Results: A visual solution of having the viewfinder in the Sony Portable Camcorder show the exact empty room the camera is pointing to but with one twist. In the viewfinder, the room had one extra component: A loved one A memory.

36 INESCAPABLE | School: Syracuse University, The Newhouse School
Instructor/Professor: Mel White | Student: Talia Adler
Assignment: Create a campaign for Tile that shows a product benefit in a unique way.
Approach: To do this, I visually explored how an item with the Tile device attached to it is never lost because the Tile device can be instantly located using the Tile app.
Results: I expressed the Tile device is inescapable by showing valuable items you would typically attach a Tile device to being held hostage by rope, handcuffs, and duct tape.

37 MOPHIE POWERSTATION CAMPAIGN | School: Syracuse University, The Newhouse School | Instructor/Professor: Mel White | Student: Jennifer Suhr
Assignment: Create a print campaign for an electronic device. I chose the Mophie Powerstation, a portable phone charger. The campaign's goal was to emphasize how much people rely on their phones, especially while they are on the go.
Approach: I began the creative process by concepting situations when people rely on their phones the most. I concluded that every time someone's phone dies, it feels like the most inconvenient time. I demonstrated this by displaying a professional snowboarder, ice climber, and kayaker, each performing a trained skill. There is a phone in the bottom corner of each print that is attempting to take a memorable picture, but it is dead, so the moment cannot be captured.
Results: The final project encompasses the idea that phones always seem to die at the worst times, but the Mophie Powerstation ensures you have a charged phone for the moments you want to capture.

38 DOVE CHOCOLATE AD | School: Texas Christian University
Instructor/Professor: David Elizalde | Student: Courtney Shaw
Assignment: Create an 8.5 x 11 single page ad for your favorite food. Include a header, image, product shot, subhead, logo, body copy, and legal copy.
Approach: Upon my decision to create an ad for Dove, I brainstormed its associations. Women, the target market, are often gifted roses and chocolate on special occasions (or just because). But what is better when they have to choose just one? That's obvious-she'd rather have chocolate.
Results: My approach was successful in its ability to use humorous copy to heighten memorability. The dimly-lit environment created the attractive feeling associated with romance and chocolate. Successfully using Photoshop tools to enhance the headline set the scene for the bite-sized chocolate in a playful yet sultry composition.

39 SO GOOD PEOPLE WON'T BELIEVE HUMANS MADE IT | School: Faculdade Cásper Líbero Brazil | Instructor/Professor: Claudio Luiz Cecim Abraão Filho
Student: João Victor Santos Eustachio
Assignment: Make Toblerone stand out as the ultimate premium chocolate.
Approach: To show that Toblerone is the best chocolate ever, frame it as out of this world.
Results: By associating the product's shape with the theory that aliens built the pyramids, Toblerone's quality is dramatized in a memorable way.

39 COLEMAN CONSTELLATION CAMPAIGN | School: Texas Christian University
Instructor/Professor: Bill Galyean | Students: Trevor Scott, Madi Grace Thornton
Assignment: This was a group project where students were tasked with creating an advertising campaign and a market analysis for a particular company. Madi Grace Thornton and I (Trevor Scott) designed full-spread advertisements for Coleman, a company that specializes in camping gear and outdoor-tailored products. The goal was to create a simple yet striking visual that is easy to understand while promoting Coleman products.
Approach: Since tents are Coleman's flagship products, we felt it best to highlight these products in an advertising campaign. The big idea we had is where Coleman can take you, as well as where you can take Coleman. First, we developed a few design concepts that were feasible, along with thumbnail sketches to push the ideas forward. After narrowing down our ideas, we began drafting rough compositions of the possible ads. Madi Grace and I then brought our big idea to life digitally, where we developed a brilliant ad campaign. The ads show a single tent in wide open nature, glowing from a source of lantern light. Above the tent is a constellation that reflects the adventure that is to come. There is a sense of connectivity between the tent and the constellation, suggesting the constellation is the dreamy anticipation of a fishing trip or kayak exploration. Finally, "Tomorrow is a Dream Away" seals the trifecta, influencing the relation of the stars and

the tent. We felt this was an interesting way to display a dream in the night sky.
Results: The overall concept was seen as effective and intuitive.

40 ALL GREAT WORK START WITH A SKETCH. | School: Syracuse University, The Newhouse School | Instructor/Professor: Mel White | Student: Brian Chau
Approach: People want to find the perfect pen that lets them write beautifully and a good pen creates beautiful writing. Muji pens is that pen.
Results: To show that Muji Pens write beautifully, I used Muji Pens to draw out three beautiful pieces of famous artwork.

41 PLAY-DOH ADVERTISEMENTS | School: Texas Christian University
Instructor/Professor: David Elizalde | Student: Sarah Cuttic
Assignment: Create an advertisement series for a randomly assigned brand.
Approach: To start this project, researching Play-Doh was the first step in order to understand the brand and how to represent the ideas of the brand in the ads. This series of advertisements were created to show the imagination behind Play-Doh. With Play-Doh you can create whatever you think of. Children have wonderful imaginations that make novice Play-Doh creations into whatever they think of. These ads use images of not-so-prefect Play-Doh creations to emphasize the freedom with the product paired with a child's imagination. The three ads work together to show the variety of things that can be created.
Results: This advertisement series succeeds at representing the imagination and creativity of Play-Doh by showing three different ideas of what can be created with Play-Doh.

42 YETI: GEAR FOR YOU | School: Texas Christian University
Instructor/Professor: Bill Galyean | Student: Madison Jones
Assignment: The project assigned was to create an advertising campaign for a brand that we respect and own ourselves. I spend a lot of my time outside and immediately my mind went to products that I utilize when I am outdoors. Yeti is one of those brands. Yeti is highly recognized for being high-quality, durable and "cool". My goal was continue this view in a way that hadn't been done before. To me, Yeti is the Apple of cooler products. Once you have an iPhone, you tend to buy Air Pods, an iPad and an Apple Watch. You get used to the quality and the way they work together seamlessly. This is how I picture Yeti. Much of their current branding focuses on highlighting one particular product rather than their brand as a whole. This spurred my brain on thinking about who Yeti's ideal target market was. I landed on the outliers.
Approach: I read through countless entries by their ambassadors and watched many videos of the people Yeti represents. They all lived lives marked by grit and adventure. The outlaws. The people that don't make sense on paper. The people who do bucket list items for a living. I thought about if Yeti was to tell all of their representatives something, what would they say? They would probably cheers them with an ice cold beer and say, "This ones for you." I decided to create a copy-focused ad that gave a nod to the people that formed the heart and soul of Yeti. The background of the campaign aligns with the word that is highlighted in each ad. The titles chosen were inspired by the videos and written words of those who use Yeti in their everyday life.
Results: Many claimed that Yeti was a necessity. I thought about how climbers or fishermen often talk about the items they use every day as "gear." Yeti isn't just a product that helps you live life, it is gear that is needed to accomplish your days. I believe this ad successfully portrays the uncomfortable, outlier lifestyle of Yeti's target market.

43 AVOID THE MESS | School: Syracuse University, The Newhouse School
Instructor/Professor: Kevin O'Neill | Student: Rachel Hayashi
Assignment: Create a visual solution campaign for Bounty Paper Towels.
Approach: People hate messes and spills.
Results: Bounty paper towels quickly picks up spills. So even if something is spilled, you avoid the mess.

44 DECIBULLZ EARPLUGS | School: Syracuse University, The Newhouse School
Instructor/Professor: Mel White | Student: Allison Scherger
Assignment: Create a print campaign for Decibullz Earplugs that demonstrates the product benefit in an interesting way.
Approach: There are no earplugs that can eliminate sounds entirely, but Decibullz Earplugs can reduce more noise than most. I took the honest route and showed how Decibullz Earplugs can make some of the loudest activities more bearable.
Results: I manipulated different objects that produce loud noises by making them tiny to show that sounds are greatly reduced when wearing Decibullz Earplugs.

44 BULLDOG SKINCARE FOR MEN | School: Syracuse University, The Newhouse School | Instructor/Professor: Kevin O'Neill | Student: Jeffrey Robie
Assignment: Create a print campaign for Bulldog Skincare that differentiated itself from other men's skincare brands.
Approach: Bulldog is proud of its cruelty-free manufacturing; animals deserve better.

45 ATOMIC CANDY | School: Texas A&M University Commerce
Instructor/Professor: Kiran Koshy | Student: Tony B. Roberson
Assignment: We were given a fun campaign to highlight and promote Atomic Candy.
Approach: I began to look at powerful leaders in the world who have done bad things. Then I came up with the idea that even the worst people in society still deserve candy because candy makes us all feel like a kid again.
Results: I was able to bring this idea to life with tears, rosy cheeks, and a sniffling nose to showcase how bad someone can feel with the exception of no candy being given to them.

46 VANS EXTREMELY EXTREME GRIP | School: School of Visual Arts
Instructor/Professor: Frank Anselmo | Students: Jasmine Espejo, Yoojin Jung
Assignment: The Vans Pro Classics look like classic Vans, but their stronger sole grips make them the perfect shoes for modern skateboarders. The goal of this project is to differentiate the Vans Pro Classics from classic Vans for skateboarders by advertising the uniqueness of their strong waffle sole grips.
Approach: A Vans print campaign showcases animals with naturally strong grips to promote the strong grip of Vans Pro Classics.
Results: Skateboarders resonate with the imagery of the print campaign, becoming more inclined to search for and purchase the Vans Pro Classics.

47 YOU ARE WHAT YOU TREAT | School: Texas A&M University Commerce
Instructor/Professor: Kiran Koshy | Student: Will Schlesinger
Assignment: To create a fun Halloween campaign for Atomic Candy, a quirky boutique candy shop in the historic town square in Denton, TX.
Approach: The focus was on highlighting the massive variety of different candies

that were for sale from all different generations. As well as how those candies reflect the individual that buys and treats them. The fact of the matter is that kids remember which houses give out great candy. They tell their friends, they judge for years, and reputations are made on October 31st. So the main idea that "You Are What You Treat" is not only catchy but stands true year after year.
Results: The result is a colorful and fun visual that not only shows the delicious variety of candy but is a call to action that oozes Halloween spirit.

48 NOMORE.ORG PRINT AD | School: Syracuse University, The Newhouse School
Instructor/Professor: Mel White | Student: Xinyue Chen
Assignment: Create a print campaign for Nomore.org that shows domestic verbal abuse can cause mental illness of survivors.
Approach: While exploring domestic violence and hearing their experience, I realized that abusers are hurting the survivor's self-esteems with their words and language. Though language cannot cause tangible injures, intangible damage are still detrimental.
Results: I visualize the abusing language to be the killing weapons – guns – to demonstrate the invisible damage caused by verbal abuse.

48 SPALDING | School: Syracuse University, The Newhouse School
Instructor/Professor: Mel White | Student: Jeffrey Robie
Assignment: Create a visual based print campaign for Spalding's NBA official game ball showcasing the grip of the ball.
Approach: Grip is necessary on and off the court, in any situation.
Results: I exaggerated the grip strength of the ball to provide a clear view of its quality.

SILVER ADVERTISING WINNERS

50 YOU ARE WHAT YOU DRIVE | School: Texas Christian University
Instructor/Professor: David Elizalde | Student: Caroline Broadus

50 HOLY KOMBUCHA | School: Texas Christian University
Instructor/Professor: David Elizalde | Student: Nicole Oesterreicher

51 RAISE YOUR BUD | School: M.AD School of Ideas Madrid
Instructors/Professors: Marina Beldi, Jessica Lomasson
Students: Andrea Serrano Villaverde, Chris Chiarulli

51 SAMSUNG 8K | School: Syracuse University, The Newhouse School
Instructor/Professor: Mel White | Student: Jeffrey Robie

51 CARRY NINTENDO SWITCH AROUND | School: Syracuse University, The Newhouse School | Instructor/Professor: Mel White | Student: Victoria Lin

52 ON THE BRINK OF EXTINCTION. | School: Syracuse University, The Newhouse School | Instructor/Professor: Mel White | Student: Selin Akyurek

52 LITE WITH ALL THE BENEFITS | School: Texas A&M University Commerce
Instructor/Professor: Josh Ege | Student: Paige Carrera

52 WHAT IF? School: Syracuse University, The Newhouse School
Instructor/Professor: Mel White | Student: Alye Chaisson

53 SIERRA CLUB PRINT ADS | School: Syracuse University, The Newhouse School
Instructor/Professor: Mel White | Student: Sierra Fentress

53 PERSPECTIVE | School: Syracuse University, The Newhouse School
Instructor/Professor: Kevin O'Neill | Student: Joe DeBlasio

54 THURSDAY BOOTS CO. CAMPAIGN | School: Syracuse University, The Newhouse School | Instructor/Professor: Mel White | Students: Jack Lyons, Addie Christopher

54 IT'S BETTER TO BE TALLER. | School: Syracuse University, The Newhouse School | Instructor/Professor: Kevin O'Neill | Student: Selin Akyurek

55 IT'S NOT WEIRD, IT'S BEYOND MEAT | School: Texas A&M University Commerce | Instructor/Professor: Kiran Koshy | Student: Daria Tucker

55 HARIBO | School: Syracuse University, The Newhouse School
Instructor/Professor: Mel White | Student: Lynn Seah

56 SNACK HEALTHIER | School: Syracuse University, The Newhouse School
Instructor/Professor: Mel White | Student: Rachel Hayashi

56 SNACK ATTACK | School: Texas Christian University
Instructor/Professor: David Elizalde | Student: Rebecca Lang

56 MENACING MARKETING | School: Texas A&M University Commerce | Instructor/Professor: Josh Ege | Students: Cosette De La Garza, Will Schlesinger, Daria Tucker

57 UGLY FRUIT | School: Syracuse University, The Newhouse School
Instructor/Professor: Mel White | Student: Grace Curran

57 WWF BARNUM'S ANIMAL CRACKERS | School: School of Visual Arts
Instructor/Professor: Frank Anselmo | Students: Yoojin Jung, Jasmine Espejo

58 BEAUTIFUL, UNTIL YOU SEE THE STRUGGLE | School: M.AD School of Ideas Mumbai | Instructor/Professor: Unattributed | Student: Mitesh Addhate

58 SOCIALLY DISTANCED | School: Texas A&M University Commerce
Instructor/Professor: Veronica Vaughan | Student: Lauren Eudaley

59 BEAUTIFUL FREEDOM | School: Hansung University, Design & Art Institute
Instructors/Professors: Dong-Joo Park, Seung-Min Han
Students: Hye Min Han, Se Ri Kwak

59 PRODUCT EXTENSION | School: Texas Christian University
Instructor/Professor: David Elizalde | Student: Kaylen Couch

59 SPOTIFY IN THE CAR. NO JUDGMENT, JUST MUSIC. | School: M.AD School of Ideas New York | Instructor/Professor: Mina Mikhael | Students: Yunxuan Wu, Daniel Kang

60 COLD WAR | School: Texas Christian University
Instructor/Professor: Bill Galyean | Student: Trevor Scott

60 WWF SHOEBOX CAGE | School: School of Visual Arts
Instructor/Professor: Frank Anselmo | Students: Yoojin Jung, Jasmine Espejo

61 EVOLUTION OF IDEAS WITH POST-IT NOTES | School: Syracuse University, The Newhouse School | Instructor/Professor: Mel White | Student: Yuri Suh

61 UPGRADE YOUR HOME | School: Syracuse University, The Newhouse School
Instructor/Professor: Kevin O'Neill | Student: Benjamin Lin

61 BRITA FILTER CAMPAIGN | School: Syracuse University, The Newhouse School
Instructor/Professor: Daniel Lombardi | Student: Emily Bright

62 LONG LASTING IMPACT | School: Syracuse University, The Newhouse School
Instructor/Professor: Mel White | Student: Derek Rosen

62 PACKED LITE CAMPAIGN | School: Texas A&M University Commerce
Instructor/Professor: Josh Ege | Student: Brandon Castelo

63 FLAMIN' HOT CHEETOS | School: Syracuse University, The Newhouse School
Instructor/Professor: Mel White | Student: Jessica Mastorides

63 DYSON VACCUM PRINT AD | School: Texas Christian University
Instructor/Professor: David Elizalde | Student: Kirsten McFarlan

63 UNIMAGINABLY FRESH | School: Syracuse University, The Newhouse School
Instructor/Professor: Mel White | Student: Sierra Outcalt

63 OFF DEEP WOODS PRINT AD | School: Syracuse University, The Newhouse School
Instructor/Professor: Mel White | Student: Allison Scherger

64 FLAKES DON'T BELONG IN YOUR WORLD | School: Syracuse University, The
Newhouse School | Instructor/Professor: Mel White | Student: Talia Adler

64 NATIONAL GEOGRAPHIC MAGAZINE | School: Syracuse University, The Newhouse
School | Instructor/Professor: Mel White | Student: Ashley Wachtfogel

65 FINIS DUO UNDERWATER HEADPHONES | School: Syracuse University, The
Newhouse School | Instructor/Professor: Mel White | Student: Ashley Wachtfogel

65 SMELLS SO NATURAL | School: Syracuse University, The Newhouse School
Instructor/Professor: Mel White | Student: Sierra Outcalt

66 MTA - THE REAL MELTING POT OF NYC | School: Syracuse University, The
Newhouse School | Instructor/Professor: Kevin O'Neill | Student: Brian Chau

66 VANS BORN TO GRIP | School: School of Visual Arts
Instructor/Professor: Frank Anselmo | Students: Yoojin Jung, Jasmine Espejo

67 PUMA AD | School: Texas Christian University
Instructor/Professor: David Elizalde | Student: Lindsay Browne

67 NIKE/LIFELINE 2020 | School: Columbia College Hollywood
Instructor/Professor: Evanthia Milara | Student: Tony Flores

67 BREAK FREE FOR THE NORTH FACE | School: Temple University
Instructor/Professor: Kathy Mueller | Student: Lilian Broyles

68 TURNER DUCKWORTH MEETS JEAN | School: Ashesi University
Instructor/Professor: Unattributed | Student: Jean Quarcoopome

68 VANS ORIGINS | School: Texas A&M University Commerce
Instructor/Professor: Kiran Koshy | Student: Will Schlesinger

69 24/7, 365. | School: Syracuse University, The Newhouse School
Instructor/Professor: Mel White | Student: Joe DeBlasio

69 THE NORTH FACE: CONCRETE JUNGLE | School: Syracuse University, The
Newhouse School | Instructors/Professors: Kevin O'Neill, Mel White | Student: Alex Mayeri

70 THE SPECIAL OLYMPICS ART EXHIBITION | School: Syracuse University, The
Newhouse School | Instructor/Professor: Mel White | Student: Jennifer Suhr

70 A STEP BEHIND | School: Syracuse University, The Newhouse School
Instructor/Professor: Mel White | Students: Sam Luo, Olivia Gormley

71 GOVERNOR MIFFLIN GIRLS' LACROSSE POSTER SERIES | School: Kutztown
University of Pennsylvania | Instructor/Professor: Karen Kresge | Student: Ilze Spilde

71 OOBLADEE EVENT POSTER | School: Texas A&M University Commerce
Instructor/Professor: Josh Ege | Student: Erick Estrada

71 HULU NO ADS | School: Syracuse University, The Newhouse School
Instructor/Professor: Mel White | Student: Allison Scherger

ADVERTISING FILM/VIDEO WINNERS:
73 THE INVISIBLE MUSEUM | School: M.AD School of Ideas Berlin
Instructor/Professor: David Stadttmüller | Students: Seine Kongruangkit, Riya Dosani
Assignment: Vision is the only way we emotionally connect with art. But for the blind
or partially sighted, this acts as a barrier. They rely on audio descriptions that are too
literal and flat, preventing them to create a unique experience.
Approach: We realised sound evokes emotions and instinctive reactions, regardless of
sight or not. ■ Berlinishe Galerie introduces The Invisible Museum. An exhibition of
famous paintings, except we showcased blank frames and only sound translations of
the original artwork. The headphone acted as a human eye, where the sound captured
an artist's mood, and emotions depicted in the painting. Moreover, we created a Spo-
tify playlist of more artists and their works, making art accessible to all.
Results: The Invisible Museum garnered attention from the press across Thailand and
increase the footsteps at the museum by 50%. We reimagined the way the blind could
experience art while allowing them to give their own interpretation.

74 WORD WAR 3 | Schools: Cairo Ad School Egypt, M.AD School of Ideas San Francisco
Instructors/Professors: Enas Rashwan, Yasser Ghoneim
Students: Yasmine Radwan, Moataz Mohamed, Hussam Moustapha, Hatem El Akad
Assignment: When fear is gone, and hope is alive. When we take off our uniforms and put
on our human suits, then we are united, Only then will violence be halved and peace be
fulfilled. But how, when we misuse the actions of violent words? When their implications
drive our behavior? Today, we show how. Join our army. Spread the word. Word War 3.

74 AIRTIME | School: M.AD School of Ideas Toronto and San Francisco | Instructor/
Professor: Manolo Garcia | Students: Roselyn Grace, Hatem El Akad, Lee I, Ted Pedro
Assignment: Martini "Air Time" is connecting friends and family across the globe
(regardless of visa or passport status). We're overcoming legal technicalities, by char-
tering private planes to pick up a lucky few, reunite them with their loved ones, and
then drop them off in their country of origin.

74 COMPULSIVE ASSISTANCE | School: M.AD School of Ideas New York | Instructor/
Professor: Unattributed | Students: Gabs Samame, Samruddhi Pawar, Daniel Kang
Assignment: "I'm so OCD!" ■ Have you ever used this phrase, or heard someone you
know say it? This common phrase is used today by many to describe everything from
being neat freaks to being obsessed with details to being quirky. ■ But the truth is that
obsessive-compulsive disorder is a real mental illness that intrudes on the lives of its
sufferers. If you don't obey its impulses, it feels like your world will literally end.

Every time we use the term lightly, we make it harder for actual sufferers to seek help.
Approach: To help raise awareness and break stigmas during International OCD Aware-
ness Week, we had the International OCD Foundation partner with Amazon to give
Alexa OCD traits with the hope that people will think twice about using that phrase.

74 THE NORTH FACE- CHANGE THE FACE OF IT | School: M.AD School of Ideas
Mumbai | Instructors/Professors: Siddhi Ranade, Deep Chhabria | Student: Vidhi Agarwal
Assignment: The North Face wants to encourage, inspire and enable the next genera-
tion of female explorers to support them through their journey of exploration.
Approach: We changed the names of some of the most sexist and derogatory routes,
practices and traditions in outdoor sports like rock climbing, skiing and female athlet-
ics to make the outdoors an equal and comfortable space for women.
Results: With astounding female participation in our outdoor events, The North Face
managed to Change The Face Of It.

75 THEY CAN - NIKE | School: University of the Arts London
Instructor/Professor: Jordan Hodgson | Student: Nicolò Pavin
Assignment: The objective is to make people focus on what disable people are able
to do, not on what they can't do. There is a common belief: disabled are people with
limits, they are considered lesser people. We wanted to change this thought.
Approach: The solution is an emotional video of Nike in which we show what disabled
people are able to do, they can do things that people with two harms or two legs can't
do. Can you play basketball in a wheelchair? Can you jump 2.19m high? They can.

75 THE ART WE WASTE | School: M.AD School of Ideas Madrid
Instructor/Professor: Amaia Ugarte | Students: Andrea Serrano Villaverde, Sergio Martin
Mendez, Stefanie Salguero Say
Assignment: Combat throwaway culture and cut food waste with a device, publication
or service from Hellmann's.
Approach: Rich people have a tendency to throw away more food before its expiration
date because they can afford it. We hacked another one of their spending habits to
show them the value of the food they're actually wasting. ■ We created a gallery with
paintings made by renowned artists and have a silent auction for people to buy them.
■ Once all the art pieces are sold, we'll reveal exactly how they were made by using
the food they just wasted as painting materials. Proving the value of the food they just
threw out. ■ The money fundraised at the auction will go to Feeding America.
Results: The reaction at the end painted a clear picture of the campaign's effectiveness.

75 GIFFVOICE | School: M.AD School of Ideas New York
Instructor/Professor: Rajath Ramamurthy | Students: Yunxuan Wu, Daniel Kang
Results: Childhood is most crucial time for a child to learn language—and auditory
feedback plays a key role. But what about families where the parents are mute? We
came up with giffvoice—a 5G home camera system that instantly scans and translates
gestures into speech in real-time using 5G's near-zero latency.

75 AFINITY | School: M.AD School of Ideas Europe | Instructors/Professors: Philip
Wogart, Shannon Christie | Students: Sukratti Jain, Paras Juneja, Justus Rozenkranz
Assignment: Virtual reality has not been used to its full potential as an empathy
machine. So far, it has mostly dominated a consumer market. We wanted to expand its
horizons in the B2B market. Hence, we came up with the idea of making a sensitiv-
ity training application for corporates, schools, hospitals, warehouses, etc. Sensitivity
training exists as a video in most workplaces. It never makes an impact because it lacks
connection. Afinity is a virtual reality application that is used as a sensitivity training
tool for workspaces and schools. We make sensitivity training an immersive experi-
ence for the employees and students by making them see things from the perspective of
a disabled person. Afinity makes them experience the challenges that disabled people
face in their day to day lives especially at work. Afinity aims to make people compas-
sionate and empathize with persons with disabilities.

76 TRAILS | School: M.AD School of Ideas Europe
Instructor/Professor: Sabine Georg | Students: Paras Juneja, Sukratti Jain
Assignment: Humans have been harming nature for a long time. We lack empathy and
do not understand the importance of flora and fauna in our ecosystem. It has led to
thousands of species to get endangered. Trails is a browser based platform launched in
partnership with the World Wildlife Fund. It helps to create a bond between humans
and wildlife through various videos of endangered animals in their natural habitat.
They can be viewed on any personal device or a virtual reality headset. Trails help us
realize that these animals are important and they need to be saved.

76 VOICE OF EXPLORATION | School: M.AD School of Ideas Mumbai
Instructor/Professor: Deep Chhabria | Student: Yashashree Samant
Assignment: Women form half of the global population and have an equal claim over
the world as their male counterparts. Yet when it comes to exploring, women have
never been encouraged to go outdoors. Even when women scaled mountains and
crossed oceans, their voices got lost amidst all the noise.
Approach: However, there's still one woman who couldn't be silenced, one voice who
guides all expeditions - Google Maps. The default voice on Google Maps is female.
The North Face collaborates with Google Maps, to make a voice that has reached mil-
lions to embolden the voices that couldn't. The current robotic voice is switched to the
voices of various female explorers like Isabelle Eberhardt, Sacagawea, Osa Johnson,
and others help navigate your way on a day today basis, provide exploration facts, and
alternative interesting routes.
Results: The North Face also opens up navigation to places that have been unconquered
to encourage women to scale newer heights. We promote this with various touch points
and geo-targeted ads. A navigation system now helps the world go in the right direction.

76 XOXO | School: M.AD School of Ideas Miami and San Francisco
Instructor/Professor: Manolo Garcia | Students: Julia Garicochea, Monica Andrade,
Valentina Orjuela, Hatem El Akad
Assignment: At a time where millennials are so overwhelmed with life and everything
it entails, Audible decided to use the language millennials speak to their advantage:
Gossip. We will be turning some of the world's favorite plots into gossip, and use OOH
speakers to bring it to them and capture their attention.

76 RUMBLE DETECTOR | School: Syracuse University, The Newhouse School
Instructors/Professors: Mel White, Kevin O'Neill | Students: Derek Rosen, Joyee Lin
Assignment: I was challenged to come up with an idea that uses digital coupons to

delight and surprise Burger King guests.

Approach: The hungrier people are, the more food they want. So I came up with the idea to customize coupons based on people's level of hunger.

Results: I created an in app promotion that measures the loudness of people's stomach rumbles. The louder they rumble, the better coupons they get.

77 WE WANT TO HELP YOU SAY IT | School: M.AD School of Ideas Miami
Instructor/Professor: Federico Giraldo | Students: Lucy Mullix, Teresa Silva

Assignment: Make an already existing product more inclusive for everyone.

Approach: We thought about how important communication is, specially in the world we live in right now. People are more connected than ever and every place in the world is just one flight away. Which made us think about the people that even when there has been so much advance in technology, find it a challenge to communicate with others in their day to day, those are the hearing impaired. This way, we came up with an idea to translate sign language for non-speakers through Google Translate. Making it easier for the hearing impaired to navigate the world.

Results: We received positive reviews since almost everyone, at least once in their lives, has encountered a hearing impaired individual and hasn't been able to interact with them. Everyone saw it as something they could use and would like to see in action.

77 NEWS_PAPER | School: M.AD School of Ideas New York
Instructor/Professor: Michael Lipton | Students: Yunxuan Wu, Ozzie Nunez

Results: The newspaper industry is on its way out, threatening local journalism. So how will locals stay informed about their communities? We answered this by reimagining the newspaper and putting it on a different kind of paper we use every day. Receipts.

77 GOOGLE MIND | School: Syracuse University, The Newhouse School
Instructor/Professor: Mel White | Students: Emily Babcock, Jordanna Drazin

Assignment: Solve a global problem with new technology developed in the last 5 years.

Approach: For people who suffer from memory loss disorders, communication is a constant struggle and frustration. So, we utilized the Google BERT AI system, developed in 2019, to provide loved ones of those with memory loss disorders, an app and Google Home extension to aid in two way verbal communication.

Results: The result is an app that helps fill in the blanks in a conversation by listening and speaking out loud suggestions for what may come next in verbal communication. The app helps prompt those with memory loss disorders so they can continue to communicate effectively with loved ones.

77 CASHCAN | School: Syracuse University, The Newhouse School
Instructor/Professor: Mel White | Students: Joe Cutuli, Maia Baptiste

Assignment: The Cashcan is designed to increase recycling, and increase motivation to recycle. When you deposit a bottle or can, information is directly transmitted to your phone and you will receive 5 cents.

78 THE SPOILER BILLBOARD | School: M.AD School of Ideas Europe
Instructor/Professor: Sabine Georg | Students: Matithorn Prachuabmoh Chaimoungkalo, Seine Kongruangkit

78 MOMPPER POPPER | School: School of Visual Arts
Instructor/Professor: Jack Hwang | Students: Soah Kim, You Hyun Jang

78 SAFE SCAN | School: M.AD School of Ideas Europe | Instructor/Professor: Sabine Georg | Students: Paras Juneja, Riya Dosani, Shadab Wajih, Sukratti Jain

78 GANG FOR GOOD | School: M.AD School of Ideas Toronto, Europe and San Francisco
Instructor/Professor: Manolo Garcia
Students: Hatem El Akad, Refaat Rico, Lee I, Ted Pedro

78 FAIL EPICALLY | School: M.AD School of Ideas Miami and San Francisco | Instructor/Professor: Manolo Garcia | Students: Valentina Orjuela, Monica Andrade, Hatem El Akad

78 #EARTHMODE | School: M.AD School of Ideas Miami
Instructor/Professor: Unattributed | Student: Tássia Dias Valim Cunha

78 ODESZA TOUR HYPE VIDEO | School: Texas Christian University
Instructor/Professor: Yvonne Cao | Student: Rae McCollum

78 THE STORE THAT SELLS NOTHING | School: M.AD School of Ideas Miami, New York, and San Francisco | Instructor/Professor: Manolo Garcia
Students: Passant El Mohdar, Roselyn Grace, Pedro Sacilotto, Hatem El Akad

79 POCKET BUCKET APP | School: Kutztown University of Pennsylvania
Instructor/Professor: Dannell MacIlwraith | Student: Ilze Spilde

79 MILLER GENUINE DRAFT: NO BULL, JUST BEER | School: Syracuse University, The Newhouse School | Instructors/Professors: Kevin O'Neill, Mel White
Students: Spencer Krimsky, Shawn Depaz

79 FORT WORTH STOCK SHOW & RODEO COMMERCIAL (3) | School: Texas Christian University | Instructor/Professor: Yvonne Cao | Student: Kirsten McFarlan

79 CHIP ON THE SHOULDER | School: M.AD School of Ideas Miami, Toronto and San Francisco | Instructor/Professor: Manolo Garcia | Students: Passant El Mohdar, Lee I, Ted Pedro, Hatem El Akad

79 A MOMENTARY LAPSE IN CONCENTRATION | School: M.AD School of Ideas Europe | Instructor/Professor: Sabine Georg | Student: Patrick Chase

79 DEAD-NET WHOPPER | School: School of Visual Arts
Instructor/Professor: Jack Hwang | Students: Soah Kim, You Hyun Jang

79 #REOOTD | School: National Institute of Fashion Technology
Instructor/Professor: Vijay Kumar Dua | Student: Nithika Romy

79 EMPORIUM PIES APP CONCEPT COMMERCIAL | School: Texas A&M University Commerce at Dallas | Instructor/Professor: Jonathan Hunter | Student: Emil Miralda

PLATINUM DESIGN WINNERS:
84 HIDE & SEEK | School: ArtCenter College of Design
Instructor/Professor: Tracey Shiffman | Student: Xiaoying Ding

Assignment: Design a book based on any "-ism" word (idealism, atheism, voyeurism, and so on). Students need to choose visual elements, including typography and images, based on their understanding to deliver this "-ism" word to the audiences.

Approach: The word I picked is "voyeurism". When I first heard this word, it reminded me of my favorite game I played in my childhood – Hide & Seek. As a hider, I enjoyed the excitement when seeker searching around me, while as a seeker, I got a sense of achievement when I found someone successfully. You may think such games just belong to kids, but actually, we still played this game in the adults' world and it has a new name called "voyeurism". Today almost everyone is a "Peeping Tom": we keep watch on others' lives through their Facebook and Instagram. Meanwhile, we are also peeped by others: the surveillance system makes us nowhere to hide.

Results: To make the reader to be a real "Peeping Tom", I make the cover of the book a door with a peephole. If you look through the hole, you can find a girl is changing her clothes. To connect voyeurism with the game hide-and-seek, meanwhile make it more related to the adults' world, I started this book with several number-shaped body figures, which imitates the process of counting down when we play hide-and-seek, while such naked bodies also have some grownup sensibilities.

85 KYOTO FOUR SEASONS | School: ArtCenter College of Design
Instructors/Professors: Ann Field, Christine Nasser | Student: Grace Park

Assignment: An illustration for a luxury square scarf.

Approach: An illustration based on four seasons in Kyoto, Japan. Each corner represents flowers and plants from a particular season in the region. Starting from the right top corner going clockwise is spring, summer, fall and winter; the red crowned cranes are dancing as the sun sets in the scene.

Results: The illustration received many calls for about licensing from scarf companies.

86 CHRISTMAS DINNER | School: ArtCenter College of Design | Instructors/Professors: Ann Field, Paul Rogers, David Tillinghast, Rob Clayton | Student: Haley Jiang

Assignment: Illustration based on Washington Irving's short story Christmas Dinner

Approach: Photoshop, Pen and Ink

87 NIKE RISE | School: Brigham Young University
Instructor/Professor: Doug Thomas | Student: Sam Verdine

Assignment: The fitness industry is an 80-billion-dollar industry serving millions of Americans. Within in it, there are over 320,000 fitness and training apps, yet less than 10% of them are marketed towards youth.

Approach: Nike RISE is the opportunity for youth athletes to excel and reach new heights in the sports that they love. It allows an opportunity to be mentored by those that have mastered their crafts, sharpen their skills by challenging friends, and to stay motivated through achievements. ■ The concept behind RISE is to not just tell the youth athletes that the sky is the limit but to show it. Typography towers and a grid is used that keeps everything in the bottom half, conveying the room for growth. Bright color schemes can be chosen by the athletes to keep the appearance energetic. Packaged all together in a simple user experience bridges the rising generation to the success they dream of achieving.

Results: Nike RISE achieved its goal to be the opportunity

87 CITY OF DETROIT | School: Texas State University
Instructor/Professor: Jeff Davis | Student: Mikayla Stump

Assignment: To create a logo to help rebrand the historic city of Detroit.

Approach: The process for this project began with the research of various cities and which has the most history that I could utilize in creating the mark. After completing the initial research and finding a city it was time to begin experimenting with the different symbols based on the city of Detroit's history of music, cars, etc. The solution turned into combination of a car license plate and radio based on the nicknames "Motorcity" and "Motown" from history.

Results: This logo is a success because of its simplicity and unexpected way of combining two different objects to represent a city.

88 THE XI POSTER SERIES | School: School of Visual Arts
Instructor/Professor: Justin Colt | Student: Junghoon Oh

Assignment: Design posters that promote an event that is currently happening in the city.

Approach: I designed posters inspired by the shape of the apartment building.

89 TRANSLATION OF STYLE | School: University of Cincinnati, DAAP
Instructor/Professor: Reneé Seward | Student: Ryan Page

Assignment: The development of a compelling visual design system seeks to unify a system's differing components yet instill excitement through its innovative representation of meaning. This project focuses on the manipulation and arrangement (composition) of typography and image as it conveys messages through a poster series.

Approach: I utilized a variety of design methods to communicate each part of this overall concept. To visually translate what each of their music styles sounded like, I considered image warping methods, typographic texture, and overall color palette. I chose a different complementary color palette for each poster for a couple of reasons. One, complementary colors contrast each other the most, and therefore the instruments would jump off the page even more. And two, I wanted the posters to encapsulate the brightness and vibrancy of music that jazz, specifically, has always epitomized. The warped instruments represent Hwang's erratic sound. On the piano, I used a curved piano image to represent the fluidity of Waller's style. I also wanted to convey the patterns and beats of their music by creating various typographic textures, using different letter widths and thicknesses in their names. Lastly, I used fragmentation throughout all three of my posters by having the text of their names be disrupted by or interact with the instrument they played, conveying that their names and music go hand-and-hand and that their music broke stylistic boundaries by having the text of their names and their instruments' images overlap each posters' surrounding white border.

Results: My concept for this poster series for Sound Assertions: 3 Jazz Pioneers, a hypothetical event series focusing on the contributions of Buddy Bolden, Fats Waller, and Jason Kao Hwang to the jazz musical genre, was to spotlight the main instruments that each of these men used in their styles of jazz (Buddy Bolden on the cornet, Fats Waller on the piano, and Jason Kao Hwang on the violin.) Not only did I want to emphasize the difference in each of their instrumentation, but I also wanted to visually translate the different styles, rhythms, and patterns heard within their music, with Bolden's style upbeat and lively, Waller's smooth and melodic, and Hwang's style unpredictable and eerie. Finally, I also wanted to convey their impact on the genre of jazz as a whole. How each of these three men's music revolutionized the jazz musical landscape of their time and broke the boundaries of what jazz was thought to have been.

90 VISUALISATION OF SOUND | School: Hansung University, Design & Art Institute
Instructors/Professors: Dong-Joo Park, Seung-Min Han | Student: Han Sang Hee

Assignment: Make a poster that promotes a project that unravels Hangeul designs with visual and sound correlations.

Approach: It is an original visualization of Korean sounds with pansori phrases that contain the emotional characteristics of Koreans and the unique sounds of Korea. ■

Visualize the sound of Pansori "Sarangga" and visualize the rhythm of the master's buk (traditional Korean drum) with the word "up" to express the movement of sound.

91 SOMETHING BLUE | School: Pennsylvania State University
Instructor/Professor: Taylor Shipton | Student: Scotti Everhart
Assignment: The objective for this project was to create a surreal movie poster for the Chicago underground film festival. I was given the festival topic "Something Blue" and was quickly inspired by the idea of a haunted portrait of a victorian woman.
Approach: This project only spanned one week, so I worked very quickly with minimal art direction to bring the piece together. Due to COVID-19, I did this project entirely remote. I modeled for it myself, and took all of the photographs in my own home. All of the objects incorporated into the image are family heirlooms belonging to my mother, so it was extremely gratifying to be able to breathe new life into them.
Results: I received wonderful criticism from my professor and my classmates.

92 LIVE IN WONDER | School: Texas Christian University
Instructor/Professor: Bill Galyean | Student: Rose Hoover
Assignment: Make a poster about a mantra you to live by using any medium.
Approach: The mantra I decided to base my design off of is the word, "wonder". Since my inspiration for this word came from my curiosity for the world, I wanted to incorporate actual elements from the environment that I am inspired by. The different elements used were at some point living, and include: octopus, crab, moss, Asian cactus, and Texas plants that were spray painted. All of the elements were arranged to appear out of the laser-cut poster board that communicated the mantra. The entire production was then photographed to communicate the mantra.
Results: The final product communicated the mantra successfully to the audience and kept a strong correlation to the environmental aspect of the poster that I wanted to portray.

92 SEEKING SOLACE CHAIR | School: M.AD School of Ideas at Portfolio Center
Instructor/Professor: Hank Richardson | Student: Dimitri Ferreira
Assignment: Design a chair based on an art movement between 1847 to the present and a personal story. The chair should reflect Modernist principles of form and function.
Approach: To design my chair, I focused on my struggle with anxiety that developed from a young age in an orphanage. Inspired by the short-lived art movement Vorticism, an industrialized and rebellious style. I explored the principle of contrast through materials, resulting in the understanding of who I am versus who anxiety makes me.
Results: My chair is a representation of my constant underlying battle with anxiety. Reaching back for my authentic self, I realize that all discomfort feels dangerous, but there is always a light found in the dark.

GOLD DESIGN WINNERS:

94 PATTERN BOOK COVER | School: School of Visual Arts
Instructor/Professor: Tina Fong | Student: Junghoon Oh
Assignment: I was assigned to design book covers. As I had deep interest in fashion and textile design, I especially liked patterns among the clothes I wore.
Approach: On my way to the subway, I saw the well-designed walls and floor tiles of the New York subway, that inspired me to create my pattern book cover design.

95 DEPARTMENT OF DIGITAL REMAINS | School: Maryland Institute College of Art
Instructor/Professor: Jennifer Cole Phillips | Student: Anjali Nair
Assignment: I explored the topic of digital afterlife by creating a fake federal agency that cares for your digital data after you die. I wanted to show hiw the bureaucracy works while investigating the digital afterlife industry and the digital lives we lead.
Approach: The Department of Digital Remains is a fictional federal agency that keeps a tab on all your virtual actions which will determine your fate in the digital afterlife. In an age of immortal digital presences, this is a speculative look at what happens to our online selves after we die. ■ This project uses design fiction to examine digital lives through the lens of digital death while trying to answer the question: If we have found ways to treat physical remains of the departed with dignity, why not digital remains? This book is a visual narrative journey that takes the reader through this fictional department that includes its workings, case files as well as its origin story.
Results: This speculative approach is an effort to open up a conversation about the digital lives we lead and our digital remains without the burden of the word 'death'.

96 THE WIZARD OF OZ COLLECTION | School: School of Visual Arts
Instructor/Professor: Pablo Delcan | Student: Justin Wong
Approach: Custom lettered cover series for L. Frank Baum's children's series about the magical Land of Oz. The collection drew inspiration from the timeless elegance and whimsy of Oz, with intricate lettering drawn for all 14 covers to introduce the stories and craft a unifying system. The set was designed in a gradient from ruby red to brick yellow to deep emerald as a nod to Dorothy's iconic journey to the Emerald City.

96 OCEAN'S ELEVEN | School: Pennsylvania State University
Instructor/Professor: Emily Burns | Student: Rachel Smith
Assignment: Create an original book cover jacket design for a hardcover book. Instead of redesigning an existing book cover, I had to choose a film and imagine that this cover is for the original written manuscript of the book version of the film.
Approach: I chose "Ocean's Eleven" written by Ted Griffin. I summarized the theme as many extremely different, conflicting personalities coming together to pull off an impossible challenge. The story takes place in the casinos of Las Vegas; I specifically chose items (such as a glass of whiskey and a gold lighter) that represented the different personalities from this setting. Each of these personalities are unique and distinct, yet they work together to create strong casino imagery. I found these items, arranged them on a poker table, photographed them, and created the lettering for the spine and author. I used these distinctive items and the entire layout to evoke the overall casino vibe. The final product required many rounds of adjusting the items in the layout and photographs.
Results: When presented to my professor and peers, they were immediately able to understand that the unique items on the cover created strong imagery alluding to a casino. The many items were recognizable as distinct objects and personalities, but they worked together to create imagery that related to the film and its plot.

97 CA MAGAZINE DESIGN | School: School of Visual Arts
Instructor/Professor: Eileen Hedy Schultz | Student: Yeojin Chun
Assignment: CA is a Korean design magazine. I had a hard time at first because I had to express the abstract concept of the "future" visually. At the beginning of the process, I tried to organize and write down my thoughts about the future in my notebook.

Approach: I think the future is the process and the result of gathering visible, certain present moments to build clarity against the uncertainty. I expressed my thoughts using shapes and futuristic neon colors. Also, since the present and the future were expressed in a circle, the circle was used as a main element in the editorial design.

98 IT'S YOUR FRIENDLY UFO! | School: ArtCenter College of Design
Instructor/Professor: Stephen Serrato | Student: Haozhe Li
Assignment: Design an editorial project for an art exhibition that is about six artists from the same genre. I picked "Super Flat" and included artists such as Takashi Murakami, Yoshimoto Nara, Ito Junji, and Chiho Aoshima in my work.
Approach: Super Flat is an artistic idea proposed by Takashi Murakami. It believes that the world of the future might be like Japan is today: Super Flat. The superior and inferior culture will finally meet each other and will be flatten on the same layer and become extremely two demential. The name of this project comes from one of the super flat artist – Chiho Aoshima's painting. Meaning the future is coming and it's coming friendly.
Results: Since it's a futuristic idea I chose Slyther as my display font because I want the font to be non–historical. The arrow was created by the gesture of the font.

99 THRESHOLD | School: ArtCenter College of Design
Instructor/Professor: Brad Bartlett | Student: Shiang-jye Yang
Assignment: Threshold aims to examine and argue not only the resemblance of graphic design and liminal spaces but the intricacies of the role they take in each other. Liminal space is the transitional period between two states. In these spaces, the past structures do not apply, and the new is yet established; it is amid the ambiguity and disorientation where genuine creation occurs, and meaning is derived.
Approach: The moiré pattern, the main graphic element, symbolizes the transition of past structure to the future; the in-between space of both past and future creates the animation. The typography treatment creates animation with the moiré sheet that comes within the book. ■ A metal fastener binds the entire book together, and no glue was involved in the process. This gesture acknowledges the fluid state in liminal spaces where everything is in flux. ■ The garden serves as an analogy for liminal space in our domestic environment. It's a space between the human space and nature, sharing characteristics of them both. Therefore, various greens in the color palette mimic the scenery in a garden.
Results: This project demonstrates the ability to generate a thesis statement and support it with research, content curation, and critical thinking. Liminal space serves as a powerful analogy to the inherently expansive scope of graphic design.

99 THE ARQIVE REBRAND | School: CalState LA
Instructor/Professor: Zachary Vernon | Student: Liz Sweeney
Assignment: Originally founded in 2014, GlobaltraQs is a global digital mapping website that collects queer stories, experiences, events, and resources throughout history. The project had never really gotten off the ground, so in 2020 the organization decided to rebrand and relaunch the website with a whole new vision and team. The rebrand included naming, design, UX/UI, and applications in social media as a starting point.
Approach: The new name, The arqive, came from a discussion about "queering" the canon of historical knowledge through exposing marginalized queer histories and experiences. The concepts of community and storytelling are central to the brand, which is why the wordmark utilizes speech bubbles as letterform. The energy of multiple voices expands into the visualization of the global map, with story pin speech bubbles adding color to the black and white landscape. Typography, colors, and photography styling connect the past to the present: a typewriter-style serif mixed with a modern sans serif, an sophisticated rainbow palette based on the original Pride flag, and historical photography colorized and presented in a modern way.
Results: The new brand has been implemented on the website, which launched in May 2020, alongside a social media campaign promoting the new look and website. Creating this identity not only gives LGBTQ individuals a visual connection to a larger historical consciousness, but also connects activists, organizers, resources, and community spaces around an ethos of solidarity. This identity visualizes how storytelling can change perceptions and actions of LGBTQ individuals and communities.

100 CONSPIRACY CASE | School: Texas Christian University
Instructor/Professor: Lewis Glaser | Student: Madeleine Alff
Assignment: Create an infographic on a topic of choice and then base a subscription box off of the infographic. The design must be represented similarly throughout both pieces and all of the items within the box.
Approach: For my infographic, I decided to research the Apollo 11 Conspiracy Theory. Since the photos are so iconic, I wanted to use illustration to clearly demonstrate the conspiracists thoughts and include a debunked point in order to remain unbiased. In order to base the subscription box off of the infographic, I decided to create a company called Conspiracy Case that would send monthly conspiracies for the customer to investigate; Apollo 11 being the first one.
Results: The infographic's results includes a dark space image with close up illustrations of the facts in order to help explain. The box includes a badge of the Apollo 11 lunar lander that alludes to the astronaut badges, info cards with images based off the infographic, and a CD with an introduction of how Conspiracy Case works. It also includes a test tube filled with "moon dust" which is just kinetic sand, and a card in a wax sealed envelope that when solved reveals the code to receive the next box.

100 UMIDO COOKWARE | School: Texas State University
Instructor/Professor: Carolyn Kilday | Student: Olivia Romero
Assignment: Develop a logo and branding system for Umido, a cookware company.
Approach: The process started with the Logo, finding the right look for the name Umido. Taking a letterform, and combining it with the shape of a pot was the best solution. Next came the letterhead system and the touchpoints for a possible store, keeping in mind the possibilities of potential events and what customers and staff would need.
Results: The logo's outcome was successful as it's a simple, slightly abstract mark. It's inviting and warm, and I wanted to extend that warm nature into the Branding.

101 ERIS PARFUMS | School: University of North Texas
Instructor/Professor: Douglas May | Student: Parker Metcalf
Assignment: ERIS Parfums is a niche perfume brand run by Barbera Herman. It specializes in scents that are evocative, sensual, and progressive. The goal was to elevate ERIS and create a brand presence that better positions the company's offering against other luxury boutique perfume houses while appealing to a fashion-forward audience.
Approach: The brand solution for ERIS Parfums was to create a distinctive visual

language—recognizable by high contrast compositions and neoclassical typography, striking a balance between the contemporary and the classic. In an industry often saturated with overtly sexual ads—the 'MX' campaign crosses binary norms of what self-expression through perfume can be conveyed through fresh and eclectic images.
Results: The campaign better represents ERIS through a recognizable system of typography, symbolic geometry, photography, and a timeless trademark.

102 OMSI | School: Brigham Young University
Instructor/Professor: Adrian Pulfer | Student: Hunter Young
Assignment: Create a new identity for the Oregon Museum of Science and Industry.
Approach: The rebrand's purpose is to create a greater platform to showcase the power that design has by incorporating contemporary grid layouts, strong imagery, and a variable logo system. The flexibility of the system not only helps with but also represents the ever-evolving educational environment that OMSI offers to future generations.
Results: A new identity system that's timeless but allows the brand to continue to grow.

103 TAMPA MUSEUM OF ART | School: School of Visual Arts
Instructor/Professor: Courtney Gooch | Student: Jun Hong Park

104 LAKESHORE | School: Texas State University
Instructor/Professor: Carolyn Kilday | Student: Samantha Chapman
Assignment: To rebrand Lakeshore Learning to become a cohesive brand.
Approach: I started by gathering research and developing a logo for the company. I wanted it to tell a story, and be unique to its industry. I took toy building blocks as my inspiration and created a logotype using fundamental shapes and colors. I picked a color palette that portrayed the primary colors to join with basic learning shapes.
Results: The brand successfully portrays what the company does, and is simplified in a beautiful and cohesive manner.

104 AMITY LINK TATTOO ARTISTRY | School: Texas Christian University
Instructor/Professor: Jan Ballard | Student: Kenzie Ashley
Assignment: Amity Link was the result of a collaborative project between selected Graphic Design Students and selected Interior Design students. The goal was to create either a tattoo shop or pet store. Two interior design students were placed with one graphic design student to work in a client/designer relationship. The interior designers were clients while the graphic design student lead the branding process.
Approach: Due to Covid-19, the creative process was completely virtual. Over the course of one month, the interior designers and graphic designer worked in close communication through messaging and video conferences. The graphic designer provided a questionnaire for the interior design team to help ideate a name and brand voice. Once the name was decided upon, a joint moodboard was created, and the branding process began.
Results: The other teams spoke highly of the created brand voice, and the client/designer relationship was a great learning experience for both parties.

105 KAMEN ESTATE WINE BRANDING | School: Brigham Young University
Instructor/Professor: Chris Mann | Student: Deb Figueroa
Assignment: Robert Kamen is a screenwriter who bought a vineyard in Sonoma, CA. This spontaneity and his passion to entertain and bring people together made me want to rebrand their brand into something recognizable and unique.
Approach: I wanted to bring a monospaced typeface to play on screenplays and the typography used in those. I accomplished this by using Pitch Sans and Pitch as primary typefaces. I wanted to also pay homage to the editing process and hand drew lines and scribbles to add texture and pattern.
Results: A sophisticated brand that can be used within Kamen's vineyard and tasting room in downtown Sonoma.

106 MIKUNI SUSHI BRANDING | School: Brigham Young University
Instructor/Professor: Chris Mann | Student: Brenna Vaterlaus
Assignment: Choose an existing company to refresh their brand in a new way. I chose Mikuni, a sushi restaurant in California. The goal was to elevate and bring elegance to their brand to match the rich history of culture and cuisine.
Approach: Refined their identity by bringing elegance to their logo and brand language. Inspired by Japanese cuisine, art, and the idea of order and simplicity.
Results: Though this was a student project, the owner of Mikuni did reach out on social media saying it was very impressive.

107 DHL IDENTITY SYSTEM | School: ArtCenter College of Design
Instructor/Professor: Simon Johnston | Student: Tiffany Shen
Assignment: Create a rebrand for DHL, the largest global logistics company. The deliverables should include brand guidelines, identity and event posters, stationery, spatial design, web and mobile interface, and any additional, specific collateral.
Approach: My approach was to reinforce the ideas of global, directional, and speed. I did this by creating a slanted form language and choosing a color palette with 'faster' colors such as green and orange, while the tones of brown bring back the company's environmental awareness. The brand voice is another factor I took into consideration when creating this rebrand. I wanted to use a language that would be relatable to the speed of this generation and how we all want everything to be fast and how we are always watching deliveres waiting for the moment it arrives.
Results: The project was praised by the faculty and the chair of the graphics department, Sean Adams. He also asked me to use my mobile design as an example for a lesson.

108 INTERNATIONAL CONTEMPORARY FURNITURE FAIR | School: School of Visual Arts | Instructors/Professors: Kenneth Deegan & Brankica Harvey | Student: Jun Hong Park

109 WE LOVE GREEN | School: School of Visual Arts
Instructor/Professor: Courtney Gooch | Student: Chaiun Oh
Approach: We Love Green is a Parisian music festival that encourages the participants, including the artists, to be part of the green movement. Design language from the eco-friendly movement tends to be very friendly. This rebrand focuses on a design aesthetic that better represents the edgier artists and audience, making the green movement something younger generations can proudly participate in along with the music.

109 VELCRO | School: School of Visual Arts
Instructor/Professor: Courtney Gooch | Student: Chaiun Oh
Approach: Velcro is a small but versatile product that people use regularly in daily life. Creating a colorful, energetic packaging design system for an ordinary household object highlights the product and converts it into something customers want to use.

110 OVELLE | School: San Diego City College | Instructors/Professors: Sean Bacon, Bradford Prairie | Students: Olivia Larsen, Chiara Barbagallo
Approach: As a craft with known benefits such as reduced anxiety and increased sense of wellbeing, knitting is gaining interest amongst women ages 25–35, who value the traditional techniques and beauty of simpler times. A perfect balance between mom & pop and luxury shop, Ovelle brings to Dublin, Ireland a range of exclusive workshops hosted by renowned knit designers, paired with superb yarn quality—proof of centuries of tradition. ■ To communicate the femininity of the brand, the name Ovelle was given—a union of the words ovella (sheep) and elle (her). The curvy, old-fashioned and slightly imperfect Edda pro in the logotype, paired with the all caps Lulo Clean implies the coming together of two eras. A tender yet earthy color palette was chosen to reflect the softness of the fibers. The delicate serif Cormorant, placed in a layout grid that is meticulously followed for increased legibility of the pattern instructions, evokes that same feminine yet modern touch, dominant throughout the brand. A universal, visual label is placed on the ready-to-use packages, which keeps costs down and the standards high.

111 MERRIJIG INN | School: Brigham Young University
Instructor/Professor: Adrian Pulfer | Student: Audrey Hancock
Assignment: To choose an existing company or brand and give them a complete rebrand.
Approach: I decided to rebrand the Merrijig Inn, Victoria's oldest Inn. It is located in Port Fairy with a view next to the wharf; the Merrijig is close to all of the historic Port Fairy attractions including galleries, shopping and beaches. They pride themselves on the cosy country feel and homey touches throughout. Tanya in the kitchen takes care and effort to source produce locally and her cooked breakfasts are delicious. Their resident chickens are the star of the show and love hanging out with the guests.
Results: I wanted the rebrand to reflect the Merrijig's charm, and felt the inn would be best represented using a modern approach.

112 DODECA | School: Hongik University
Instructor/Professor: Daeki Shim | Student: Huiyun Jung
Assignment: Dodeca is a scented candle brand that presents 12 different scents a year under the theme of one scent per month. Feel the scent with your eyes through Dodeca's unique graphic illustration that visualizes the scent.
Approach: Dodeca means 12 in Greek. Thus, the logo of the brand was designed in organic shape that looks like melted wax or smoke, taking the shape of the Greek numeral 12. Similarly, I created symbols based on Greek numerals for every month.

112 DOT | School: School of Visual Arts
Instructor/Professor: Eric Baker | Student: Hyupjung Lee
Assignment: I did a virtual stationery store 'DOT' branding inspired by Bauhaus. I wanted to expand to various logos so that people could think of the DOT brand even if they looked at all the various logos. Also, I tried to focus on this brand to look creative.
Approach: "EVERYTHING STARTS FROM A DOT." ■ Wassily Kandinsky. Despite its simplicity, the dot is fundamental. ■ It all begins with that dot and the possibilities for where you take it from there are endless. Based on this, By changing the "O" in the middle of the brand name DOT to the shapes representing the geometric shape of Bauhaus and various stationery. With various logos, I wanted to give people an expectation that they would know what this brand was selling and that they would meet a wide variety of stationeries if they went to DOT and I wanted to give a modern and joyful feeling. I add a geometric DOT brand's pattern to give this feeling more.
Results: The project was presented to other branding class students. After seeing this project, a branding request was received from one local store.

113 PAPER MAGAZINE | School: Brigham Young University
Instructor/Professor: Adrian Pulfter | Student: Ben Law
Assignment: This is a redesign assignment for the iconic pop culture magazine PAPER.
Approach: I decided to enhance the masthead design and elevate the front cover. The original type-face looks dated and hasn't changed for decades. By using die-cutting, the new type-face also double as windows that play on color, design, and connection to the content on the second page. From far away, one would assume it is simply a flat cover. Up close, the cover draws the reader to engage and explore the contents inside.
Results: This new look can draw more people to buy it and speak to more audiences.

114 ZOO MAGAZINE | School: Brigham Young University
Instructor/Professor: Adrian Pulfer | Student: Sam Verdine
Assignment: ZOO Magazine hopes to share the diverse fashion coming out of the Netherlands, yet the visual direction was a poor ripoff of renowned magazines, doing nothing to justify that Netherlands fashion was one of a kind.
Approach: With a goal to show the eclectic nature of fashion, ZOO needed a design to match variety. The masthead becomes simple geometric type with a crossbar striking through it. From issue to issue, the crossbar would change, demonstrating the diversity of fashion ideals. Multiple typefaces come together to create unity in variety, but among all these ideas lies a strong grid, zoo cages, that helps contain a bold vision.
Results: ZOO has a strong system that makes it identifiable as a fashion magazine but different enough to stand on its own. With a strong grid containing the design's energy, it comes across as clean while displaying the uniqueness of the Netherlands fashion.

115 WALLPAPER MAGAZINE | School: Brigham Young University
Instructor/Professor: Adrian Pulfer | Student: Ellie Jepsen
Assignment: Redesign a magazine. I chose Wallpaper*, a London-based magazine that specializes in a wide variety of departments including culture, fashion, architecture, travel, design, and lifestyle. This company values a space where creatives can show their best work and be reviewed by their peers. They value art in all forms, but above all value beauty in everyday aspects of life. Wallpaper* strives to re-imagine, re-design, and re-make the physical world as a smarter, more sustainable place.
Approach: I decided to strengthen the grid and typography and to more accurately emulate the values of their creative audience. The new design is now structured with a new type system and unified grid that is intended to inspire the influential and push boundaries, ensuring that their coverage of the arts remains unrivaled.
Results: The redesign of Wallpaper* magazine ultimately elevated the publication and gave it ground to stand on in front of its creatively predominant audience.

116 BAU BLOCKS | School: Brigham Young University
Instructor/Professor: Adrian Pulfer | Student: Dominique Mossman
Assignment: Create a project to commemorate the centennial celebration of the Bauhaus.
Approach: My proposal to commemorate the Bauhaus school is to create a 3-dimen-

sional puzzle of 14 objects (one for each year the school was in operation). Each piece would celebrate the influential people, designs, and products that came from the Bauhaus in all fields of craft. The puzzle would replicate a minimalist theme, and symbolize each iconic piece of the Bauhaus without compromising the beauty of the piece itself.
Results: I was able to travel to Germany and visit the original Bauhaus school. I was also able to create my puzzle and share with visitors.

117 SANTA MONICA | School: ArtCenter College of Design
Instructor/Professor: Jim Salvati | Student: Skye Zhang
Assignment: The project was to create a travel poster.
Approach: I made a poster for Santa Monica because I've lived there a long time and I love this city. The illustration is based on a photograph taken by my friend at the pier.
Results: The interaction between seagulls and human at the sea presents a harmonious coexistence of nature and human in the City of Santa Monica.

118 LONDON ANTIQUE | School: ArtCenter College of Design | Instructors/Professors: Ann Field, Paul Rogers, David Tillinghast, Rob Clayton | Student: Haley Jiang
Assignment: Illustration based on Washington Irving's short story Rip Van Winkle
Approach: Photoshop; Pen and Ink

119, 120 HISTORY OF FASHION IN PARIS | School: ArtCenter College of Design
Instructor/Professor: Jason Holley | Student: Grace Park
Assignment: Do research on any subject, and turn it into a commercial product.
Approach: I chose to base my research on the history of fashion in Paris, France. I chose 5 well-known brands and realized that all these brands have their unique histories, and most of them did not start as a clothing/ bag company.
Results: Each illustrations successfully included the inspirations of the founder; people that were crucial; the social events that was impactful at the time; as well as their start.

121 INTOXICATING NETFLIX | School: ArtCenter College of Design
Instructors/Professors: Brian Rea, Paul Rogers | Student: Grace Park
Assignment: To create an illustration based on an Op-ed article on New York Times.
Approach: The piece was based on an article called: Netflix Is the Most Intoxicating Portal to Planet Earth. ∎ Instead of trying to sell American ideas to a foreign audience, it's aiming to sell international ideas to a global audience. Countries in the illustration are: Japan, South Korea, Netherlands, Italy and Greenland.
Results: Brian was an art director at NYT. He directed me throughout the sketching and coloring process, and concluded that I finished the assignment successfully.

122 THE TELL-TALE HEART | School: ArtCenter College of Design
Instructor/Professor: Jim Salvati | Student: Alex Kupczyk
Assignment: The assignment was to pick a Legend, Myth or Story and Illustrate that narrative. I chose The Tell-Tale Heart by Edgar Allen Poe.
Approach: I wanted to depict the hight of the narrative, where the narrator is taken by his madness. From concept sketch to finished illustration I was concerned with the psychological state of the characters, as well as the body language, and tone.
Results: Beyond meeting the goals that I set out for the project and design choices, I was immensely satisfied with the shape design and with the beautiful texture of the watercolor.

123 COL FITNESS TRACKER | School: San Diego City College
Instructors/Professors: Sean Bacon, Bradford Prairie | Student: Olivia Larsen
Approach: COL was created for the skier who wants to track their activity in a complete and accurate way. To distance itself from its competitors, COL knew they needed to always be available, no matter the conditions. As a fast paced sport, an app able to showcase the collected data at a quick glance in a very clear and concise way was developed. To keep the app as functional as possible I chose Euclid, as its geometric and monolinear features leave behind anything that can be regarded as superfluous. A palette of black with high contrast colors was chosen to promote legibility when in the snow. COL uses the accelerometer and GPS to automatically track jumps and tricks by detecting when a user catches air time. A calendar allows users to look back at their past runs to follow their own improvement and the social aspect of adding and comparing results of favorite users on the map encourages personal improvement. The brand of COL further extends to show exclusive data thanks to its Apple Watch integration.

123 ANCHORED SHIP COFFEE BAR LETTERHEAD | School: University of North Texas
Instructor/Professor: Karen Dorff | Student: Ashley Owen
Assignment: Students were assigned a rebrand of an existing business.
Approach: Students research their assigned client, review the existing brand, execute a marketing analysis/brand strategy, create mood boards, execute thumbs, roughs, and tight pencils. Collateral, signage, and brand boards are executed for the final presentation.

124 OPEN SEA | School: Texas State University
Instructor/Professor: Genaro Solis Rivero | Student: Hannah Tanner
Assignment: Create a logo for Open Sea, a company that uses their expertise to safely lead tourists into shark populated waters for an experience they'll never forget.
Approach: The process involved combining a mask with a shark fin to represent the viewing experience of the divers.
Results: The logo successfully uses negative space to combine both forms into a ne form for a logo that communicates the experience the divers will have with Open Sea.

124 KAT'S TOY | School: Texas State University
Instructor/Professor: Genaro Solis Rivero | Student: Allison Satterfield
Assignment: Create a logo for Kat's Toys, a small eclectic boutique toy shop.
Approach: Made with the morphological approach of combining a cat and a slinky toy. This logo mimics the bend of a cat's back when being picked up along with a slinky arching when being played with. For the name of the company the play on the founders name worked with the imagery of the logo as it helps reinforce the playful nature of the store.
Results: The trademark was successful, captivating the toys' essence at the store.

124 PAPER THEORY LOGO | School: University of North Texas
Instructor/Professor: Douglas May | Student: Hana Snell
Assignment: Develop a unique, recognizable logo for Paper Theory, an online retail service providing women with printable sewing patterns to up-cycle their wardrobe.
Approach: Inspired by prêt-à-porter sewing patterns and the sewing process, this logo uses a humanist sans serif, cut-paper effect, and sewing pattern patch in the shape of a "P" to induce a sense of handcrafted, slow fashion.
Results: The final logo communicates the brand's story, is authentic to the craft of sewing, and is unique to inspire the support of ethical fashion.

124 SEIDO LOGO | School: Texas State University
Instructor/Professor: Genaro Solis Rivero | Student: Roy Resendez
Assignment: Develop a logo for Seido, a fish processing company by using the morphological approach of combining two images.
Approach: Fish processing involves gutting, filleting, and packaging of the product. The pictorial mark includes a fish skeleton that hints at what the company does, and fits nicely into the usual slot of a razor blade. The razor blade reflects the precision in which the company processes fish. The typography is strong in order to give the company credibility.
Results: The trademark is simple, yet bold which successfully matches Seido's precision of processing fish and the integrity of the company's practice.

124 ELAPAINT | School: Texas State University
Instructor/Professor: Genaro Solis Rivero | Student: Ronaldo Mundo
Assignment: Create a logo combining two different objects.
Approach: I took a morphological approach to combine the silhouette of the paint bucket to the head of elepaint. The typography reflects shapes of the logo design. The color of the logo is subtle and not to harsh hinting that of Elapaint's paint colors. And the design is very simple yet elegant which goes well with Elapaint the paint company.
Results: The project successfully created a unique brand identity for a paint company.

125 STINGER | School: Texas State University
Instructor/Professor: Genaro Solis Rivero | Student: Giang Pham
Assignment: Create a pictorial mark and propose a name for a Tattoo or Piercing business using a morphological approach to combine two different objects.
Approach: The process began with an extensive wordlist of different categories, then exploring a plethora of thumbnails. The strongest ideas were then vectorized and refined using Adobe Illustrator. After successfully creating a black and white mark, color and type were explored and added.
Results: The project was successful because it combines two different elements and communicates what the business is about in whimsical and unusual way.

126 ZINNEKEN'S GOURMET WAFFLES | School: University of North Texas
Instructor/Professor: Douglas May | Student: Anna Long
Assignment: Created a proposed trademark for a gourmet waffle restaurant.
Approach: The letterform was designed to resemble a golden brown waffle.

127 EMPEROR APPAREL | School: Texas State University
Instructor/Professor: Genaro Solis Rivero | Student: Andres Meza
Assignment: To create a logo for the brand Emperor, which is a fashion forward apparel company that provides brisk looks and elegant clothes for both men and women.
Approach: The process began with creating a list of objects related to the brand, then creating thumbnails for roughs of unique conceptual solutions. The chosen mark showcases two main brand objects, Shoes and a Penguin, that represents adaptability.
Results: The brandmark is successful because it captures the slick appearance of a penguin and dress shoes. The black and white color scheme is bold yet elegant.

127 INTOSPACE | School: Texas State University
Instructor/Professor: Genaro Solis Rivero | Student: Kierra Simmons
Assignment: The goal of this project was to create a logo for Intospace, a planetarium that offers an immersive learning experience through augmented and virtual reality.
Approach: I took a morphological approach of integrating the planet into the letter O.
Results: The trademark is simple, bold and successfully captures the concept of space and matches the personality of the planetarium.

127 BAKEOLOGY | School: Texas State University
Instructor/Professor: Genaro Solis Rivero | Student: Felipe Rodriguez
Assignment: The goal of this project was to create a logo for a particular Bakery shop that uses a more scientific and tech approach. Bakeology.
Approach: I took a morphological approach, combining a microscope and a croissant. The end-result product shows their scientific process—symbolized by the microscope.
Results: This logo is very successful in capturing the science behind their technique to bake goods. It positions the brand in a unique, simple, yet effective way.

127 EZ GRILL | School: Texas State University
Instructor/Professor: Genaro Solis Rivero | Student: Daniela Dunman
Assignment: The goal of this project was to create a letterform logo design, by combining an object and a letter, for EZ Grill, an EZ's-inspired restaurant.
Approach: I morphed the letters "e" and "z" into a burger. Each part was colored differently to represent different burger ingredients. The colors are inspired by EZ's.
Results: This logo is successful because it implies the nature of the establishment (a restaurant), and it is simple while being playful, eye-catching, and recognizable.

127 DRUPA LOGO | School: Texas State University
Instructor/Professor: Genaro Solis Rivero | Student: Robert Warrix
Assignment: To create an identity system for the Drupa 2021 conference.
Approach: The process began with extensive word listing, and thumbnail sketching to come-up with a creative solution for the Drupa Printing conference. The morphological approach combined the letter D with a piece of paper.
Results: The project is successful because it combines the printing with the letter D.

128 ROSAMONTE PACKAGING | School: Brigham Young University
Instructor/Professor: Adrian Pulfer | Student: Marie Oblad
Assignment: Redesign packaging for an existing brand by creating a visual language that resonates with the history and cultural aspects of the product, elevate the brand, and introduce it to a new audience.
Approach: The redesign is inspired by the local wildlife and indigenous weaving patterns that connect the mate brand to Misiones, Argentina. The color palette is based on the local landscape. Each flavor is represented by a different animal on the label.
Results: This packaging solution reflects the lively identity and quality of the brand. It makes it appealing to new consumers with a contemporary, charming, and refined feel that makes it stand out from the rest.

129 CUIT BAKERY CAFE | School: Texas State University
Instructor/Professor: Carolyn Kilday | Student: Alondra Vazquez
Assignment: To create a packaging system for Cuit bakery.
Approach: The process began with researching other bakeries packaging. Once there was an understanding of the necessary components needed to be functional I was able to explore shapes and colors to fit Cuits brand.

Results: This project successfully created a packaging system that was functional and memorable for its shapes and colors.

130 AASAV / INDIAN SPICED GIN | School: Syracuse University, College of Visual and Performing Arts | Instructor/Professor: Unattributed | Student: Jenna Wengle
Assignment: In today's day and age, many health and fitness advocates cut drinking alcohol from their diet for numerous reasons. Inspired by India's health regime, Aasav's objective is to provide a holistic line of Indian Spiced Gin that contain multiple antioxidants and create a liquor that promotes a mindful consumption of alcohol.
Approach: India's architecture and spiritual beliefs heavily influenced the approach in creating the bottle designs. Ancient Indian art and architecture promote the ideologies of Buddhism and Hinduism through the use of iconographies such as gods/goddesses and nature. This type of iconography symbolizes the knowledge and purity of the body, speech, and mind. The imagery of structures within India and an array of greenery were therefore used as a means to capture these ideas.

131 DIGIORNO PACKAGING REDESIGN | School: Texas A&M University Commerce Instructor/Professor: Garrett Owen | Student: Kaitlin Deutsch
Assignment: We were randomly assigned various products that needed a redesign. I was assigned DiGiorno frozen pizza due to the lack of a cohesive branding system.
Approach: I decided to creative a vintage Italian/art deco inspired design system to solidify the top quality of the product regardless of its affordable price. I also opted for a delivery style pizza box to play along with their tagline, "it's not delivery, it's DiGiorno." For each flavor and crust type I applied a different Italian-inspired color scheme to the same design to maintain a consistent visual system across the entire product line.
Results: A packaging system that was unique from all other frozen pizza brands and appears accessible to the wide target audience of DiGiorno.

132 DYNAMIC POWER OF KOREA | School: Hansung University, Design & Art Institute Instructors/Professors: Dong-Joo Park, Seung-Min Han | Student: Ji Young Moon
Assignment: Create a national symbol image poster promoting Korea while promoting the performing arts of Taekwondo.
Approach: The broken pine boards form the word taekwondo and express the colors of Korea, Convey the message of 'Dynamic Korea, Power of Korea'

133 THE FAITH CELL PROMOTION POSTER | School: ArtCenter College of Design Instructor/Professor: Simon Johnston | Student: Eun Jung Bahng
Assignment: The Faith Cell is a hypothetical exhibition held at The Museum of Modern Art, featuring four artists whose works are inspired by shamanism—Nam June Paik, Joseph Beuys, Saya Woolfalk, and Jeremy Shaw.

134 DO YOU WANNA PLAY A GAME? | School: National Taiwan University of Science and Technology | Instructor/Professor: Ken Tsai Lee | Student: Ying Chun Chen
Assignment: 1.Do you wanna play a game? Stop it! Nuclear power is not funny! (The game of death combined nuclear and hand spinner.) 2.Do you wanna play a game? Stop it! Oil spill is not funny! (The game of death combined oil barrel and water gun.) 3.Do you wanna play a game? Stop it! The war is not funny! (The game of death combined bomb and kendama.)

135 INTERNATIONAL CONFERENCE ON MATHEMATICS OF PAPER FOLDING POSTER | School: Texas A&M University Commerce | Instructor/Professor: Josh Ege Student: Jonathan Berumen
Assignment: Make a poster for real-world events. The event I got was the International Conference of Paper Folding. Mathematics of Paper Folding Conference aims to bring together leading academic scientists, researchers, and research scholars to exchange and share their experiences and research results on all aspects of Mathematics of Paper Folding Conference.
Approach: The concept was to visually show the act of folding like with origami. For a different approach, I used typography as the main visual instead of just illustrating folded paper. Origami has a repetitive movement of folding and that lead to this design.

136 THE GODFATHER | School: School of Visual Arts
Instructor/Professor: Eileen Hedy Schultz | Student: Fangzhao Zhou
Assignment: Poster design for sophomore basic graphic design class.
Approach: I inspired from the movie's name, and create the visual combination of design.

137 CC BALLET | School: Texas State University
Instructor/Professor: Genaro Solis Rivero | Student: Chelsea Wechsler
Assignment: To rebrand the CC Ballet company with a more modern look, to help elevate them in the movement of ballet in modern culture.
Approach: The process began with creating an abstract logo that reinforces the idea of inclusivity as it represents dancers in a non-conformitive way. The arrangement of the logo mark represents the figure of a dancer in arabeqsque and also the foundation footsteps that are taught to dancers. The logo inspired the rest of the brand by utilizing the dots that are seen in the logo to highlight the form of the dancer's body in any imagery used, such as the stationery, show posters and website.
Results: This project was successful because of the versatility that the logo can inspire different shapes and movements throughout the system. It speaks to the inclusivity of all dancers and viewers as it brings the company into a more modern day appearance for such a timeless art form.

138 NAMGANG YUDEUNG FESTIVAL | School: Hansung University, Design & Art Institute | Instructors/Professors: Dong-Joo Park, Seung-Min Han | Student: Eugene Kim
Assignment: In South Korea, there is a traditional lantern festival called NAMGANG YUDEUNG FESTIVAL. In spite of its scale and historicalness, overall visual design was not developed till recently (poster is representative example). So I devised a project to redesign the poster so it can be a more appropriate visual for a traditional Koeran festival.
Approach: Origin of the festival is war. Yudeungs (lanterns) were used as military signals to prevent armies from crossing the river and as communications to sent their safety to families. This stories were very charming so i thought i should express in poster. First, placed traditional elements such as soldiers, dragon, namgang-river, jinju castle, lanterns like they are making a story and added little crowd below. Also used diverse korean traditional color to express festival's own mood.
Results: I displayed the poster on my degree show. and crowd, especially interested in tradition were loved my work. I have confidence of my work and planning to talk with Jinju-si so my poster can be official next year.

139 GONE WITH THE WIND POSTER | School: Texas Christian University
Instructor/Professor: Lewis Glaser | Student: Trevor Scott
Assignment: To design a poster for a critically-acclaimed movie that is part of a hypothetical film festival. The goal of the poster was to conceptually communicate the film's message with use of hand-manipulated typography and supportive imagery.
Approach: My approach was to focus on the underlying message presented in "Gone With the Wind," which tells the story of how Southern America was consequentially never the same following the events of the Civil War. I used Scarlett O'Hara's (the main character) final quote in the movie and connected it to a map of 1861 Atlanta, Georgia. The map is burning, highlighting the degradation of the south. However, it reveals a clean, empty canvas to communicate how the South has the chance to rebuild with a clean slate. I used hand-manipulated typography, which was painted with a quill pen in gold ink, to provide a sense of hope with the powerful quote. The plan was to give the type a feminine feel to connect the quote to the artist (Scarlett).
Results: This poster is successful in communicating the concept in a simple manner. The hand manipulated typography is meant to have some personality to it as a script hand-written quote, which I believe works well. It was well received by peers and professors.

140 THE THIRD MAN | School: Texas Christian University
Instructor/Professor: David Elizalde | Student: Michaela Bollinger
Assignment: Create a poster for an assigned movie to be shown in a film festival.
Approach: I was assigned The Third Man, a noir murder mystery film, so I decided to create a black and white poster designed like an evidence map. I paced the film in the Cold Bodies Film Festival to capitalize on the murder mystery aspect and open the festival possibilities to murder mystery movies from any era and movie genre.
Results: The final poster connects each major plot point through artifacts and photos from the film. The noir style of the movie is translated through the black and white coloring and the type-writer-like typeface used for the movie title. The headline is created through the intertwined thread connecting each aspect of the movie, and the composition is completed by the festival information stamped on the bottom.

141 UNMASKED | School: Texas A&M University Commerce
Instructor/Professor: Virgil Scott | Student: Kaitlin Deutsch
Assignment: This poster series was created for a course called Cross Cultural Design, in which we learned how design can be an international language and that cultures that are opposite to our own deal with the same issues. The specific issue we addressed in our assignment was climate change and how it has specifically affected China.
Approach: I wanted to illustrate how China's ancient and rich culture is often not the first thing that comes to mind when thinking of China, and is instead associated with extreme air pollution and the masks that many Chinese people wear to tolerate an increasingly unbreathable atmosphere. The illustration of the masks act as a metaphor for how climate change will render all culture, no matter how old and established, useless in the face of the need to survive the changing conditions on our planet. ■ For more information, visit www.climateiscrosscultural.com
Results: Ironically this idea was conceptualized before the pandemic was declared in the United States, and really doesn't relate to the issue of COVID-19. However, I believe that any non-Chinese viewer of this poster has a better understanding of the burden of needing to wear a mask in order to out in public, and can better sympathize with those directly affected by climate change, and will need to wear a mask after the pandemic is over.

142 PRAISE THE NEON GOD | School: Sejong University
Instructor/Professor: Daeki Shim | Students: Yujin Cho, Junhaeng Lee
Assignment: With the development of technology people are leading comfortable lives, but they have become reliant of the technology. They absorb only the information exposed on the media which has been proven to greatly reduce their thinking ability. In this exhibition, artists criticize the phenomenon through Neon God, which deceives people with technology and media in order to break the silence and regain the ability blocked by Neon God.
Approach: If you look at the colorful squares that signify the screen of digital media, many people are easily dazzled by the color and movement. However, these squares move quickly and randomly distort information, making the text difficult to read. Then people get surrounded by unknown information that pours out every day and is trapped in the screen. This makes people hard to understand information. Furthermore, They lose their judgment and discernment.

143 KENDRICK LAMAR MUSIC ICON | School: University of Cincinnati, DAAP
Instructor/Professor: Reneé Seward | Student: Katie Van Gulick
Assignment: The development of a compelling visual design system seeks to unify a system's differing components yet instill excitement through its innovative representation of meaning. This project focuses on the manipulation and arrangement (composition) of typography and image as it conveys messages through a poster series.
Approach: Hands painted with negative words represent Lamar wearing their critiques on his sleeve and holding himself high inspite of their messages. The hand is constricted with tight bands and held down with colorful tethers, representing those people who tried to hold down music icons for sharing messages they didn't believe in. Waving, large scale text furthers the message of Lamar spreading his message regardless of critique with its unabashed brightness and major occupation of page space.
Results: Music icons are fearless, bold, and unapologetically individual. They push through the traditional ideals held by people of their time to spread the message they feel called to share. Though others may try to constrict and pull down an artist for sharing messages they don't deem acceptable, music icons are always able to shine through their defiers. Their fearless expression of individuality and ideals have been catalysts for change throughout history and is the very thing that makes them iconic.

144 THOUGHTS AND PRAYERS | School: University of Cincinnati, DAAP
Instructor/Professor: Reneé Seward | Student: Kiley Gawronski
Assignment: The development of a compelling visual design system seeks to unify a system's differing components yet instill excitement through its innovative representation of meaning. This project focuses on the manipulation and arrangement (composition) of typography and image as it conveys messages through a poster series.
Approach: I tried to communicate using metaphor, with the image and text creating a tear. ■ The small pop of yellow was purposeful in being eye-catching without overwhelming the content of the tear, which I felt was the most important part of my composition and message. I chose yellow because it was still bright without being in your face

and there was less vibration with the halftoned background, which kept the text legible.
Results: My concept for this poster was centered around the tension and meeting point of the two sides of the conflict. I took the tear and applied the words "Thoughts and Prayers" which is often the only action many policymakers and people make after a school shooting. The kids leading March for Our Lives make it clear that what we need is a policy change and common-sense gun control, which is met with backlash.

145 NORTH BY NORTHWEST MOVIE POSTER | School: Texas Christian University
Instructor/Professor: David Elizade | Student: Annika Ballestro
Assignment: Goal of the project was to create a movie poster that relied on hand manipulated type. The title movie (North By Northwest) was predetermined. A secondary goal was to create a fictional film festival logo and incorporate it into the poster.
Approach: I took inspiration from the setting of the movie which was the Pacific Northwest, and a match which is a recurring tool from the movie. To manipulate the type, I used a wood-burning tool to burn the headline into a piece of wood then photoshop the headline onto the poster image. The film festival title was chosen because North By Northwest was selected by the Writer's Guild as one of the 101 best screenplays of all time.
Results: A movie poster with unique hand-manipulated type that represents the feel of the movie. The film festival logo represents the prestige and class of the Writer's Guild.

146 INTERACITVE POSTER / ARCADE GAME CERN | School: University of Ljubljana, Academy of Applied Arts and Design | Instructor/Professor: Boštjan Botas Kenda
Student: Ana Valenko
Assignment: To approach scientific discoveries in an interesting, funny and clear way that intrigues people and animates them into research, or at least an in-depth understanding of a given content. In any case, bringing the discoveries and events in science closer to everyday life. ■ The problem is the scientific language code which is the wider masses are moving away from understanding the fundamental functioning of things in the everyday environment, the larger systems in which they live and operate. If people understood the new effects of technology, new discoveries in the field of science in the micro and macro-even cosmos world, new ideas and applications of new discoveries would begin to be created according to the principle of 'more heads, more knowledge'.
Approach: An interactive poster with an arcade game in a humorous and simplified way shows the operation of one of the largest innovation centers in the world Cern, where scientists design and manufacture new instruments for detectors and accelerators to explore new scientific frontiers in particle physics. ■ The atoms are represented by LED lights circulating through a circular scheeme that represents accelerators. Above every accelerator is written required speed with wich atoms can travel through the sistem. User speeds and pushes the 'atoms'/LED lights in the next accelerator/circular scheme by pressing on the button in the right time. LED light is getting faster in every accelerator and gets divided in the last one where collides in the middle. Just like atoms don't always collide, LED light is programmed to collide at random succesful operation. The entire basic procedure and logic behind Cern accelerators is explained with few simple arcade game elements.

147 WHO AM I ANYMORE? | School: M.AD School of Ideas Miami
Instructor/Professor: Ginny Dixon | Student: Keerthikeyan Dakshinamurthy
Assignment: People's sense of self-identity is declining due to the rise of technology and social media. I wanted to create a series of posters highlighting this issue.
Approach: Photoshopping photos of people with a robot underneath their faces as a poster series to showcase what people could be turning into. I also thought this campaign would be perfect to launch on Halloween to incorporate a spooky element.

147 PENCIL | School: School of Visual Arts
Instructor/Professor: Kevin O'Callaghan | Student: Zhuoyuan Li
Assignment: Madison Ave public exhibition 'ONE OF A KIND LUXURY'
Approach: 288 pencils made these shoes. That's enough to write 12.9 million words.
Results: Published in Maire Claire magazine, Oct 2018.

148 BROOKLYN BRIDGE DRESS | School: School of Visual Arts
Instructor/Professor: Kevin O'Callaghan | Student: Barbara Cadorna
Approach: My piece was inspired by the Brooklyn Bridge, which held the superlative of the longest suspension bridge in the world for two decades. Opened on May 24, 1883, It was an honor to use all the history behind this revolutionary architecture as inspiration.
Results: "Hemlines From Skylines," Architectural Fashion along Madison Avenue BID. Inspired by New York's iconic art deco architecture, more than 15 sculptural dresses created by students from SVA's BFA Design and BFA Interior Design programs were spread through Madison Avenue, celebrating the fall fashion season; and then installed during the Christmas season at 75 Rockefeller Plaza.

149 HOCKDI | School: Royal College of Art
Instructor/Professor: Alex Williams | Student: Johannes von Schoenebeck
Assignment: To design a piece of furniture for low-cost and easy production.
Approach: The bench gains it stability due to it's unique construction without the need for adhesives. It was designed it in a way, that it can be manufactured from ready-made goods and off-the-shelf parts. ■ The planed and chamfered timber is cut to length and joined with screws. ■ The bench can be made form ash, walnut, oak, or any other solid wood. ■ To increase comfort indoors, an upholstered cushion can be added. ■ In humid environments such as outdoors, the horizontal beam at the very bottom can be exchanged for a custom made sheet metal piece.

149 CHAINSAW REDESIGN | School: M.AD School of Ideas at Portfolio Center
Instructor/Professor: Hank Richardson | Student: Dimitri Ferreira
Assignment: My redesign of the chainsaw focuses on safety, simplicity, and intuitive features making it specifically for unexperienced, intimidated users, and for those who see no need into hiring a company to do the backyard trimming.
Approach: I wanted to redesign a product that does not see a lot of attention and recent changes. I had a life-threatening experience from a chainsaw and I wanted to make the change in fear but insipration to create something safe.
Results: Project was given extremely postive feedback along with suprise due to the he chainsaw lacking innovation for many of years.

150 MOHAWK SUMMER FLAVORS PAPER SAMPLER | School: California State University, Fullerton | Instructor/Professor: Theron Moore | Student: Andre Gomez
Assignment: A paper sample product designed to showcase Mohawk's summer-oriented colored papers. Contextualized around ice cream and its various flavors, the paper sampler intends to be interactive and palpable through prompting the handler to mix-and-match "flavor swatches" held within this booklet.

151 MAZDA 2035 SAGITTA CONCEPT | School: ArtCenter College of Design
Instructor/Professor: Ricky Hsu | Student: Taylor Chen

151 LABYRINTH | School: University of Illinois at Chicago
Instructor/Professor: Sharon Oiga | Student: Nada Abourashed
Assignment: To create innovative typography by exploring materials and a physical process as well as to premise the concept on a self-written narrative.
Approach: Based on Labyrinth, a short story written in class during the Writing Workshop portion of the course, letterform maze objects were constructed using laser-cut plexiglass.
Results: All twenty-six letters of the alphabet were created as handheld maze objects.

152 TYPEFACE TWIST | School: OCAD University
Instructor/Professor: Martyn Anstice | Student: Vivian Chen
Assignment: Typeface Twist is a san serif display typeface inspired by ribbons. Design emphasizes on the characteristic of the object and its flexibility to form multiple twists.
Approach: Clean and simple strokes make Twist a minimal and a modern typeface. The twisting points in each letterform creates a typeface that is also decorative and feminine. The design evokes a sense of fluidity, elegance, and quirkiness.
Results: Typeface Twist can be used as headlines for magazine, packaging, poster, and album artwork. While the design is intended to be used for fashion branding, it is also suitable for art and music branding.

153 ANATOMY A TO Z | School: School of Visual Arts
Instructor/Professor: Tina Fong | Student: Junghoon Oh
Assignment: Making A to Z book with own concept
Approach: I looked at the Anatomy A to Z index, which was blooming on the bookshelf, and although there were many strange and exciting parts, I designed my own Anatomy A to Z Letterbook to make it easier to get closer to the specialized fields where I was not interested in reading books.

154 ABC POSTER | School: University of Texas at Arlington
Instructor/Professor: Veronica Vaughan | Student: Giorgi Woolford
Assignment: This poster was created for the Personal Expression in Type exhibition that was showcased at the University of Texas at Arlington. Designers were to choose a typeface to experiment with and make it personal to them.
Approach: The typeface chosen for this poster was Franklin Gothic and the letters were morphed into following objects represented in traditional tattoo art. The letters were created in Adobe Illustrator and shaded to add a grungy effect to the poster. All of the letters follow the traditional tattoo theme, such as the R for Rose and the K for knife.
Results: Traditional tattoo art is composed of beautiful line work and edgy themes that have always been a part of my life. I admire the beauty of it and decided to replicate it in my own style of design.

155 CALLA LILY | School: Syracuse University, The Newhouse School
Instructor/Professor: Claudia Strong | Student: Xiaoqian Dong
Assignment: This is a typeface inspired by calla lilies.
Approach: This typeface panel is inspired by my muse Martha Coria. Calla lily is her favorite flower, so I tried to design my typeface long and rounded. She also said she prefers to have the typeface well organized and not to be complex. So I tried to design it without too many curves or decorations.
Results: Calla lily looks nice and easy to read.

156 LP DESIGN/ YOU ARE FREE BY CAT POWER | School: School of Visual Arts
Instructor/Professor: Peter Ahlberg | Student: So Youn Chun
Assignment: LP Design tor the album You are free by Cat Power.
Approach: Transparency is a keyword for this project. Cat Power's voice is like a dandelion in a concrete jungle. It's soft but has a strength inside. I used a chubby typeface that I manipulated and used with an outline. I reversed the left and right of the front design and put it for the back cover so the front and back goes together transparently.

157 VINYL COVER DESIGN | School: School of Visual Arts
Instructor/Professor: Justin Colt | Student: Junghoon Oh
Assignment: I was assigned to design an album cover design. Justin randomly assigned me a typographic movement and a music genre.
Approach: My typographic movement and music genres were constructivism and jazz. B.B King's soul made it possible for me to approach the design. His sharp sound is similar to the composition of constructivism.

158 FLIP SIDE: SELF-PROMOTION | School: University of North Texas
Instructor/Professor: Erica Holeman | Student: Javier Ruiz Navarro
Assignment: In this project, each student decides on a problem appropriate to their own career goals to address. It begins with goal setting, research, creative briefs and drafting a timeline before finally designing and producing a piece to meet that challenge. The primary aim is to produce an artifact outside of a portfolio or website that can promote the student and their work.
Approach: A record/vinyl set was decided as an ideal medium to showcase some personality alongside a passion for music and crafting physical pieces. It begins with the record cover: a seemingly simple title made of physical materials and photographed. Held one way the typography reads "flip"; but rotate it 180 degrees and it reads as "side". The concept of thinking of things from a different angle carries through with the inner sleeve. A grid of photographed constructed forms spell out "on the flip side, unexpected things happen". Each word is constructed out of materials that can be "flipped" — tables, burgers, and more. Finally, the laser-cut and etched acrylic record nestled inside links to a custom playlist and holds a coin with the designer's portrait overlaid.

SILVER DESIGN WINNERS:
160 NEW YORK TIMES 2020 ANNUAL REPORT | School: University of Texas Arlington
Instructor/Professor: Pauline Hudel Smith | Student: Dan Pham

160 CIRCLES | School: Academy of Art University
Instructor/Professor: David Hake | Student: Ruonan Hu

161 THE EXTRAORDINARY VOYAGES | School: Brigham Young University
Instructor/Professor: Adrian Pulfer | Student: Wil Osborne

161 BLEEDING EDGE | School: Pennsylvania State University
Instructor/Professor: Taylor Shipton | Student: Ronald Feinberg

161 BLUE IS THE WARMEST COLOR | School: Pennsylvania State University
Instructor/Professor: Taylor Shipton | Student: Jackie Siry

161 SIMONE DE BEAUVOIR BOOK SERIES | School: Brigham Young University
Instructor/Professor: Adrian Pulfer | Student: Monica Mysyk

162 SCHOOL OF THE ART OF DENIAL (S.A.D) | School: Maryland Institute College of Art | Instructor/Professor: Ellen Lupton | Student: Anjali Nair

162 MARS TRILOGY | School: Brigham Young University
Instructor/Professor: Adrian Pulfer | Student: Ben Law

162 A LAND OF TALES | School: M.AD School of Ideas San Francisco
Instructor/Professor: Nelson Carnicelli | Student: Aarti Thamma

162 SEOUL BIENNALE OF ARCHITECTURE AND URBANISM BOOK
School: ArtCenter College of Design | Instructor/Professor: Cheri Gray
Student: Eun Jung Bahng

163 PHENOMENAL WOMEN - BOOK SERIES | School: Brigham Young University
Instructor/Professor: Adrian Pulfer | Student: Deb Figueroa

163 TONI MORRISON BOOK COVERS | School: Brigham Young University
Instructor/Professor: Adrian Pulfer | Student: Gracie Nicholas

163 DARKNESS AT NOON | School: Texas Christian University
Instructor/Professor: David Elizalde | Student: Trevor Scott

163 DISCUSSING TIME — TIME HAS PAST | School: School of Visual Arts
Instructor/Professor: Olga Mezhibovskaya | Student: Zona Guan

163 DREAM AGE: LOVE, DEATH & SEX | School: ArtCenter College of Design
Instructor/Professor: River Jukes-Hudson | Student: Jingping Xiao

164 TSHKEEL EDUCATIONAL SYSTEM | School: Thomas Jefferson University
Instructor/Professor: Beth Shirrell | Student: Iman Morsy

164 EDGAR ALLAN POE BOOKS | School: Brigham Young University
Instructor/Professor: Adrian Pulfer | Student: Marie Oblad

164 ROMEO AND JULIET BOOK COVER | School: M.AD School of Ideas Miami
Instructor/Professor: Vassoula Vasiliou | Student: Tássia Dias Valim Cunha

164 GRID | School: School of Visual Arts
Instructor/Professor: Olga Mezhibovskaya | Student: Fangzhao Zhou

164 THE FAITH CELL | School: ArtCenter College of Design
Instructor/Professor: Simon Johnston | Student: Eun Jung Bahng

164 PALE FIRE BOOK COVER | School: Texas Christian University
Instructor/Professor: David Elizade | Student: Annika Ballestro

164 WIDE SARGASSO SEA BOOK COVER | School: Texas Christian University
Instructor/Professor: David Elizalde | Student: Lindsay Browne

165 IF I DON'T TALK, WHO WILL? | School: ArtCenter College of Design
Instructor/Professor: Cheri Gray | Student: Chelsea Le

165 GOD DOES NOT PLAY DICE | School: ArtCenter College of Design
Instructor/Professor: Brad Bartlett | Student: Kenneth Kuh

166 RANCH IT UP | School: ArtCenter College of Design
Instructor/Professor: Simon Johnston | Student: Haozhe Li

166 TYPE UNWRAPPED | School: Capilano University
Instructor/Professor: Heather Jalbout | Student: Sara Nguyen

167 JULES VERNE BOOK COVERS | School: Kutztown University of Pennsylvania
Instructor/Professor: Karen Kresge | Student: Rebecca Schupp

167 A BAUHAUS PILGRIMAGE | School: Brigham Young University
Instructor/Professor: Adrian Pulfer | Student: Lauren Canizales

167 FELLINI: LA STRADA | School: University of Ljubljana, Academy of Fine Arts and Design | Instructor/Professor: Eduard Čehovin | Student: Ana Valenko

167 THE ARKENSTONE GALLERY | School: University of North Texas
Instructor/Professor: Stephen Zhang | Student: Tama Higuchi-Roos

167 I AM FASHION | School: Texas Christian University
Instructor/Professor: Yvonne Cao | Student: Cassie Schmidt

168 REMINISCENCE | School: Texas Christian University
Instructor/Professor: Yvonne Cao | Student: Rae McCollum

168 MODELS OF SILENCE | School: ArtCenter College of Design
Instructors/Professors: Cheri Gray, Angad Singh | Student: Jack Moore

168 STREETLIGHTS | School: Texas State University
Instructor/Professor: Genaro Solis Rivero | Student: Seth Jones

168 FILM BOOKLET PAISAN | School: University of Ljubljana, Academy of Fine Arts and Design | Instructor/Professor: Eduard Čehovin | Student: Ana Karlin

168 HOW GREAT SALES LEADERS MAKE THINGS HAPPEN | School: TU Dublin
Instructor/Professor: Unattributed | Student: Finán Callaghan

169 TIMBER PRESS | School: School of Visual Arts
Instructors/Professors: Courtney Gooch, Rory Simms | Student: Miki Isayama

169 BRANDING/BRAND IDENTITY FOR EXHIBITION | School: School of Visual Arts
Instructor/Professor: Willie Ip | Student: Alicia Liu

170 SEOUL BIENNALE OF ARCHITECTURE AND URBANISM | School: ArtCenter College of Design | Instructor/Professor: Cheri Gray | Student: Eun Jung Bahng

170 THE ENJOYMENT OF DAYDREAMING | School: Hansung University, Design & Art Institute | Instructors/Professors: Dong-Joo Park, Seung-Min Han
Student: Gi Hyeon Kim

170 PANIC PINBALL EXPO | School: Texas State University
Instructor/Professor: Genaro Solis Rivero | Student: Jennifer Garza

170 GLOBE JAM | School: Portland Community College
Instructor/Professor: Nathan Savage | Student: Spencer Olson

171 ASARASI BRANDING | School: Brigham Young University
Instructor/Professor: Adrian Pulfer | Student: Brenna Vaterlaus

171 760 MOD BRANDING | School: Texas Christian University
Instructor/Professor: Jan Ballard | Student: Sarah Cuttic

171 SUNKIST REBRAND | School: ArtCenter College of Design
Instructors/Professors: Gerardo Herrera, James Chu | Student: Jack Moore

171 THE BAO | School: School of Visual Arts
Instructor/Professor: Jon Newman | Student: Justin Wong

171 TORCHLIGHT | School: West Chester University
Instructor/Professor: Scotty Reifsnyder | Student: Chuck Scott

171 SUN SNO FESTIVAL | School: Texas State University
Instructor/Professor: Carolyn Kilday | Student: Colby Gill

172 ELECTRONIC ENTERTAINMENT EXPO | School: ArtCenter College of Design
Instructor/Professor: Rudy Manning | Student: Haozhe Li

172 GUEREWOL FESTIVAL REBRAND | School: ArtCenter College of Design
Instructor/Professor: Brad Bartlett | Student: Kenneth Kuh

173 CHAVELA'S RESTAURANT BRANDING | School: School of Visual Arts
Instructor/Professor: Eric Baker | Student: Junyu Chen

173 LUNCH BRANDING | School: School of Visual Arts
Instructors/Professors: Ros Knopov, Graydon Kolk | Student: Junghoon Oh

174 FUTURIUM | School: Moholy-Nagy University of Art and Design Budapest
Instructor/Professor: Balázs Vargha | Student: Ágoston Hajdú

174 MOONDANCE FILM FESTIVAL | School: University of North Texas
Instructor/Professor: Douglas May | Student: Taylor Minth

174 CHOCOLATE FOR MEN BRAND IDENTITY | School: Texas Christian University
Instructor/Professor: David Elizalde | Student: Rebecca Lang

174 SANTA FE OPTICAL | School: Texas State University | Instructor/Professor: Holly Sterling | Students: Megan Myles, Chantal Lesley, Nathanael Loden, Jack Parker

174 STARCK BRAND IDENTITY | School: School of Visual Arts
Instructors/Professors: David Frankel, Shawn Hasto | Student: Jiin Choi

174 SAN FRANCISCO SALT CO. | School: Brigham Young University
Instructor/Professor: Adrian Pulfer | Student: Bram Linkowski

175 UNLIKE: THE ASHESI CREATIVE CHALLENGE | School: Ashesi University
Instructor/Professor: Unattributed | Student: Jean Quarcoopome

175 SOUTH EATS ASIAN BAR AND KITCHEN | School: Concordia University
Instructor/Professor: John DuFresne | Student: Fuechee Thao

175 WISDOME.LA | School: Brigham Young University
Instructor/Professor: Adrian Pulfer | Student: Ben Law

175 EMBODY: WEARABLE ART SHOW | School: Temple University, Tyler School of Art & Architecture | Instructor/Professor: Abby Guido | Students: Olivia Colacicco, Josephine Kostusiak, Wenqing Liu, Tara Ryan

175 OMERTÁ | School: Texas State University
Instructor/Professor: Carolyn Kilday | Student: Carolina Martinez

175 SWEETEASY | School: Maryland Institute College of Art
Instructor/Professor: Ellen Lupton | Student: Celi Monroe

176 ERROR: ART OF IMPERFECTION | School: ArtCenter College of Design
Instructor/Professor: Cheri Gray | Student: Jaiwon Lee

176 ON SALE POP-UP SHOP | School: Brigham Young University | Instructor/Professor: Linda Reynolds | Students: Monica Mysyk, Audrey Hancock, Dominique Mossman

177 BEYAZIT STATE LIBRARY REBRAND | School: ArtCenter College of Design
Instructor/Professor: Brad Bartlett | Student: Kenneth Kuh

177 SCOTLAND RUGBY REBRAND | School: Brigham Young University
Instructor/Professor: Adrian Pulfer | Student: Bethany Coates

177 MMCA | School: ArtCenter College of Design
Instructor/Professor: Rudy Manning | Student: Yicen Liu

177 CHINATI ART MUSEUM | School: ArtCenter College of Design
Instructor/Professor: Brad Bartlett | Student: Jisu Kim

177 SMALLS JAZZ CLUB BRANDING | School: Brigham Young University
Instructor/Professor: Adrian Pulfer | Student: Lauren Canizales

178 CHARLES THEATRE BRANDSHIFT | School: Maryland Institute College of Art
Instructor/Professor: Jennifer Cole Phillips | Student: Xinmeng Yu

178 THE MIMIC MUSEUM | School: Maryland Institute College of Art
Instructor/Professor: Minsun Eo | Student: Xizhong Zhang

179 QUICK COOK | School: Texas State University
Instructor/Professor: Genaro Solis Rivero | Student: Kara Watterson

179 FALL INTO A HOLE OF FUN, HITE HOLE | School: Hansung University, Design & Art Institute | Instructors/Professors: Dong-Joo Park, Seung-Min Han
Students: Ji Young Moon, Yoon Ki Lee

179 THE FARRINGTON INN REBRAND | School: Texas Christian University
Instructor/Professor: Bill Brammar | Student: Kenzie Ashley

179 RESTAURANT BRANDING | School: Texas Christian University
Instructor/Professor: David Elizalde | Student: Gretchen Rea

179 SLOWPOKE | School: Texas State University
Instructor/Professor: Carolyn Kilday | Student: Kristen Todorovich

179 COWBOY CULTURE | School: Texas Christian University
Instructor/Professor: Yvonne Cao | Student: Nicole Oesterreicher

180 7-ELEVEN | School: University of North Texas
Instructor/Professor: Douglas May | Student: Andrew Ashton

180 BEACON'S CLOSET | School: Brigham Young University
Instructor/Professor: Adrian Pulfer | Student: Brenna Vaterlaus

180 BERLIN ATONAL, 2021 | School: School of Visual Arts
Instructors/Professors: Courtney Gooch, Rory Simms | Student: Miki Isayama

181 THE UNDERGROUND MUSEUM | School: ArtCenter College of Design
Instructor/Professor: Cheri Gray | Student: Yanwen Hang

181 BONBON DELIGHTS | School: Columbia College Hollywood
Instructor/Professor: Evanthia Milara | Students: Helen Curtin, Steven Rhodes

181 DENALI RESTAURANT | School: Portland Community College
Instructor/Professor: Nathan Savage | Student: Sari Field

181 KUNSTHAUS GRAZ | School: University of North Texas
Instructor/Professor: Douglas May | Student: Javier Ruiz

181 4X5 PHOTO FEST | School: Texas State University
Instructor/Professor: Jeff Davis | Students: Brooke Holle, Chantal Lesley

182 CAPITOL STUDIOS BRANDING | School: Brigham Young University
Instructor/Professor: Adrian Pulfer | Student: Madi Jackson

182 ARTE LUISE HOTEL BRAND IDENTITY | School: ArtCenter College of Design
Instructor/Professor: Annie Huang Luck | Student: Sunny Tianqing Li

183 FILM BOOKLET NIGHTS OF CABIRIA | School: University of Ljubljana, Academy of Fine Arts and Design | Instructor/Professor: Eduard Čehovin | Student: Polona Kačič

183 REVOLUTIONARY EVOLUTION - WILSON SPORTING GOODS
School: Texas A&M University Commerce | Instructor/Professor: Geoff German
Student: Camryn Hezeau

183 WHAT IN JE NE SAIS QUOI? | School: University of North Texas
Instructor/Professor: Douglas May | Student: Hana Snell

184 AZTEC DECK | School: Concordia University
Instructor/Professor: John Dufresne | Student: Jorge Vázquez Tejeda

184 BODONI PLAYING CARDS | School: School of Visual Arts
Instructor/Professor: Unattributed | Student: Yunyang Li

185 SUPERPOSITION | School: ArtCenter College of Design
Instructor/Professor: Stephen Serrato | Student: Phoebe Hsu

185 NEWS MAGAZINE | School: California State University, Fullerton
Instructor/Professor: Theron Moore | Student: Nathaniel Ramirez

185 POS3R MAGAZINE | School: Portland Community College
Instructor/Professor: Nathan Savage | Student: Charlie Dulaney

186 AZURE MAGAZINE | School: Brigham Young University
Instructor/Professor: Adrian Pulfer | Student: Sydney Chiles

186 OBJEKT INTERNATIONAL REDESIGN | School: Brigham Young University
Instructor/Professor: Adrian Pulfer | Student: Wil Osborne

187 ARCH+ MAGAZINE | School: Brigham Young University
Instructors/Professors: Adrian Pulfer, Ryan Mansfield | Student: Zoë Hart-Wagstaff

187 THE MEDIUM IS NOT THE MESSAGE | School: ArtCenter College of Design
Instructor/Professor: Cheri Gray | Student: Phoebe Hsu

187 CRAFT AS TIME CAPSULE: POSTDIGITAL PRESERVATION
School: Pratt Institute | Instructor/Professor: Gaia Hwang | Student: Hsiao-Wen Hu

187 THE WELL | School: Pennsylvania State University
Instructor/Professor: Emily Burns | Student: Scotti Everhart

187 YOUR SYSTEM IS UNDER ATTACK | School: Portland Community College
Instructor/Professor: Nathan Savage | Student: Kristofer McRae

187 OH ★ FRUCTOSE | School: ArtCenter College of Design
Instructor/Professor: Annie Huang Luck | Student: Yanwen Hang

188 REBRANDING FOR THE SMITHSONIAN MAGAZINE | School: ArtCenter College of Design | Instructor/Professor: Annie Huang Luck | Student: Ellis Yu

188 JUXTAPOZ MAGAZINE REBRANDING | School: ArtCenter College of Design
Instructor/Professor: Annie Huang Luck | Student: Yuchen Xie

188 BLACK BOX / PUBLICATION | School: Syracuse University, College of Visual and Performing Arts | Instructor/Professor: Unattributed | Student: Nila Nejad

188 ASCEND | School: Texas Christian University
Instructor/Professor: Yvonne Cao | Student: Elizabeth Ireland

188 STRANDED: A SCOUT'S SURVIVAL GUIDE | School: Texas Christian University
Instructor/Professor: Yvonne Cao | Student: Elizabeth Ireland

188 FORKIT MAGAZINE | School: California State University, Fullerton
Instructor/Professor: Theron Moore | Student: Ada Loong

189 SECOND HAND MAGAZINE | School: California State University, Fullerton
Instructor/Professor: Theron Moore | Student: Sarah Fong

189 ECHO MAGAZINE 2020 | School: Columbia College of Chicago
Instructors/Professors: Guy Villa, Jr., Betsy Edgerton | Student: Janessa Torres
Designers: Sadaf Akhtar, Vicky Mavreas, Ronny Baker, Andrea Sperry, Chase Mincey, Gianella Goan, Memo Ferreira, Shannon Carrillo, Aleya Huebner

189 TRILL MAGAZINE | School: Texas Christian University
Instructor/Professor: Yvonne Cao | Student: Madeleine Alff

189 MINIMAL& MAGAZINE | School: School of Visual Arts
Instructor/Professor: Robert Best | Student: Mingxin Cheng

189 ROLLING STONE REBRAND | School: ArtCenter College of Design
Instructor/Professor: Annie Huang Luck | Student: Jack Moore

189 OSCILLATE MAGAZINE DESIGN | School: Drexel University
Instructor/Professor: Mark Willie | Student: Ashley Wiederspahn

189 NOMAD TRAVEL MAGAZINE | School: Texas Christian University
Instructor/Professor: Yvonne Cao | Student: Elizabeth Ireland

190 FORTUNE FASHION SPREAD | School: Pennsylvania State University
Instructor/Professor: Taylor Shipton | Student: Taylor Mazzarella

190 ABITARE MAGAZINE | School: Brigham Young University
Instructor/Professor: Adrian Pulfer | Student: Deb Figueroa

191 DOMUS MAGAZINE | School: Brigham Young University
Instructor/Professor: Adrian Pulfer | Student: Marie Oblad

191 NOOK MAGAZINE | School: George Brown College
Instructor/Professor: Jerri Johnson | Student: Brendan Irving

192 THE NEW ARMS RACE | School: Temple University
Instructors/Professors: Abby Guido, Jenny Kowalski | Student: Alex Kim

192 VIRTUAL EXHIBITION OF INTERNET LANGUAGE CULTURE 'YAMINJEONGEUM' | School: Hongik University | Instructor/Professor: Daeki Shim
Student: Hangeul Lee

193 AN UNDERLYING MESSAGE FROM THE GRID EXHIBITION CATALOG
School: Savannah College of Art and Design | Instructor/Professor: Melissa Kuperminc
Student: Kexin Chen

193 EYE IN THE LAKE | School: Savannah College of Art and Design
Instructor/Professor: Chuck Primeau | Student: Kexin Fan

194 SILK ROAD WONDERS | School: ArtCenter College of Design
Instructors/Professors: Ann Field, Christine Nasser | Student: Grace Park

194 ONLINE EXHIBITION PLATFORM FOR YOUNG ILLUSTRATORS
School: Hansung University, Design & Art Institute | Instructors/Professors: Dong-Joo Park, Seung-Min Han | Students: Gwak Se Ri, Mary Kim, and Jeon Su Jin

194 THE VOYAGE | School: ArtCenter College of Design
Instructors/Professors: Ann Field, Paul Rogers | Student: Haley Jiang

194 CHUSEOK NOSTALGIA | School: ArtCenter College of Design
Instructors/Professors: Brian Rea, Paul Rogers | Student: Grace Park

195 PORTRAITS OF WESTLAKE | School: ArtCenter College of Design
Instructor/Professor: Jason Holley | Student: Dominic Bodden

195 THE POSTER BUSAN 2020 | School: ArtCenter College of Design
Instructor/Professor: Unattributed | Student: Hyunjeong Yi

195 PROTECT THE POLLUTION OF THE OCEAN | School: Hansung University, Design & Art Institute | Instructors/Professors: Dong-Joo Park, Seung-Min Han
Student: Hyeeji Kim

195 RIP VAN WINKLE | School: ArtCenter College of Design
Instructors/Professors: Ann Field, Paul Rogers | Student: Haley Jiang

195 THE LEGEND OF SLEEPY HOLLOW | School: ArtCenter College of Design
Instructors/Professors: Ann Field, Paul Rogers, David Tillinghast, Rob Clayton
Student: Haley Jiang

195 THE SPECTRE BRIDEGROOM | School: ArtCenter College of Design
Instructors/Professors: Ann Field, Paul Rogers | Student: Haley Jiang

195 AN ILLUSTRATION FOR A POEM, PUNG-GYEONG | School: ArtCenter College of Design | Instructor/Professor: Unattributed | Student: Hyunjeong Yi

196 WHAT DID JACK DO? | School: ArtCenter College of Design
Instructor/Professor: Jim Salvati | Student: Alex Kupczyk

196 GARDEN OF SOLACE | School: ArtCenter College of Design
Instructors/Professors: Paul Rogers, Brian Rea | Student: Haley Jiang

196 EDC POSTER | School: ArtCenter College of Design
Instructor/Professor: David Tillinghast | Student: Brian Lee

196 PASS ON PLASTIC | School: ArtCenter College of Design
Instructor/Professor: Gayle Donahue | Student: Grace Park

196 PREPPER MOM | School: ArtCenter College of Design
Instructors/Professors: Brian Rea, Paul Rogers | Student: Grace Park

196 GREY GARDENS: ROMANCE, GHOSTS, AND STAUNCH WOMEN
School: ArtCenter College of Design | Instructors/Professors: David Tillinghast, Rob Clayton | Student: Dominic Bodden

196 WITCH TRIAL IN THE 21ST CENTURY | School: Virginia Commonwealth University
Instructors/Professors: Roy McKelvey, Nicole Killian, Orla McHardy | Student: Feixue Mei

197 MY EPIPHANY | School: ArtCenter College of Design
Instructor/Professor: Steve Turk | Student: Hyunjeong Yi

197 STEEL WOOL | School: ArtCenter College of Design
Instructor/Professor: Mark Todd | Student: Dominic Bodden

198 CORONAVIRUS DIVORCE | School: ArtCenter College of Design
Instructors/Professors: Brian Rea, Paul Rogers | Student: Grace Park

198 MARS IS HEAVEN | School: ArtCenter College of Design
Instructor/Professor: Owen Freeman | Student: Garrett Daniels

199 COGNITIVE EATING | School: Purdue University
Instructor/Professor: Li Zhang | Student: Tayler Wullenweber

199 A DISNEY FILM EVOLUTION | School: Brigham Young University
Instructor/Professor: Doug Thomas | Student: Kaitlyn Richardson

200 PLOOP | School: Brigham Young University
Instructor/Professor: Aaron Shurtleff | Student: Sam Verdine

200 QUIPIC | School: Columbia College Hollywood
Instructor/Professor: Evanthia Milara | Student: Morgan Moehlenkamp

201 HYDRA GAMING | School: Texas State University
Instructor/Professor: Genaro Solis Rivero | Student: Elisabeth Klein

201 RAINDROPS RAIN GEAR | School: Texas State University
Instructor/Professor: Genaro Solis Rivero | Student: Alondra Vazquez

201 BONSAI DOJO | School: Texas State University
Instructor/Professor: Genaro Solis Rivero | Student: Dondi Aguirre

201 HULA HOPS BREWERY | School: Texas State University
Instructor/Professor: Genaro Solis Rivero | Student: Katelen Jennings

201 LOHENGRIN'S | School: Temple University, Tyler School of Art and Architecture
Instructor/Professor: Abby Guido | Student: Katie Fish

201 LUKE'S LOCKER LOGO | School: Texas A&M University Commerce
Instructor/Professor: Ken Koester | Student: Melissa Camacho

201 MEDUSA PASTA | School: Texas State University
Instructor/Professor: Genaro Solis Rivero | Student: Blaik Romo

201 CAROTENE ENERGY | School: Texas State University
Instructor/Professor: Genaro Solis Rivero | Student: Victoria Nieves

201 SWEET STRINGS | School: Texas State University
Instructor/Professor: Genaro Solis Rivero | Student: Spencer Critendon

201 WELCOME TO LEGAL | School: School of Visual Arts
Instructor/Professor: Sal DeVito | Student: Yanira Janes Parsons

201 PLANTHUG | School: Texas State University
Instructor/Professor: Genaro Solis Rivero | Student: Isidora Beskorovajni

201 THE SHADE TREE PLAYERS | School: University of North Texas
Instructor/Professor: Douglas May | Student: Taylor Minth

202 SPIRIT HALLOWEEN SYMBOL LOGO | School: Texas A&M University Commerce
Instructor/Professor: Joshua Ege | Student: Julio Reyes

202 JOEY'S VINEYARD | School: Texas State University
Instructor/Professor: Genaro Solis Rivero | Student: Mikayla Stump

202 HOTTAH SPIRIT | School: Texas State University
Instructor/Professor: Genaro Solis Rivero | Student: Cynthia Murray

202 HECTOR'S CABINETS | School: Texas State University
Instructor/Professor: Genaro Solis Rivero | Student: Christina Nguyen

202 RED FOX YARNS LOGO | School: University of North Texas
Instructor/Professor: Karen Dorff | Student: Taylor Minth

202 STEEPING SERPENT COFFEEHOUSE | School: Texas State University
Instructor/Professor: Genaro Solis Rivero | Student: Hannah Morehead

202 FLAMES PRIME SEAFOOD | School: Texas State University
Instructor/Professor: Genaro Solis Rivero | Student: Hannah Morehead

202 PEARL STREET | School: Texas State University
Instructor/Professor: Genaro Solis Rivero | Student: Grace Hayes

202 SOUTH SIDE SUBS | School: Texas State University
Instructor/Professor: Genaro Solis Rivero | Student: Grace Hayes

202 ZIPPO LOGO | School: Texas State University
Instructor/Professor: Genaro Solis Rivero | Student: Daniela Dunman

202 ELEGANT ARCHITECTURE | School: Texas State University
Instructor/Professor: Genaro Solis Rivero | Student: Jaret Smith

202 NINTH NINPO | School: Texas State University
Instructor/Professor: Genaro Solis Rivero | Student: Cheyenne Carrasco

203 BRASS MONKEY | School: Texas State University
Instructor/Professor: Genaro Solis Rivero | Student: Jaret Smith

203 LE COQ ES MORT | School: Texas State University
Instructor/Professor: Genaro Solis Rivero | Student: Andres Meza

203 CAPITAL BEE COMPANY LOGO | School: University of North Texas
Instructor/Professor: Douglas May | Student: Andrea Garoutte

203 LITTLE LILAS | School: Texas State University
Instructor/Professor: Genaro Solis Rivero | Student: Kylee Palmer

203 TWISTED | School: Texas Christian University
Instructor/Professor: David Elizalde | Student: Trevor Scott

203 GOING GONE | School: Texas State University
Instructor/Professor: Genaro Solis Rivero | Student: Ashlea Wood

203 OCTOCLEAN | School: Texas State University
Instructor/Professor: Genaro Solis Rivero | Student: Hannah Morehead

203 GRANDER | School: Texas State University
Instructors/Professors: Jeff Davis, Genaro Solis Rivero | Student: Aspen Walter

203 NOCTURNO | School: Texas State University
Instructor/Professor: Genaro Solis Rivero | Student: Ronaldo Mundo

203 LAST CALL | School: Texas State University
Instructor/Professor: Genaro Solis Rivero | Student: Kylee Palmer

203 WOOLY MAMMOTH YARN & FIBER | School: University of North Texas
Instructor/Professor: Douglas May | Student: Alexis Houser

203 TECHBOY | School: Texas State University
Instructor/Professor: Genaro Solis Rivero | Student: Giang Pham

204 SIX LITTLE SWANS | School: Texas State University
Instructor/Professor: Genaro Solis Rivero | Student: Kayla McKee

204 PASOS | School: University of North Texas
Instructor/Professor: Douglas May | Student: Andrea Chavez

204 NEW HEAVEN CONSERVANCY | School: Texas State University
Instructor/Professor: Genaro Solis Rivero | Student: Andres Meza

204 DENTAL ATELIER | School: Unattributed
Instructor/Professor: Unattributed | Student: Stefan Mijič

204 BIRKENSTOCK LOGO | School: University of North Texas
Instructor/Professor: Douglas May | Student: Andrew Galvan

204 WEBBED SITE | School: Texas State University
Instructor/Professor: Genaro Solis Rivero | Student: Erin Ckodre

204 QUARTER TURBOCHARGER | School: Texas State University
Instructor/Professor: Genaro Solis Rivero | Student: Cheyenne Carrasco

204 CHOCELOTL | School: Texas State University
Instructor/Professor: Carolyn Kilday | Student: Nathanael Loden

204 BEAST & CLEAVER | School: University of North Texas
Instructor/Professor: Karen Dorff | Student: Kristina Armitage

204 NEURO HEALTH LOGO | School: Texas State University
Instructor/Professor: Genaro Solis Rivero | Student: Joel Nieto

204 100% NATURAL | School: Texas State University
Instructor/Professor: Genaro Solis Rivero | Student: Erin Ckodre

204 MAGIC MOUSE | School: University of North Texas
Instructor/Professor: Karen Dorff | Student: Holden Pizzolato

205 EDEN'S ESSENTIALS | School: Texas Christian University
Instructor/Professor: Bill Galyean | Student: Elizabeth Ireland

205 PLAYTIME UNPLUGGED | School: Texas State University
Instructor/Professor: Carolyn Kilday | Student: Jasmine Garcia

206 GOSSAMER GIN | School: Capilano University
Instructor/Professor: Vida Jurcic | Student: Kathrin Teh

206 SLAUGHTERNECK BREWING | School: West Chester University
Instructor/Professor: David Jones | Student: Madison Argo

206 BLUE AHAYA BEVERAGE BRAND | School: George Brown College
Instructor/Professor: Jerri Johnson | Student: Giovanna Ragali

206 BREW MOON | School: Texas State University
Instructor/Professor: Carolyn Kilday | Student: Addison Wittler

206 ARIZONA BEVERAGES | School: Texas A&M University Commerce
Instructor/Professor: Garrett Owen | Student: Gabrielle Melendez

206 MAINSTAY BEVERAGE BRAND | School: George Brown College
Instructor/Professor: Jerri Johnson | Student: Mike Deinum

207 A2 MILK | School: Brigham Young University
Instructor/Professor: Adrian Pulfer | Student: Ben Law

207 LUNKER | School: San Diego City College
Instructors/Professors: Sean Bacon, Bradford Prairie | Student: Heather Yancey

207 CUCINA ITALIANA | School: Texas Christian University
Instructor/Professor: Yvonne Cao | Student: Caroline Fischer

207 APOTHEKE PACKAGING | School: Brigham Young University
Instructor/Professor: Adrian Pulfer | Student: Ben Law

207 MILLER BEER - GENUINE DANCE | School: M.AD School of Ideas Berlin
Instructor/Professor: Sarah Buggle | Students: Seine Kongruangkit, Riya Dosani, Yamen Emad

208 RADIAN SUNSCREEN | School: Texas Christian University
Instructor/Professor: Bill Galyean | Student: Caroline Fischer

208 THWART | School: ArtCenter College of Design
Instructor/Professor: Dan Hoy | Student: Eun Jung Bahng

208 CHANCE THE RAPPER: VIP CONCERT BOX | School: Texas Christian University
Instructor/Professor: Yvonne Cao | Student: Rose Hoover

208 LUCID COSMETIC LINE | School: George Brown College
Instructor/Professor: Jerri Johnson | Student: Jenni Filman

208 CHOCELOTL | School: Texas State University
Instructor/Professor: Carolyn Kilday | Student: Nathanael Loden

208 ELSA ARTISANAL | School: School of Visual Arts
Instructor/Professor: Jon Newman | Student: Justin Wong

209 ALPHA PI OLIVE OIL | School: Brigham Young University
Instructor/Professor: Adrian Pulfer | Student: Lauren Canizales

209 ZOOM | School: Drexel University
Instructor/Professor: Jody Graff | Student: Matthew Barnett

209 SPEAKEASY | School: West Chester University
Instructor/Professor: Scotty Reifsnyder | Student: Tori Evert

210 BARE BY OLAY | School: University of North Texas
Instructor/Professor: Karen Dorff | Student: Hana Snell

210 FOR LIFE TATTOO CARE | School: Kutztown University of Pennsylvania
Instructor/Professor: Karen Kresge | Student: Carly Kozacheck

210 MOIMOI | School: Texas State University
Instructor/Professor: Carolyn Kilday | Student: Alyssa Sullivan

210 WELLER GOLDEN WHEAT WHISKEY | School: Texas A&M University Commerce
Instructor/Professor: Josh Ege | Student: Nathan Essary

210 SEKA HILLS PACKAGE | School: Texas State University
Instructor/Professor: Carolyn Kilday | Student: Rachel Arthur

210 KNAUTS | School: Texas State University
Instructor/Professor: Genaro Solis Rivero | Student: Kaitlin McCall

210 CHOC-O-LATTE | School: Texas State University
Instructor/Professor: Carolyn Kilday | Student: Roy Ramirez

211 THE THIN BLUE LINE DVD PACKAGING | School: School of Visual Arts
Instructor/Professor: Scott Buschkuhl | Student: Jiin Choi

211 SUCCO / PRESSED CITRUS | School: Syracuse University
Instructor/Professor: Unattributed | Student: Audrey Stevens

211 SIDEWINDER COWBOY HAT ACCESSORIES | School: Texas Christian University
Instructor/Professor: Bill Galyean | Student: Caroline Fischer

211 CHROMA / ARTIST INSPIRED PREMIUM PAINTS | School: Syracuse University
Instructor/Professor: Unattributed | Student: Elese Gaydos

211 ANTI AGING COSMETICS | School: Hansung University, Design and Art Institute
Instructor/Professor: Dong-Joo Park | Student: Kim Ji Eun

211 GOOD VIBES COFFEE PACKAGING. | School: Kutztown University of Pennsylvania
Instructor/Professor: Karen Kresge | Student: Jen Pepper

212 BAUHAUS MANIFESTO POSTER DESIGN | School: Maryland Institute College of Art | Instructor/Professor: Tom Wedell | Student: Xinmeng Yu

212 3 THEATER POSTERS | School: School of Visual Arts
Instructor/Professor: Douglas Riccardi | Student: Jihyun Lee

212 VIRUSES! | School: University of California, Davis
Instructor/Professor: Glenda Drew | Student: Alireza Vaziri Rahimi

212 FIGURES: DEAD LECTURE SERIES | School: School of Visual Arts
Instructor/Professor: Scott Buschkuhl | Student: Jiin Choi

213 DISSECTED KICKS | School: Savannah College of Art and Design
Instructor/Professor: Sam Ekersley | Student: Zach Stremmel

213 SYNCOPATED TREBLE | School: University of Cincinnati, DAAP
Instructor/Professor: Reneé Seward | Student: Marisa Thoman

213 EVENT POSTER | School: School of Visual Arts
Instructor/Professor: Justin Colt | Student: Junghoon Oh

213 LUCKY CHARMS FEST, CAIRO | School: West Chester University
Instructor/Professor: Karen Watkins | Student: Sophia DiDonato

213 LITERACY OF CHOICE | School: Unattributed
Instructor/Professor: Unattributed | Student: Stefan Mijič

213 SAVE THE BURNING EARTH | School: Hansung University, Design & Art Institute
Instructors/Professors: Dong-Joo Park, Seung-Min Han | Student: Yeji Kim

213 BUILDING A LEGACY | School: University of Cincinnati, DAAP
Instructor/Professor: Reneé Seward | Student: Eddie Loughran

213 FILM POSTER FOR "PSYCHO" | School: Texas Christian University
Instructor/Professor: David Elizalde | Student: Kaylen Couch

213 OO-BLA-DEE POSTER | School: Texas A&M University Commerce
Instructor/Professor: Josh Ege | Student: Prajoo Shrestha

214 FANCY SHOE FEST ROME | School: West Chester University
Instructor/Professor: Karen Watkins | Student: Jhade Gales

214 FACETS OF ARCHITECTURE | School: ArtCenter College of Design
Instructor/Professor: Constantine Chopin | Student: Eun Jung Bahng

214 THE END OF THE WORLD | School: University of Illinois at Chicago
Instructors/Professors: Pouya Ahmadi, Meghan Ferrill | Students: Nour Zaki, Ola Alsarraj, Sara Armstrong, Samuele Bianchi, Madison Chessare, Farida Fadly, Jonathan Hernandez, Jasmine Hu, Anthony Jones, Ali Khan, Yawen Lin, Yingtang Lu, Amod Mahadik, Jewel Mathew, Ashely Menardo, Adrian Politzer, Ivan Salazar, Heather Trofimchuk, Asha Whitehorne

214 STARLIGHT MUSIC FESTIVAL | School: Woodbury University
Instructor/Professor: Rebekah Albrecht | Student: Nya Walker

214 WORLD BEARD & MUSTACHE CHAMPIONSHIPS POSTER | School: Texas A&M University Commerce | Instructor/Professor: Ken Koester | Student: Tyler Devitt

214 FOR THE GREATER CAUSE | School: University of Cincinnati, DAAP
Instructor/Professor: Reneé Seward | Student: Riley Best

214 UNITED BEAUTY, SPIRIT OF KOREA | School: Hansung University, Design & Art Institute | Instructors/Professors: Dong-Joo Park, Seung-Min Han | Student: Yujeong Son

214 YOUTHS TAKE A STAND | School: University of Cincinnati, DAAP
Instructor/Professor: Reneé Seward | Student: Stephanie Krekeler

215 COOL HAND LUKE POSTER | School: Texas Christian University
Instructor/Professor: Lewis Glaser | Student: Tryn Woessner

215 EXPLORING PERSONAL COLOR ASSOCIATIONS | School: Brigham Young University | Instructor/Professor: Doug Thomas | Student: Morgan Shreenan

215 NATIONAL TRAIN SHOW POSTER | School: Texas A&M University Commerce
Instructor/Professor: Lee Hackett | Student: Nathan Essary

216 KEYCHAINS | School: School of Visual Arts
Instructor/Professor: Kevin O'Callaghan | Student: Tae Gyung Kang

216 KELO / BIODEGRADABLE NOTEBOOKS | School: Syracuse University, College of Visual and Performing Arts | Instructor/Professor: Unattributed | Student: Sarah Noll

216 A TYPE STOOL | School: Seoul National University of Science and Technology
Instructor/Professor: Lee Sang Jin | Student: Kim Seong Je

217 LOOP FESTIVAL | School: Capilano University
Instructor/Professor: Dominique Walker | Student: Sharleen Ramos

217 TYPOGRAPHY EXHIBITION CAMPAIGN | School: University of Texas at Arlington
Instructor/Professor: Veronica Vaughan | Student: Paula Hoke

218 C-ME: STEREOTYPES OF CHINESE INTERNATIONAL STUDENTS
School: Temple University, Tyler School of Art & Architecture
Instructor/Professor: Abby Guido | Student: Xinjian Li

218 FREEDOM IAM SKATER | School: Hongik University
Instructor/Professor: Daeki Shim | Student: Jinhyung Seo

219 KETTLE & SCONE | School: San Diego City College
Instructors/Professors: Sean Bacon, Bradford Prairie | Student: Parker Anne Poole

219 CURRYOUS | School: Texas Christian University
Instructors/Professors: David Elizalde, Dusty Crocker | Student: Clair Levisay

219 UNBOUND BOOK BAG | School: California State University, Fullerton
Instructor/Professor: Theron Moore | Student: Andre Gomez

220 TO THE MOON AND BACK - STAMPS | School: Syracuse University, The Newhouse School | Instructor/Professor: Claudia Strong | Student: Shannon Kirkpatrick

220 STAMPS FOR EQUITY AND INCLUSION | School: San Jose State University
Instructor/Professor: Jean-Benoit Levy | Students: 25 students from course DSGD63 (Fundamental Graphic Visualization)

220 THROUGH THE DECADES | School: Syracuse University, The Newhouse School
Instructor/Professor: Claudia Strong | Student: Huiru Yu

220 CENTURY OF DESIGN_DUTCH DESIGN_POSTAGE STAMP DESIGN
School: Savannah College of Art and Design | Instructor/Professor: Peter Wong
Student: Kexin Chen

221 PORSCHE EV INTERIOR CONCEPT | School: ArtCenter College of Design
Instructor/Professor: John Krsteski | Student: Taylor Chen

221 BROADCAST TYPEFACE | School: Syracuse University, The Newhouse School
Instructor/Professor: Claudia Strong | Student: Meghan Gulley

222 FLOW SCRIPT | School: Syracuse University, The Newhouse School
Instructor/Professor: Claudia Strong | Student: Natalia Deng Yuan

222 COORDINATE | School: Syracuse University, The Newhouse School
Instructor/Professor: Claudia Strong | Student: Elizabeth Wolf

222 ANALOG TYPOGRAPHY | School: School of Visual Arts
Instructor/Professor: Justin Colt | Student: Junghoon Oh

222 TYPEFACE EARTH | School: Seoul National University of Science and Technology
Instructor/Professor: Daeki Shim | Student: Jeonghyo Park

222 RISE | School: University of Illinois at Chicago
Instructor/Professor: Sharon Oiga | Student: Jonathan Pacheco

222 RIO TYPEFACE | School: School of Visual Arts
Instructor/Professor: Travis Simon | Student: Barbara Cadorna

223 MODULAR GROTESK TYPEFACE | School: Brigham Young University
Instructor/Professor: Eric Gillet | Student: Morgan Shreenan

223 IOTA DISPLAY POSTER | School: ArtCenter College of Design
Instructor/Professor: Simon Johnston | Student: Eun Jung Bahng

223 LET THE GAMES BEGIN | School: M.AD School of Ideas Mumbai
Instructor/Professor: Lindsei Barros | Student: Yashashree Samant

223 VINYL RECORDING' PACKAGING OF VOCAL GROUP REMŠNIK
School: University of Ljubljana | Instructor/Professor: Unattributed | Student: Karin Rošker

DESIGN FILM/VIDEO WINNERS:

225 HIDDEN FIGURES TITLE SEQUENCE | School: ArtCenter College of Design
Instructor/Professor: Miguel Lee | Students: Quinta Yu, Tiffany Shen, Kayley Wang
Assignment: The film Hidden Figures highlights the accomplishments of three women who were given little opportunity as black women in a male-dominated and unequal society. We wanted to honor these women by creating a title sequence that was visually classic and inspiring paired with epic music to extend the idea of achieving greatness. We found it important to shed light on the unseen and this project was an opportunity for that. We did this by emphasizing the themes that worked against the three women but representing it as something magnificent that ultimately played to their success.
Approach: The initial stages of this project began by studying the elements of the film which we found to be most important to the symbolism of the story. By using analog methods, we moved rough sketches on paper around on a table, figured out how to best convey our message, and determined the flow of our story. ■ Outer space is seen to be an infinite and magical place with much to discover. We intended for the shift of scenery from the wonders of space to a mundane office environment to accentuate the accomplishments of the great minds of three black women. We utilized dramatic lighting and a slowed camera movement to provide an overall mysterious and magical feeling to our sequence. ■ In this project, one of our biggest challenges included using learning and using Arnold with very little prior experience. We ran into several bumps with this particular challenge technically and creatively. However, as a team, we were able to work together effectively and problem-solve quickly in order to achieve the visions we had imagined.
Results: Our project was submitted into the Fall 2019 ArtCenter Hillside Student Gallery and selected by faculty to be submitted in the Promax Awards. Reception toward our project has been very positive and continues to be a strong project for our team members.

226 BP-06: 12 PRINCIPLES OF ANIMATION | School: California State Polytechnic University, Pomona | Instructor/Professor: Justin Abadilla | Student: Michelangelo Barbic
Assignment: The scope of this project entailed portraying the 12 principles of animation outlined by Disney animators Ollie Johnston and Frank Thomas in an animated video. The recommended approach was creating thumbnail sketches, proceeding to create a storyboard, then animating 2D graphics in Adobe After Effects. Requirements were to display each principle with text indications of the respective principle along with an accompanying animation. This project had a timeline of 4 weeks.
Approach: Prior to working on this project, I had a couple of years of experience with Adobe After Effects and wanted to do a little bit more with this project. I decided on practicing how to work in a theoretical professional setting where file organization, playblasts, and working between multiple programs are a must. With a decent understanding of how to navigate through 3D packages and work to create still compositions, I decided early on that I wanted to make a fully 3D/CGI short that was narrative-driven to be more than a demonstration video with no connection between the scenes. ■ With a love for robots, I decided the story would be told through a robot. I began thumbnail sketches that lead into creating storyboards that outlined each principle. ■ During preliminary reviews, I received a lot of criticism that ultimately helped me create a more robust project but at the expense of redoing a lot of the original concepts. After the storyboard was solidified and concept sketches of a frontal, side and back view of the robot were created, I began doing rough 3D block-outs in Blender 3D with basic rigging to test out how I would end up animating the characters. Most of my time went into this phase as it was my first time ever animating a full character. After many failed attempts, I had a rigged skeleton that I could use for animating and began to brush up the geometry and add texture to the model. I knew I wanted to have the settings of the animation relate to a laboratory so created an outdoor environment that would lead to a test lab. The dark moody tones of the environment came from inspiration from videogames like Crysis, Portal, and movies like Kung Fury and Chappie. I love throwing in little easter eggs into my projects and wanted to do so for this one. Through in references to the videogame portal, some old drawings I did many years ago, some written notes to friends and loved ones, and a pop-culture reference at the end. Adding these in made the project feel more personal and overall fun to do. After exporting the 3D renders from my laptop over a course of hours, I began piping those playblasts into Adobe After Effects where I interpolated the PNG sequences into clips and added light post-processing. From there the sequence was brought into Adobe Premiere Pro where I added in sound foliage and ambient sound. Sounds were sampled from the Youtube Audio Library as well as some custom recorded sound bits to give the video more life. After many run-throughs and revisions, I arrived at the final version.
Results: Admittedly there was a lot of dead time spent on this project due to other time allocations and this was completed a little under 2 weeks. The project itself was finished a few minutes before presentations were due and were able to present this project to our class. The overall response was of high-praise for going above and beyond the project requirements. For this project, this was one of those projects that were doing a high risk of shooting way over the scope of the project, and successfully delivering a product in time paid off tremendously. Conclusively, for my first attempt at 3D animation, this was a lot of fun to do. There are endless bits of knowledge that I have picked up along the way working on this project. I would not have been able to achieve it without the support of my peers and professor. I had learned several bits of information that would have to lead me to approach this project differently, become aware of issues I could fix, and overall be more efficient if I were to do this again.

227 STRIKE | School: Brigham Young University
Instructor/Professor: Brent Barson | Student: Hunter Young
Assignment: Create an animated video based off a recorded poem given by a homeless man living in the cold winter New York City streets.
Approach: The strict use of typography and the greyscale color theme were chosen as to not distract from the message of the poem and to represent the contrast between the enlightening words and the harsh street environment that this man lives in.
Results: The video shines a light on this man's experiences and gives an opportunity for everyone to listen and reflect.

228 2020 YOUNG VOTERS PSA | School: Texas State University
Instructor/Professor: Caleb Horn | Student: Chantal Lesley
Assignment: Create a PSA to encourage 18-25 year olds to vote in elections.
Approach: Through VO work, and making collage images move in After Effects I created a PSA for young voters explaining why their vote matters.
Results: The video successfully shows why it is imperative for young voters to show up to the polls in an engaging way.

228 GUQIN | School: School of Visual Arts
Instructor/Professor: Ori Kleiner | Student: Wenxin Yuan
Assignment: Create a motion graphic work to introduce a Chinese instrument call Guqin.
Approach: I researched the history of Guqin. Then I illustrated some scenes that I imagined to fit with the vibe of Guqin. Then I played the music behind and made some change to it. After 3 months of adjustment, I finished this project.
Results: The motion graphic represent the spirit of this instrument, which is calmness and longing for nature.

228 UNFINISHED STORY | School: Oklahoma State University
Instructor/Professor: Justen M. Renyer | Student: Do Kim
Assignment: Kim Bok-Dong came forward in 1992 and began to testify about her experience as a wartime sex slave publicly. She spent the remainder of her life fighting for victims' rights on behalf of the "comfort women." The narration, given by a Korean-American in her Korean tongue, expresses Koreans' feelings about the pain and suffering of the "comfort women".
Approach: I've arranged historical documents, photographs, and videos to provide an accurate picture of the lives and history of the "comfort women." The timeline captures Japanese military sexual slavery history. Against collages and a photo-montage of images and videos, the Korean song "Ye Mac A-Ra-Ri" begins. A sad piano sounds the history of the "comfort women's" life. Each scene begins with the image of the Japanese flag. Within the red circle, I added moving images of pictures, collages, and videos to illustrate a factual history of the "comfort women's" plight and women's rights issues.
Results: This motion graphics is a critique of the current Japanese government's response to the human rights of the "comfort women". This motion graphics is propaganda and design that conveys comfort women's messages in visual language.

228 THANK YOU ESSENTIAL WORKERS | School: School of Visual Arts
Instructor/Professor: Ori Kleiner | Student: Bruno Pasi Bergallo
Assignment: A frame-by-frame animation that follows New Yorkers during a day in quarantine. Narrated by Governor Cuomo's words on being New York Tough, and dedicated to all essential workers that were assigned to the frontline during the COVID-19 pandemic.
Approach: At the beginning of 2020, COVID-19, a deadly pandemic spread throughout the world, drastically changing the way we interact with each other. Essential workers blindly jumped to the frontlines, and we owe them an immense amount of gratitude and recognition. My intention with this piece was to convey a personable atmosphere by showcasing a diverse group of people instead of centering it around a main character. Also, I wanted to value the strength and courage of essential workers.
Results: I conveyed the emotions and storyline looking to be portrayed in this piece.

229 DISTORTED BOUNDARY | School: Virginia Commonwealth University
Instructor/Professor: Nicole Killian | Student: Feixue Mei
Assignment: How technology influence people's life? What will happen when contemporary technology meets with traditional Chinese paintings? What will happen when ancient court ladies play with robot dogs? How will they think of new technology? What will happen when ancient people have cars? How will they think of the pollution that cars produced? What will happen when ancient people have access to the internet? Will they be addicted to internet games like contemporary people? If they have access to the internet, they would have access to tons of information around the world. How will they respond to this information? Will information change their opinions? Will information change their aesthetic standard? Will they be self-conscious about their appearances? Will they use contemporary technology to change their appearances? What will happen when the boundary distorted?

229 WE ARE ASIANS | School: M.AD School of Ideas Berlin | Instructors/Professors: Florian Weitzel, Sabine Georg | Students: Quynh Tran, Seine Kongruangkit
Assignment: Since the outbreak of COVID-19, the number of racist assaults and hate crimes towards the Asian community has skyrocketed all over the world, significantly in America. We, the Asian, are punched, kicked, spitted on, mocked, yelled at, and shooed away through no fault of our own, and mass media is flooded with heart-breaking cases.
Approach: As Asian ourselves, we are furious about this situation. But instead of adding more fuel to the fire, we decided to switch our lense and shed light on positivity: the tastiest food, the most preserved culture, the hardest-working parents, and the bravest medical staff on the front line amidst this pandemic – those are what make us Asian, and no punch, kick, spit, mockery, or yell would ever wreck our pride on the long way we have come.
Results: Published on Adsoftheworld, welovead, Campaigns Of The World, Best Ads On TV, and Desi Creative.

229 THE POST TITLE SEQUENCE | School: Pennsylvania State University
Instructor/Professor: Ryan Russell | Student: Taylor Mazzarella
Assignment: To design a relevant and conceptual title sequence for a film through the usage of powerful imagery and storytelling.
Approach: After researching the political events that led up to to the publishing of the Pentagon Papers, I determined that highlighting the route in which news travels from the government to the public would be an important perspective to illustrate. Using free source imagery, I created a storyline that follows the heated rise and fall that led to the leaking of the Pentagon Papers by the Washington Post.

Results: This project finds its success through its historical and political context. By using imagery that physically highlights government officials and images of the ongoing Vietnam War, this composition illustrates the years of lies and corruption that were leaked to the public during the 1970's.

229 BIRDS ARE NOT REAL | School: Brigham Young University
Instructor/Professor: Brent Barson | Student: Wil Osborne
Assignment: Create a 30 second PSA, something the public needs to know.
Approach: I chose to go a satirical route for this brief, and rooted the imagery and cause in a classic spy aesthetic. The PSA is meant to leave the viewer wondering if the organization is a real one which actually holds the belief that birds aren't real, or if it's a joke.
Results: The creator of the fake conspiracy "Birds Aren't Real" has seen the PSA, and felt it exactly suited the brief.

230 INSECT HANDBOOK | School: West Chester University
Instructor/Professor: Jeremy Holmes | Student: Chuck Scott

230 COSMOS | School: West Chester University
Instructor/Professor: Jeremy Holmes | Student: Kevin Mesquite

230 PAIN TONES: THE WORLD'S MOST UNCOMFORTABLE COLOR TONES
School: Ashesi University/M.AD School of Ideas Miami/Seneca College
Instructor/Professor: Unattributed | Student: Jean Quarcoopome
Assignment: To create a provocative campaign that directly addresses racism in America.
Approach: Pantone - the world's authority on color in all shades and tones - is a brand uniquely equipped to act in support of people of color. Tapping into their color resources, we saw an opportunity for Pantone to take a stand with a bold act of branding. ■ We created PAIN TONES: a first of its kind Pantone color book. We picked colors from the last moments of some black lives taken by racial police brutality. After matching each PAIN TONE color to the Pantone Matching System, we renamed them. Each new name is an immortal reminder of the innocent black men, women and children whose last living moments were colored by hate. Plane tracking AR technology shows the brutal videos that bring each PAIN TONE to life, and the entire color palette was made available to creatives for purchase and use on Adobe software. ■ But we didn't stop there. ■ We hacked the Pantone Color of the Year, changing it from Classic Blue to Transparent, and showed it boldly in outdoor media, as a call to action for the world to choose to see through a person's skin color, rather than to see more PAIN TONES. We followed this up with a pledge that puts the weight of responsibility in the hands of anyone with a voice and a choice.
Results: Our campaign was featured in an article published on DesignTAXI.

230 PRAISE THE NEON GOD | School: Sejong University
Instructor/Professor: Daeki Shim | Students: Yujin Cho, Junhaeng Lee
Assignment: With the development of technology people are leading comfortable lives, but they have become reliant of the technology. They absorb the information shared on media which has been proven to reduce their thinking ability. In this exhibition, artists criticize the phenomenon through Neon God, which deceives people with technology and media in order to break the silence and regain their thinking abilities.
Approach: If you look at the colorful squares that signify the screen of digital media, many people are easily dazzled by the color and movement. However, these squares move quickly and randomly distort information, making the text difficult to read. Then people get surrounded by unknown information that pours out every day and is trapped in the screen. This makes people hard to understand information. Furthermore, They lose their judgment and discernment.

231 MICHELE OKA DONER | School: School of Visual Arts
Instructor/Professor: Ori Kleiner | Student: Junyu Chen

231 POWELL'S BOOKS BRAND STORY | School: Savannah College of Art and Design
Instructor/Professor: Christina Maloney | Student: Evan Eggers

231 10 THINGS I LEARNED IN COLLEGE | School: West Chester University
Instructor/Professor: Karen Watkins | Student: Tori Evert

231 UNITED IN LOVE | School: M.AD School of Ideas Miami, New York, and San Francisco | Instructor/Professor: Manolo Garcia | Students: Passant El Mohdar, Roselyn Grace, Pedro Sacilotto and Hatem El Akad

231 DIVE APP PROMO | School: Texas Christian University
Instructor/Professor: Yvonne Cao | Student: Cassie Schmidt

231 HOW TO MAKE A CERAMIC CUP | School: School of Visual Arts
Instructor/Professor: Ori Kleiner | Student: So Youn Chun

231 TAIYO NO TANI DISTILLING COMMERCIALS | School: Texas Christian University
Instructor/Professor: Yvonne Cao | Student: Derek Bowers

231 DODECA | School: Hongik University
Instructor/Professor: Daeki Shim | Student: Huiyun Jung

232 SERENDIPITY MOVIE TITLE SEQUENCE | School: School of Visual Arts
Instructor/Professor: Ori Kleiner | Student: So Youn Chun

232 THE VAULT OF DREAMERS TRAILER | School: Texas Christian University
Instructor/Professor: Dusty Crocker | Student: Brooke Honcharik

232 "CORALINE" TITLE SEQUENCE | School: University of North Texas
Instructor/Professor: David Wolske | Student: Julia Pamer

232 "AMERICAN HORROR STORY: ASYLUM" TITLE SEQUENCE | School: University of North Texas | Instructor/Professor: David Wolske | Student: Javier Ruiz Navarro

232 PARIS IS BURNING - TITLE SEQUENCE | School: School of Visual Arts
Instructor/Professor: Ori Kleiner | Student: Bruno Pasi Bergallo

232 A VERY FATAL MURDER PODCAST | School: Texas State University
Instructor/Professor: Caleb Horn | Student: Laura Ortiz

232 "BLOOD AND BLACK LACE" TITLE SEQUENCE | School: University of North Texas | Instructor/Professor: David Wolske | Student: Cecilia Ontiveros

232 THE UMBRELLA ACADEMY TITLE SEQUENCE | School: Pennsylvania State University | Instructor/Professor: Ryan Russell | Student: Amber Lai

233 "KNIVES OUT" TITLE SEQUENCE | School: University of North Texas
Instructor/Professor: David Wolske | Student: Andrew Ashton

233 REMOTE | School: Temple University, Tyler School of Art & Architecture
Instructor/Professor: Abby Guido | Student: Reyna Hixton

233 KANOPY REBRAND | School: ArtCenter College of Design
Instructor/Professor: Elaine Alderette | Student: Jingping Xiao

233 TUTORLY MOBILE APPLICATION | School: Texas Christian University
Instructor/Professor: Yvonne Cao | Student: Kenzie Ashley

233 CHARON | School: Temple University, Tyler School of Art & Architecture
Instructor/Professor: Abby Guido | Student: Alex Kim

233 INTERDISCIPLINARY DESIGN LOGO ANIMATION | School: School of Visual Arts
Instructors/Professors: Olga Mezhibovskaya, Nada Ray | Student: Zona Guan

233 POEM COMPOSITION, I AM AS I AM BY LAWRENCE FERLINGHETTI | School:
School of Visual Arts | Instructor/Professor: Peter Ahlberg | Student: So Youn Chun

233 MESSAGES OF HOPE AND HIGH SPIRIT FROM COVD-19 LOCKDOWN CITIES
School: School of Visual Arts | Instructors/Professors: Olga Mezhibovskaya, Nada Ray
Student: Zona Guan

GOLD PHOTOGRAPHY WINNERS:
235 FLOATING INK PRODUCT PHOTOGRAPHY | School: Dawson College
Instructor/Professor: Barry Muse | Student: Roya Esmaeili
Assignment: An editorial and impactful image that can stand alone and drag attention
to the product by its contrast with the background, which Portrays beauty and softnes.
Create a feeling of the uniqueness of the product and its usage at night.
Approach: I tried to achieve the solution by creating an abstract shape with ink in the
water where the Product would be the center of attention. Using dark blue colors to
create the night feeling as the product is meant to be used at night. The product was
shot separately to achieve the best lighting on the product and enhance all the details.
Then By using Photoshop both images were combined.
Results: This glamour shot was a success by skillfully blending the Product in an abstract
environment while maintaining the product photography standards and adding the extra
pizzazz that the product required to be noticed. It is used in my final graduating portfolio.

236 A FIRM GRASP | School: California State University, Fullerton
Instructor/Professor: Linda Kroff | Student: Andre Gomez
Assignment: This series peers into the raw desires that manifest within ourselves.

237 AFFAIR: EXPERIMENTAL PORTRAIT | School: Pennsylvania State University
Instructor/Professor: Taylor Shipton | Student: Megan Tam
Assignment: Create portrait(s) using experimental techniques that would catch atten-
tion. The final photograph(s) need to be manipulated in real-time and used straight from
the camera, without any post-production editing. I decided to tell the story of a fictional
character while imitating old oil painting portraits. These types of pictures were usually
hung above the fireplace in living rooms to memorialize the rich and powerful.
Approach: The goal is to set an overall mysterious tone and aesthetic for these por-
traits. When photographing these portraits, I chose to capture deep depth of field and
to bring a more yellow tint to imitate the grunginess of old oil paintings. The styling
of the character and the background setup also needs to be meaningful contributions
to the story. I created a fictional character from an inanimate object for a twist. The
lampshade character was seen holding onto his new lover (the smaller lamp) in the
first portrait. The second portrait depicts the lampshade character drinking wine as
his dead wife (the chandelier) is laying in the back. Although no face or expressions
were captured from the lampshade character, the overall atmosphere contributed to the
personality of the character and the mood of each portrait.
Results: With the character's out-of-the-ordinary appearance and their uncanny story, I
made interesting photographs with an unconventional, comedic approach.

238 PORTRAIT | School: Texas Christian University
Instructor/Professor: Dusty Crocker | Student: Kaylen Couch
Assignment: To take two portrait photos that are completely different. One must be
shot in the studio and the other outside of the studio. The goal was to use your art
direction and photography to express whatever you feel will be an interesting portrait.
Approach: I immediate began thinking of friends that would be my model. My best
friend is a very slender, pale, and beautiful. I have always thought she has the most
beautiful bone structure with her collarbones, shoulders, and neck. I wanted to capture
the comparison between what most people think of as beautiful and delicate compared
to what I see as beautiful and delicate. I glued flowers on her face to represent the
common external beauty people tend to pay attention to. With her head tilted by you
are able to see these beautiful lines of her neck muscles and the studio lights create
different pockets of shadows and shapes to look at and observe.

238 ELLIE | School: Texas Christian University
Instructor/Professor: Dusty Crocker | Student: Madison Jones
Assignment: Photograph any type of portrait we desire. Our goal was to have a portrait
that stopped you in your tracks, to have a focal point that'd capture the viewer.
Approach: When approaching this assignment, I knew immediately I wanted to create
a sense of confusion; a photograph that questioned whether it was real or manipulated.
Through brainstorming different aspects of the body, I thought about the way hair
moves when it is tossed. It is an unpredictable motion that typically cannot be con-
trolled. This stemmed my wondering: what if I could control where the hair landed?
Gravity was my competitor in this thinking. This led me to think about the way the
model could lay to use gravity to my advantage. For this photo, I had Ellie lay on her
side, shoulder and hip on a chair, with her shoulders as straight as she could manage.
This allowed me to control each hair that crossed her face towards the floor. I then
rotated the photo to appear as though her hair is being blown across her face.
Results: This assignment was a success. I measured this by the amount of questions
I received on how this photograph was accomplished. Many viewers believed I had
timed the photo just right while having a fan blow her hair.

239 LILLY | School: Texas Christian University
Instructor/Professor: Dusty Crocker | Student: Annika Ballestro
Assignment: To photograph a portrait inside of a studio space.
Approach: In my explorations I found that I was most drawn towards gritty, natural
black and white photos. I wanted to create a photo that felt natural and also would
capture the model in a way you wouldn't normally see her. She has beautiful hair and
freckles, and I wanted a composition that would allow both to stand out.

Results: The end result is a closely cropped portrait only displaying of portion of the
model's face. Her hair is framing her face, almost like she's coming out of it. Making
the photo black and white allowed her natural features to stand out and create a very
honest or open portrait. Having the model not directly facing the camera and looking
to the side adds to the organic nature of the photo.

240 STUDENT PORTRAITS | School: Texas Christian University
Instructor/Professor: Dusty Crocker | Student: Shaye Wiley
Assignment: To produce portraits in and out of the studio.

241 HUILE D'OLIVE | School: Dawson College
Instructor/Professor: Marc Montplaisir | Student: Adam Nigro
Assignment: Photograph glass product of your choosing
Approach: The design of the unique spritzer bottle almost looks like a perfume so I
drew inspiration from fragrance advertisements to portray olive oil in a different way.
I backlit the product through plexiglass to show the vibrant color, and meticulously
arranged the basil leaves to create a comfy bed for it to lie on.
Results: My instructor believed this was the strongest image in my portfolio and
thought it was definitely up to advertising standards.

242 STILL LIFE | School: Texas Christian University
Instructor/Professor: Dusty Crocker | Student: Julia Reedy
Assignment: For this assignment, we were challenged to create and photograph a still
life using studio lights and equipment.
Approach: To achieve the final photograph, I first researched to get inspiration from
other still life photogrsphers. I was immediately drawn to the crisp photographs I had
found of fruit and decided to use it as my subject matter. To create a more visually inter-
esting photograph, I added glass vases of various sizes around the fruit to manipualte
its appearance. After photographing numerous different types of fruits with various size
vases, I found that the composition the most aesthetically pleasing was the combi-
nation of two pieces of Kiwi and a singular tall vase. Since there are so few elements
in the photograph, the negative space gives the elements room to breathe and further
highlights them. After choosing the photograph that looked the best, I brought it into
both Bridge and Photoshop to enhance the colors and remove imperfections.
Results: The feedback I received was all positive, and everyone appreciated the mini-
mal composition and the bright pop of color from the inside of the fruit.

**243 BONGS - A QUARANTINE PROJECT USING FOUND HOUSEHOLD
PARAPHERNELIA** | School: Dawson College | Instructor/Professor: Marc Montplaisir
Student: Adam Nigro
Assignment: carte blanche to photograph anything for the graduating portfolio
Approach: I was aiming to create an etheral dreamscape to accompany the cannabis
products, similar to the C4D renders you see nowadays. I constructed the sets out of
foamcore, bought the slate flooring from Home Depot, etc. The skies were photoshopped
in post. I used a large fish tank and ink to achieve the pink smoke for the cover image
Results: instructors and peers thought it was creative and different.

244 HOPE TRANSPORTER | School: School of Visual Arts
Instructor/Professor: Barbara Pollack | Student: Haofeng Yu
Assignment: This picture showed an Ilyushin IL-76TD-90VD cargo plane operated by
Volga Dnepr Airlines arriving at Newburgh Stewart Int'l Airport, NY with full of medi-
cal supplies on board. During the hard times of this year, many nations are helping each
other to overcome this difficulty of all humankind. This kind of Soviet Union-made
machine supposed to be really hard to see in this part of the world. However, it brings
hope, after flying across the globe, to reach out to the place where one needs help.
Approach: I get the message the night before this flight arrived. I was excited since
if I succeeded, this would be my first time actually catching this rare type of airplane
in this part of the world. After thinking all night about the meaningful concept behind
this flight, I leave my apartment before dawn and driving upstate with a friend. When
we get to Stewart, it started raining. The sky gets dark and I know that the background
would be in bad condition if I shoot it from the side of the fuselage. So we decided to
drive all the way down to the centerline of the runway to get a front view of the air-
plane. Luckily when the plane approaching and fly through the heavy clouds, it creates
a vortex and let the sunlight get through. Capturing this fantastic moment, I think we
have the lucky as well as making the right decision.
Results: This would definitely be one of the most outstanding pictures I've taken.

SILVER PHOTOGRAPHY WINNERS:
246 FORT WORTH/ HALTOM CITY SIGNAGE | School: Texas Christian University
Instructor/Professor: David Elizalde | Student: Madi Grace Thornton

246 I'VE SPENT A LOT OF MONEY TRYING TO LOOK LIKE YOU | School: Texas State
University | Instructor/Professor: Jason Reed | Student: Chantal Lesley

246 3 MODEL PORTRAIT | School: Texas Christian University
Instructor/Professor: Dusty Crocker | Student: Madi Grace Thornton

247 COWBOY | School: Texas Christian University
Instructor/Professor: Dusty Crocker | Student: Trevor Scott

247 SELF PORTRAIT | School: Texas Christian University
Instructor/Professor: Dusty Crocker | Student: Tryn Woessner

248 PORTRAIT PHOTOGRAPHY | School: Texas Christian University
Instructor/Professor: Dusty Crocker | Student: Gretchen Rea

248 PORTRAIT | School: Texas Christian University
Instructor/Professor: Dusty Crocker | Student: Julia Reedy

248 ICARUS | School: Syracuse University, The Newhouse School
Instructor/Professor: Mike Davis | Student: Gabrielle Cavallaro

248 CITIZEN WATCH | School: M.AD School of Ideas at Portfolio Center
Instructor/Professor: Craig Bromley | Student: Sheneatra McCoy

249 LOUIS | School: Dawson College
Instructor/Professor: Marc Montplaisir | Student: Adam Nigro

249 TEXAS CHRISTIAN UNIVERSITY | School: Texas Christian University
Instructor/Professor: Dusty Crocker | Student: Kaitlyn Kurtz

249 PILLOW SPRAY | School: Texas Christian University
Instructor/Professor: Dusty Crocker | Student: Sawyer Tucker

AWARD-WINNING STUDENTS

SCHOOL DIRECTORY

Academy of Art University
www.academyart.com
79 New Montgomery St.
San Francisco, CA 94105
United States
Tel +1 800 544 2787

ArtCenter College of Design
www.artcenter.edu
1700 Lida St.
Pasadena, CA 91103
United States
Tel +1 626 396 2200

Ashesi University
www.ashesi.edu.gh
1 University Ave., Berekuso
PMB CT 3, Cantonments, Accra
Ghana
Tel +233 302 610 330

Brigham Young University
www.byu.edu
Provo, UT 84602
United States
Tel +1 801 422 4636

Cairo Ad School Egypt
www.cairoadschool.com
318 North Chouifat,
5th Settlement
New Cairo, Governorate 11835
Egypt
Tel +20 121 110 0040

**California State Polytechnic
University, Pomona**
www.cpp.edu
3801 W. Temple Ave.
Pomona, CA 91768
United States
Tel +1 909 869 7659

**California State University,
Fullerton**
www.fullerton.edu
800 N. State College Blvd.
Fullerton, CA 92831
United States
Tel +1 657 278 2011

Cal State LA
www.calstatela.edu
5151 State University Drive
Los Angeles, CA 90032
United States
Tel +1 323 343 3000

Capilano University
www.capilanou.ca
2055 Purcell Way
North Vancouver, BC V7J 3H5
Canada
Tel +1 604 986 1911

Columbia College Hollywood
www.columbiacollege.edu
18618 W. Oxnard St.
Tarzana, CA 91356
United States
Tel +1 818 345 8414

Columbia College of Chicago
www.colum.edu
600 S. Michigan Ave.
Chicago, IL 60605
United States
Tel +1 312 369 1000

Concordia University
www.csp.edu
1282 Concordia Ave.
St. Paul, MN 55104
United States
Tel +1 651 641 8230

Dawson College
www.dawsoncollege.qc.ca
3040 Sherbrooke St. W.
Montreal, QU H3Z 1A4
Canada
Tel +1 514 931 8731

Drexel University
www.drexel.edu
3141 Chestnut St.
Philadelphia, PA 19104
United States
Tel +1 215 895 2000

Faculdade Cásper Líbero Brazil
www.casperlibero.edu.br
Av. Paulista, 900
Bela Vista, São Paulo - SP,
01310-100
Brazil
Tel +11 3170 5880

George Brown College
www.georgebrown.ca
230 Richmond St. E.
Toronto, Ontario M5A 1P4
Canada
Tel +1 416 415 2000

**Hansung University,
Design & Arts Institute**
www.edubank.hansung.ac.kr
116 Samseongyo 16-Gil
Seongbuk-gu, Seoul 136-792
South Korea
Tel +82 02 760 5533/5534

Hongik University
www.en.hongik.ac.kr
94 Wausan-ro, Sangsu-dong
Mapo-gu, Seoul
South Korea
Tel +82 2 320 1114

**Kutztown University of
Pennsylvania**
www.kutztown.edu
15200 Kutztown Road
Kutztown, PA 19530
United States
Tel +1 610 683 4000

Maryland Institute College of Art
www.mica.edu
1300 W. Mount Royal Ave.
Baltimore, MD 21217
United States
Tel +1 410 669 9200

M.AD School of Ideas Berlin
www.miamiadschool.com/
advertising-school/berlin
Feurigstrasse 54
Berlin 10827
Germany
Tel +49 40 413 46 70
vanessa@miamiadschool.de

M.AD School of Ideas Europe
www.miamiadschool.com/
advertising-school/hamburg
Finkenau 35e
Hamburg 22081
Germany
Tel +49 40 413 46 70

M.AD School of Ideas Madrid
www.miamiadschool.es
Santa Cruz de Marcenado 4,
Local 4
28015, Madrid
Spain
Tel +34 91 754 03 75

M.AD School of Ideas Miami
www.miamiadschool.com/
advertising-school/miami
571 NW. 28th St.
Miami, FL 33127
United States
Tel +1 305 538 3193

M.AD School of Ideas Mumbai
www.miamiadschool.com/
advertising-school/mumbai
61 Rose Cottage Complex, Dr
S.S. Rao Road
Mumbai, Maharashtra 400012
India
Tel +91 98195 43376

M.AD School of Ideas New York
www.miamiadschool.com/
advertising-school/new-york
35-37 36th St.
Queens, NY 11106
United States
Tel +1 917 773 8820

**M.AD School of Ideas at
Portfolio Center**
www.miamiadschool.com/
advertising-school/atlanta
125 NW. Bennett St.
Atlanta, GA 30309
United States
Tel +1 404 351 5055

**M.AD School of Ideas
San Francisco**
www.miamiadschool.com/ad-
vertising-school/san-francisco
500 Sansome St.
San Francisco, CA 94111
United States
Tel +1 415 837 0966

M.AD School of Ideas Toronto
www.miamiadschool.ca
639 Queen St. W.
Toronto, ON M5V 2B7
Canada
Tel +1 647 972 9129

**Moholy-Nagy University of
Art and Design Budapest**
www.mome.hu
1121 Budapest
Zugligeti út 9-25
Hungary
Tel +36 1 392 1180

**National Institute of Fashion
Technology**
www.nift.ac.in
Hauz Khas, Gulmohar Park
New Delhi, 110016
India
Tel +91 1126542000

**National Taiwan University of
Science and Technology**
www.ntust.edu.tw
No. 43, Keelung Road
Sec. 4, Da'an Dist., Taipei
106335
Taiwan
Tel +886 2 2733 3141

OCAD University
www.ocadu.ca
100 McCaul St.
Toronto, ON M5T 1W1
Canada
Tel +1 416 977 6000

Oklahoma State University
www.go.okstate.edu
120 Agriculture North
Stillwater, OK 74078
United States
Tel +1 405 744 5358

Pennsylvania State University
www.psu.edu
201 Old Main, University Park
State College, PA 16801
United States
Tel +1 8114 865 4700

Portland Community College
www.pcc.edu
12000 SW. 49th Ave.
Portland, OR 97219
United States
Tel +1 971 722 6111

Pratt Institute
www.pratt.edu
200 Willoughby Ave.
Brooklyn, NY 11205
United States
Tel +1 718 636 3600

Purdue University
www.purdue.edu
610 Purdue Mall
West Lafayette, IN 47907
United States
Tel +1 765 494 4600

Royal College of Art
www.rca.ac.uk
Kensington Gore
South Kensington,
London SW7 2EU
United Kingdom
Tel +44 0 20 7590 4444

San Diego City College
www.sdccd.edu
1313 Park Blvd.
San Diego, CA 92101
United States
Tel +1 619 388 3400

San Jose State University
www.sjsu.edu
1 Washington Square
San Jose, CA 95192
United States
Tel +1 408 924 1000

**Savannah College of
Art and Design**
www.scad.edu
1600 Peachtree St. NW.
Atlanta, GA 30309
United States
Tel +1 877 722 3285
scadatl@scad.edu

School of Visual Arts
www.sva.edu
209 E. 23rd St.
New York, NY, 10010
United States
Tel +1 212 592 2000

Sejong University
www.cec.sejong.ac.kr
KR Annex 101
209 Neungdong-ro, Gwan
jin-gu, Seoul
South Korea
Tel +82 2 34081878

Seneca College
www.senecacollege.ca
1750 Finch Ave. E.
North York, ON M2J 2X5
Canada
Tel +1 416 491 5050

**Seoul National University of
Science and Technology**
www.en.seoultech.ac.kr
232 Gongneung-ro,
Gongneung-dong,
Nowon-gu, Seoul
South Korea
Tel +82 2 970 6114

Syracuse University
www.syracuse.edu
900 S. Crouse Ave.
Syracuse, NY 13244
United States
Tel: +1 315 443 1870

**Syracuse University, College of
Visual and Performing Arts**
www.vpa.syr.edu
100 Crouse Drive
Syracuse, NY 13244
United States
Tel +1 315 443 2769

**Syracuse University,
The Newhouse School**
www.newhouse.syr.edu
215 University Place
Syracuse, NY 13210
United States
Tel +1 315 443 2302

Temple University
www.temple.edu
1801 N. Broad St.
Philadelphia, PA 19122
United States
Tel +1 215 204 7000

**Temple University, Tyler School
of Art and Architecture**
www.tyler.temple.edu
2001 N. 13th St.
Philadelphia, PA 19122
United States
Tel +1 215 777 9000

Texas A&M University Commerce
www.tamuc.edu
2200 Campbell St.
Commerce, TX 75428
United States
Tel +1 903 886 5102

Texas A&M University Commerce at Dallas
www.new.tamuc.edu/dallas
801 Main St.
Dallas, TX 75202
United States
Tel +1 214 954 3600

Texas Christian University
www.tcu.edu
2800 S. University Drive
Fort Worth, TX 76129
United States
Tel +1 817 257 7000

Texas State University
www.txstate.edu
601 University Drive
San Marcos, TX 78666
United States
Tel +1 512 245 211

Thomas Jefferson University
www.jefferson.edu
4201 Henry Ave.
Philadelphia, PA 19144
United States
Tel +1 215 951 2700

TU Dublin
www.tudublin.ie
143-149 Upper Rathmines Road
Rathmines, Dublin 6, D06 F793
Ireland
Tel +353 1 402 3000

University of California, Davis
www.ucdavis.edu
1 Shields Ave.
Davis, CA 95616
United States
Tel +1 530 752 1011

University of Cincinnati, DAAP
www.daap.uc.edu
2624 Clifton Ave.
Cincinnati, OH 45221
United States
Tel +1 513 556 4933

University of Illinois at Chicago
www.uic.edu
1200 W. Harrison St.
Chicago, IL 60607
United States
Tel +1 312 996 7000

University of Ljubljana, Academy of Applied Arts and Design
www.uni-lj.si/eng
Kongresni trg 12
Ljubljana 1000
Slovenia
Tel +386 1 241 85 00

University of North Texas
www.unt.edu
1155 Union Circle
Denton, TX 76203
United States
Tel +1 940 565 2000

University of Texas Arlington
www.uta.edu
701 S. Nedderman Drive
Arlington, TX 76019
United States
Tel +1 817 272 3004

University of the Arts London
www.arts.ac.uk
272 High Holborn
Holborn, London WC1V 7EY
United Kingdom
Tel +44 0 20 7514 6000

Virginia Commonwealth University
www.vcu.edu
907 Floyd Ave.
Richmond, VA 23284
United States
Tel +1 804 828 0100

West Chester University
www.wcupa.edu
700 S. High St.
West Chester, PA 19383
United States
Tel +1 610 436 1000

Woodbury University
www.woodbury.edu
7500 N. Glenoaks Blvd.
Burbank, CA 91504
United States
Tel +818 767 0888

HONORABLE MENTION Honorable Mentions appear on Graphis.com and in the digital copy. Only Platinum, Gold, & Silver winners appear in the physical book.

Schools:
Aalto University
Academy of Art University
Adhouse
ArtCenter College of Design
Brigham Young University
California State University, Fullerton
Capilano University
Cranbrook Academy of Art
Colorado State University
Columbia College Hollywood
Columbus State University
Concordia University
Drexel University
Faculdade de Belas-Artes da Universidade de Lisboa
Fashion Institute of Technology
George Brown College
Glasgow School of Art
Hansung University, Design & Art Institute
Hongik University
Kutztown University of Pennsylvania
Lorenzo de' Medici Institute
Maryland Institute College of Art
Metropolitan State University of Denver
M.AD School Berlin
M.AD School Europe
M.AD School Miami
M.AD School Mumbai
M.AD School New York
M.AD School at Portfolio Center
M.AD School San Francisco
M.AD School Toronto
Parsons School of Design, The New School for Design
Pennsylvania State University
Portland Community College
Pratt Institute
Purdue University
San Diego City College
Savannah College of Art and Design
School of the Art Institute of Chicago
School of Visual Arts
Seoul National University of Science and Technology
Syracuse University
Syracuse University, The Newhouse School
Temple University
Temple University, Tyler School of Art and Architecture
Texas A&M University Commerce
Texas Christian University
Texas State University
University of Applied Sciences Technology, Business and Design

University of the Arts London
University of Banja Luka
University of California, Los Angeles
University of Cincinnati, DAAP
University of Delaware
University of Ljubljana, Academy of Fine Arts and Design
University of Nevada, Las Vegas
University of North Texas
University of Texas at Arlington
Virginia Commonwealth University School of Art
West Chester University

Instructors:
Abbott Miller
Abby Guido
Adam Brodowski
Adrian Pulfer
Alexandra Doyle
Alexi Beltrone
Alice J. Lee
Ann Field
Anton Ginzburg
Ashley Pigford
Atila Kapitanj
Bill Brammer
Bill Galyean
Bradford Prairie
Brankica Harvey
Brendan Griffiths
Brian Rea
Caitlin Workman
Carolyn Kilday
Casey McGarr
Chercy Lott
Cheri Gray
Chris Mann
Christopher Meerdo
Chuck Primeau
Claudia Roeschmann
Claudia Strong
Craig Bromley
Daeki Shim
Damien Gilley
Daniel Sumbang
David Beck
David Elizalde
David Jones
Deep Chhabria
Domen Fras
Dominique Walker
Dong-Joo Park
Doug Thomas
Douglas May
Dusty Crocker
Eduard Čehovin
Eileen Hedy Schultz
Elaine Alderette
Ellen Lupton
Elliott Earls
Emily Burns
Enas Rashwan
Eric Baker

Erica Holeman
Erin LeForce
Esther Pearl Watson
Evanthia Milara
Frederun Scholz
Galina Arnaut
Garrett Owen
Genaro Solis Rivero
Graydon Kolk
Grayson Lawrence
Greg Lindy
Hanka Polkehn
Holly Sterling
Irina Lee
Jamie Mahoney
Jan Ballard
Jane Zash
Jay Marlsen
Jean-Paul Amore
Jeff Davis
Jennifer Cole Phillips
Jerri Johnson
Jim Salvati
Jody Graff
John DuFresne
John Gravdahl
Jon Newman
Jonathan Hunter
Jordan Hodgson
Josef Astor
Joseph Han
Josh Ege
Judy Snaydon
Justin Adu
Justin Sanders
Karen Dorff
Karen Kresge
Karen Watkins
Kathy Mueller
Ken Koester
Kenneth Deegan
Kent Williams
Kevin O'Callaghan
Kevin O'Neill
Kimberlee Lynch
Kimberly Capron Gonzalez
Kim Ki Chang
Kiran Koshy
Lauren Thorson
Lea Ladera
Lee Hackett
Leo Cardini
Li Zhang
Linda Reynolds
Manolo Garcia
Marc Baines
Marjatta Itkonen
Mark Todd
Mark Willie
Mary Ann Casem
Mel White
Melissa Kuperminc
Michael Whitney
Michael Worthington
Mikaela Buck
Mina Mikhael
Muhammad Rahman
Nada Ray

Nathan Savage
Nathaniel Haefner
Neil Raphan
Nelson Carnicelli
Nicole Killian
Niklas Frings-Rupp
Olga Mezhibovskaya
Orla McHardy
Pam Turner
Paul Haslip
Paul Rogers
Paul Royes
Paula Seo
Peter Ahlberg
Renée Stevens
River Jukes-Hudson
Robert Best
Ros Knopov
Roy McKelvey
Roy Tatum
Rudy Manning
Ruonan Hu
Ryan Russell
Sabine Georg
Sang Duck Seo
Sean Bacon
Seung-Min Han
Shawn Meek
Siddhi Ranade
Simon Johnston
Sofia Leal Rodrigues
Sondra Graff
Stacey Fenster
Stephen Farrell
Stephen Zhang
Steve Turk
Summer Doll-Myers
Susan Roan
Taylor Shipton
Theron Moore
Thomas Hull
Tom Christmann
Tom Geismar
Tu Phan
Tyrone Drake
Veronica Vaughan
Vince Sidwell
Virgil Scott
Willem Henri Lucas
Wioleta Kaminska
Yasser Ghoneim
Yvonne Cao

Students:
Aartl Thamma
Aasawari Kulkarni
Abby Evans
Abi Gaudreau
Abigail Blend
Adam Braun
Alejandra Balzac
Alex Kupczyk
Alexander Manzanares
Alexander Margitich
Alexia Montana
Allison Mandel
Allison Satterfield
Alyssa Jennings

Amanda Hartman
Amanda Smith
Amber Lai
Amelia Lytle
Amy Fang
Ana Karlin
Anastasia Golub
Andrea Raines
Andres Meza
Anmei Ladeau
Annabel Marshall
Anna Cushing
Anna Gumaer
Anna Kindred
Anna Long
Annie Lindsey
Annika Ballestro
Arayiah Stephens
Ashlea Wood
Ashleigh Calvert
Ashley Linch
Aspen Walter
Aubrey Young
Audrey Hancock
Austin Wydra
Auston Ludwick
Barbara Cadorna
Bo Youn Jang
Brandi Wright
Brianna Dent
Brooke Holle
Brooke Simmons
Cameron Baskin
Camille Lavoie
Camryn Hezeau
Carli Bruckmueller
Carlie Hedges
Caroline Broadus
Caroline Fischer
Carolyn Kilday
Cassie Luzenski
Cassie Schmidt
Catie Haugen
Chantal Lesley
Charles Theori
Chelsea Le
Chelsea Wechsler
Ching Tien Lee
Chris Helm
Christie Warren
Christina Nguyen
Christoff Miller
Chuck Scott
Clair Levisay
Claire Behan
Claire Wade
Clare Coey
Claudia McCann
Colleen Preston
Cora Welch
Corinne Deichmeister
Courtney Shaw
Cynthia Abril
Cynthia Murray
Daniel Kang
Daniela Dunman
Darcy Zacchilli
David Joseph Fleshman

Da Yeon Lee	Hye Been Woo	Kristofer McRae	Nicole Oesterreicher	Sibylle Hornung
Deb Figueroa	Hye Ji Ahn	Kyle Hunter	Nicolò Pavin	Siddhant Karale
Deleha Decker	Hyo Sun Ko	Laine Shipman	Nila Nejad	Sierra Outcalt
Devon Till	Hyunjeong Yi	Lara Orel Pogačar	Nina Son	Sihyeon Lee
Dominic Bodden	Hyupjung Lee	Larry Vida	Noah Hammerman	Skye Zhang
Eddie Guerrero	Inha Bang	Laura Angle	Nya Bragg	Skylar Braswell
Edith Secundino Bustos	Inna Valchuk	Lauren Canizales	Olivia DeLorenzo	Sophia Cordes
Elena Garcia	Isabel Nelson	Lee I	Ozzie Nunez	Sophia DiDonato
Elisabeth Klein	Isidora Beskorovajni	Lee Rhoden	Pablo Orozco	So Yeon Jeon
Elizabeth Ainsworth	Ivan Delgado	Lertchaai Hale	Paige Carrera	So Youn Chun
Elizabeth Ireland	Jackie Perez Carrasco	Lindsay Browne	Paloma Rodriguez	Spencer Krimsky
Emil Miralda	Jacob White	Lindsey Arthur	Paloma Sanchez Santana	Spencer Smith
Emily Baird	Jacqueline Siry	Lindsey Burns	Paras Juneja	Stephanie Moreno
Emily Babcock	Jacquie Tiznado	Luis Perez	Parker Anne Poole	Sukratti Jain
Emily Funck	Jamie Hahn	Luke Wagner	Parker Metcalf	Susie Koh
Emma P. Smith	Jaret Smith	Luvkumar Khemlani	Payton Alibrandi	Sydney Chiles
Enrique Ibanez	Javier Ruiz Navarro	Lydia Herne	Pedro Sacilotto	Talia Trackim
Eric Storms	Jawook Baik	Lynn Seah	Quin Phan	Tamar Najarian
Erin Ckodre	Jeonghyo Park	Madeleine Alff	Rachel Arthur	Tanya Kaufman
Esla Garcia	Jesse Pham	Madi Barney	Rachel Hayashi	Tássia Dias Valim Cunha
Eun Ha Cho	Jessica Mastorides	Madi Grace Thornton	Rae McCollum	Tatem Hayward
Eun Jung Bahng	Jessica Smith	Madison Jones	Rebecca Hawkins	Taylor Confer
Eunsol Oh	Joanne Van	Maggie de Poortere	Rebecca Lang	Taylor Mazzarella
Eve Rios	Joe DeBlasio	Mai Linh Lillard	Rebecca Osterberg	Taylor Minth
Fabrice Prepetit	Joel Nieto	Maria Ramirez	Robert Segura	Ted Pedro
Faith Stibora	Joey Schaffer	Mariangelis Pagan	Robert Warrix	Thomas Messina
Feixue Mei	Johnathon Petersen	Marie Oblad	Rodolfo Flores	Tiffany Shen
Forrest Huu Ta	Jordanna Drazin	Marisa West	Refaat Rico	Tina Nunar
Gabriel Kraft	Jordan Taylor	Maša Pušnik	Ronaldo Mundo	Tony Flores
Gabriel Salas	Jordyn Silver	Matthew Barnett	Rose Elise Achard	Tori Evert
Gabs Samame	Joshua Milos Roebisch	Matthew Brodsky	Rose Hoover	Trevor Rowell
Ga Min Park	Jueun Kim	Matthew Flewellen	Roy Resendez	Troy Vasilakis
Garrett Daniels	Julia Reedy	Matthew Frederickson	Ruonan Hu	Tryn Woessner
Giang Pham	Junghoon Oh	Matthew Hawes	Ryan Merta	Valeriia Danchenko
Gianna Corrente	Junyu Chen	Mattia Pavin	Ryann Woods	Victoria Lin
Grace Baclao	Justin Huffty	Maya Goosmann	Saloni Doshi	Victoria Nieves
Grace Bridges	Justin Wong	Maya Krishamurthy	Sam Adams	Vidhi Agarwal
Grace Curran	Juyeon Lee	McLean Carrington	Samantha Chapman	Wenxin Yuan
Grace Hayes	Kacie Price	Megan Balden	Samantha Ruiz	Will Schlesinger
Grace Park	Kaiqi Cai	Megan Hicks	Sam Dillman	Xinmeng Yu
Gradyn Sherrill	Kaitlyn Kurtz	Megan Myles	Sam Verdine	Xiyu Deng
Gregory Tuthill	Kalip Tristan	Melissa Camacho	Sara Nguyen	Xuehua Cai
Gretchen Rea	Kara Watterson	Melody Deviney	Sarah Cuttic	Yashashree Samant
Hailee Hove	Karolina Kwiek	Micah Rivera	Sarah Storch	Yasmine Radwan
Haley Jiang	Kashawn Stroman	Michael Paris	Sarah Stratton	Yea Hee Kim
Hana Snell	Kate Coningford	Michaela Bollinger	Sari Field	Yekaterina Kim
Hannah Brooks	Kate Kim	Michaela Lucas	Sawyer Tucker	Yeojin Chun
Hannah Morehead	Katelen Jennings	Michele Mardorf	Selin Akyurek	Yeon Ju Kim
Hannah Tanner	Kathryn Fiorini	Mikayla Stump	Seongje Kim	Yesenia Urquiza
Hannah Wilson	Katie Benson	Mike Gaines	Seonmin Lee	Yicen Liu
Hanseol Kim	Kayla McKee	Miki Isayama	Sergio Vera Vazquez	Youjine Lee
Haozhe Li	Kelsey Gil	Miloš Despenić	Seungha Yang	Yuchen Xie
Hatem El Akad	Kexin Fan	Mir Ortiz	Shadow Trammel	Yulin Jiang
Ha Yeon Yun	Kierra Simmons	Moataz Mohamed	Shannon Deuel	Yunseo Heo
Heather Marshall	Kie Veas	Monica Mysyk	Shannon Kirkpatrick	Yutong Liu
Heather Robinson	Kim Seong Je	Morgan Shreenan	Shaoli Yusaf	Zach Rucker
Holden Pizzolato	Kinga Ostapkowicz	Mrunalee Patel	Sharleen Ramos	Zach Stremmel
Hongkyu Park	Kirsten McFarlan	Natalia Deng Yuan	Shawn Depaz	Zareen Johnson
Hope Garver	Kristen Heglin	Natalia Przybysz	Shaye Wiley	Zheng Wang
Hsiao Wen Hu	Kristin Mizushima	Natalie Tarrant	Shelby Baker	Zofia Włoczewska
Huixin Xian	Kristina Armitage	Nathanael Loden	Shermy Chou	Zona Guan
Huiyun Jung	Kristina Edwards	Nathan D. Essary	Shuchen Zhang	Zuzanna Mlynarczyk
Hussam Moustapha	Kristina Freres	Nayeon Koong	Shukun Wang	

Don't be afraid to fail.
Success happens when you more from fail to fail without a lack of enthusiasm and curiosity.

Reneé Seward, *Associate Professor, University of Cincinnati, DAAP*

Your long term success in life will come from three things: perseverance, commitment, and patience, particularly with yourself. Real success is finding work in the things you love.

Hank Richardson, *Director of Design, M.AD School at Portfolio Center; Program Coordinator of Furman University Strategic Design program*

Photography Annual 2021

2021
Hardcover: 256 pages
200-plus color illustrations

Trim: 8.5 x 11.75"
ISBN: 978-1-931241-93-9
US $90

Awards: Graphis presents 10 Platinum, 103 Gold, 200 Silver awards, and 84 Honorable Mentions for outstanding talent in photography.
Platinum Winners: Vincent Junier, Jonathan Knowles, Trevett McCandliss, Lennette Newell, and Howard Schatz.
Judges: Vincent Junier of Vincent Junier Photography, Jonathan Knowles of Jonathan Knowles Photography, and Trevett McCandliss of McCandliss and Campbell.
Content: Award-winning work from the judges, and full pages of Platinum, and Gold-winning work. Silver and Honorable Mentions are also presented. Also featured is a retrospective on our Platinum 2011 Photography winners, a list of international photography museums and galleries, and our annual In Memoriam for photography talent that have left us within the past year.

Advertising Annual 2021

2021
Hardcover: 224 pages
200-plus color illustrations

Trim: 8.5 x 11.75"
ISBN: 978-1-931241-95-3
US $90

Awards: Graphis presents 7 Platinum, 71 Gold, 93 Silver awards, and 11 Honorable Mentions for outstanding talent in advertising.
Platinum Winners: 72andSunny Los Angeles, ARSONAL, The Beacon (Kohler Co), Colin Corcoran, The Designory Inc., FOX Entertainment, INNOCEAN USA, Judd Brand Media, and Young & Laramore.
Judges: David Chandi of Grupo daDa, Silver Cuellar of Tombras, Tony Wu of ARSONAL, and Michael Raso, a freelancer.
Content: Award-winning work from the judges, and full pages of Platinum, and Gold-winning work. Silver and Honorable Mentions are also presented. Also featured are Q&As with our panel of industry-leading, award-winning judges, and our annual In Memoriam for the talent that the advertising community has lost within the past year.

Design Annual 2021

2020
Hardcover: 272 pages
200-plus color illustrations

Trim: 8.5 x 11.75"
ISBN: 978-1-931241-94-6
US $90

Awards: Graphis presents 12 Platinum, 125 Gold, 317 Silver awards, and 241 Honorable Mentions for outstanding achievement in design.
Platinum Winners: Randy Clark, Eduardo del Fraile, Carmit Makler Haller, Young Huale, Journey Group, Leo Lin, Shadia Ohanessian, Michael Pantuso, Subplot Design, Ron Taft, Hajime Tsushima, and Young & Laramore.
Judges: All work was judged by a panel of past Platinum and Gold winners, John Fairley, Gavin Hurrell, Erin Mutlu, Alvaro Perez, Diogo Gama Rocha, Jared Welle, and Yin Zhongjun
Content: Award-winning work from the judges, and full-page presentations of Platinum and Gold-winning design work. Silver and Honorable Mentions are also presented, and a list of international design museums are included.

Poster Annual 2021

2020
Hardcover: 240 pages
200-plus color illustrations

Trim: 8.5 x 11.75"
ISBN: 978-1-931241-91-5
US $90

Awards: Graphis presents 10 Platinum, 94 Gold, 220 Silver awards, and 171 Honorable Mentions for exemplary talent in poster design.
Platinum Winners: Hoon-Dong Chung, FX Networks, Fons Hickmann, Young Huale, Landor, Marcos Minini, OGAWAYOUHEI Design, Ariane Spanier, Hajime Tsushima, and Underline Studio.
Judges: All work was judged by a panel of past Platinum and Gold winners, Mann Lao (Chiii Design), Pekka Loiri, Jisuke Matsuda (Atelier Jisuke), Marcos Minini, Spencer Till (Lewis Communications) and Thomas Wilder (Collins).
Content: Award-winning work from the judges, and full pages of Platinum, and Gold-winning posters. Silver and Honorable Mentions are presented, and a list of international poster museums are included.

Nudes 5

2020
Hardcover: 256 pages
200-plus color illustrations

Trim: 10.06 x 13.41"
ISBN: 978-1-931241-84-7
US $90

The fifth volume in this series, Nudes 5 continues to present some of the most refined and creative nudes photography. Just as this genre helped elevate photography into a realm of fine art, one will find that many of the images on these pages deserve to be presented in museums. Award-winning photographers include Erik Almas, Rosanne Olson, Klaus Kampert, Howard Schatz, Phil Marco, Joel-Peter Witkin, and Chris Budgeon, among others.

Branding 7

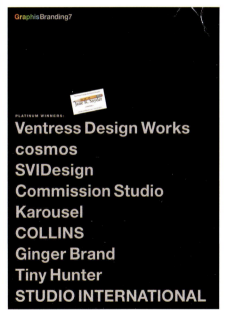

2018
Hardcover: 240 pages
200-plus color illustrations

Trim: 8.5 x 11.75"
ISBN: 978-1-931241-73-1
US $90

Awards: 10 Platinum, 73 Gold, and 194 Silver Awards, totaling nearly 500 winners, along with 124 Honorable Mentions.
Platinum Winners: Tiny Hunter, COLLINS, cosmos, Ventress Design Works, Karousel, SVIDesign, Ginger Brand, Commission Studio, and STUDIO INTERNATIONAL.
Judges: All entries were judged by a panel of highly accomplished, award-winning Branding Designers: Adam Brodsley of Volume Inc., Cristian "Kit" Paul of Brandient, and Sasha Vidakovic of SVIDesign.
Content: Branding designs from New Talent Annual 2018, award-winning designs by the Judges, and Q&As with this year's Platinum Winners, along with some of their additional work.